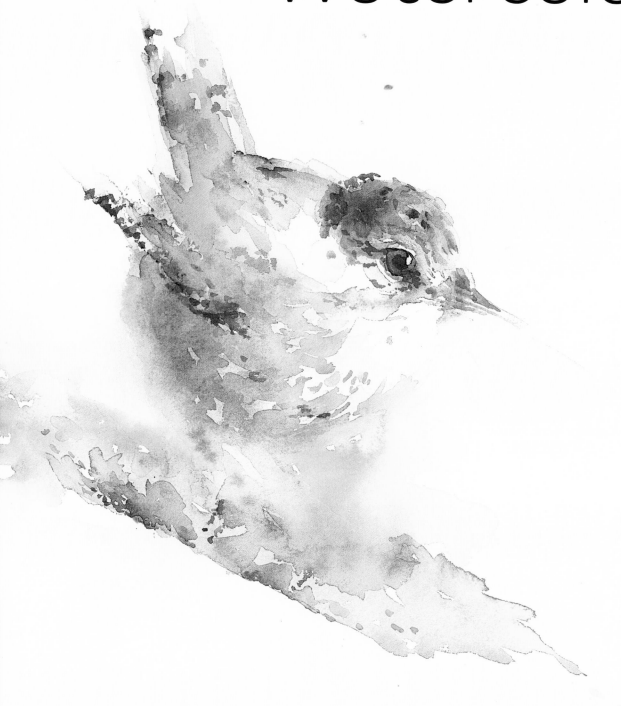

Jean Haines'
World of
Watercolour

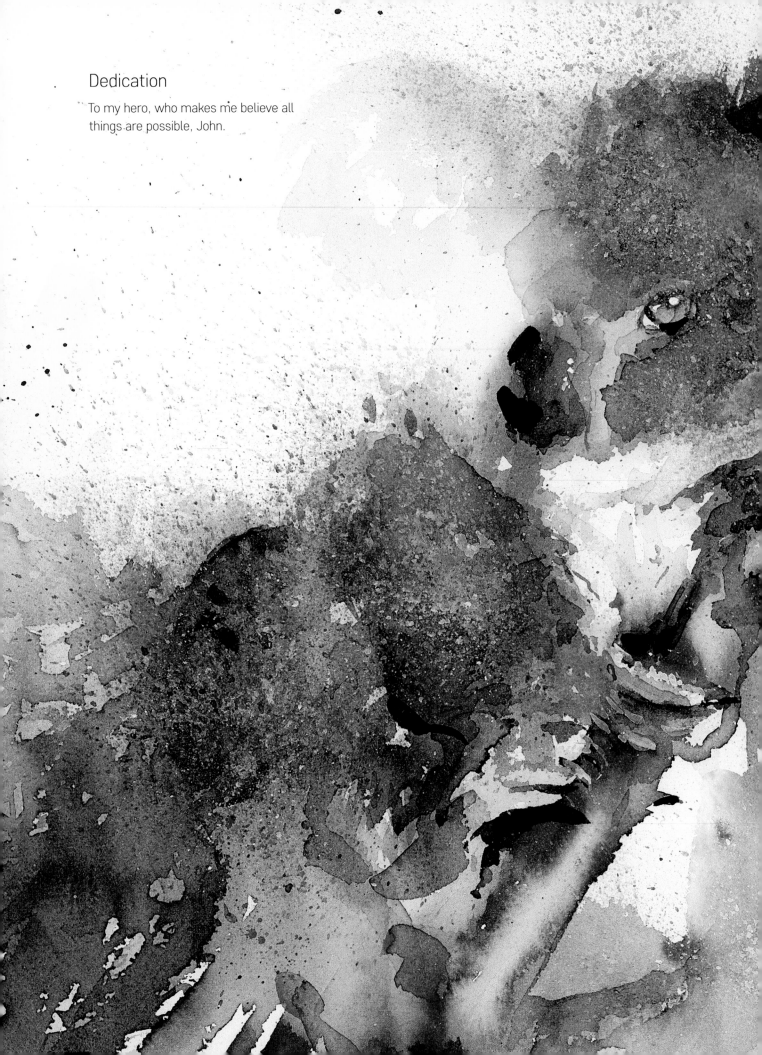

Dedication

To my hero, who makes me believe all
things are possible, John.

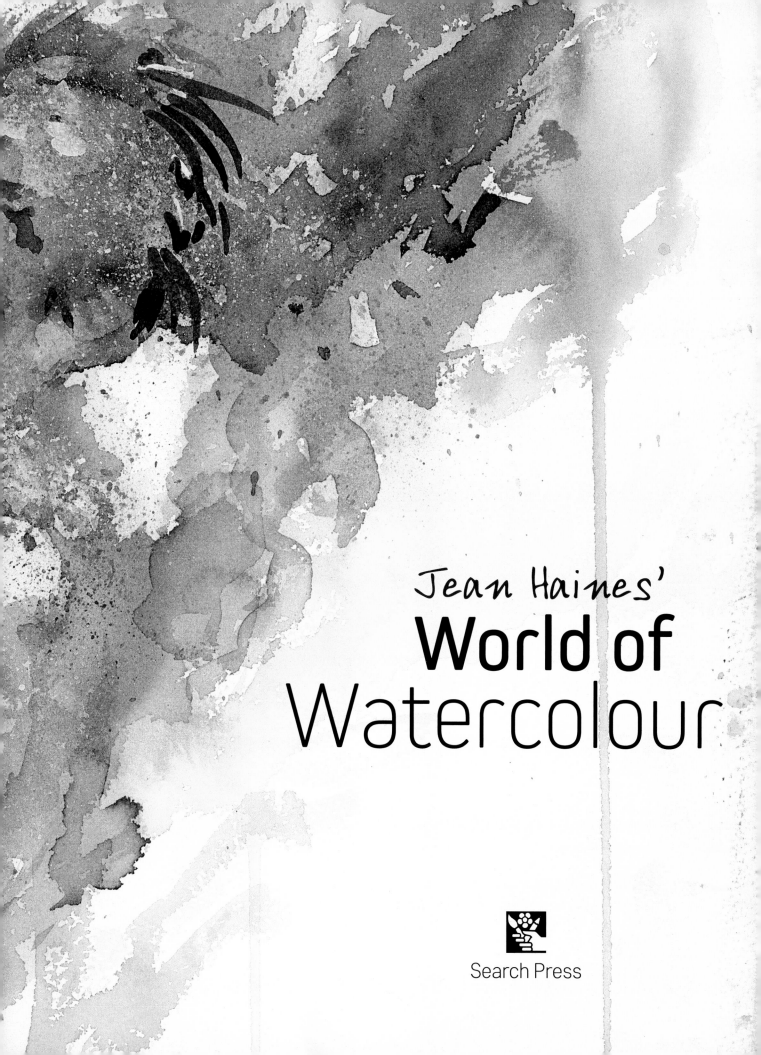

Jean Haines'
World of
Watercolour

Search Press

First published in 2015

Search Press Limited
Wellwood, North Farm Road,
Tunbridge Wells, Kent TN2 3DR

Reprinted 2015, 2016, 2017 (twice)

Text and art copyright
© Jean Haines 2015

www.jeanhaines.com
watercolourswithlife.blogspot.co.uk

Photographs by Paul Bricknell at
Search Press Studios and Roddy Paine
at Roddy Paine Photographic Studios.
Also Mij Stephens for the photographs
of the Author used on pages 8, 10, 25,
34 and 110.
Photographs and design copyright
© Search Press Ltd 2015

ISBN: 978-1-78221-039-9

The Publishers and Author can accept
no responsibility for any consequences
arising from the information, advice or
instructions given in this publication.

Suppliers
For details of suppliers, please visit
the Search Press website:
www.searchpress.com

Printed in Malaysia by
Times Offset (M) Sdn. Bhd.

Acknowledgements

With each new book that I write, the acknowledgements grow. I am so blessed to have support from so many amazing people. Firstly, nothing I have achieved in my life would be possible without the constant love and support of my incredible husband. John is my soulmate and the love of my life. He is my best critic, he encourages me when I lose my way and pulls me back to earth if I feel I am flying far too high on happiness. He travels with me on my watercolour tours and is, unsurprisingly, loved by everyone who meets him.

Being an author would not be possible without my brilliant publishers and the team at Search Press. Caroline and Martin de la Bédoyère give me freedom to write as I wish and I am thrilled with the faith they have in the popularity of my books. At meetings I am met with enthusiasm that is so fantastic, in that they understand completely what I hope to achieve with each new publication. I am very grateful to have become one of Search Press's most popular authors. Katie French, my editor, is the one responsible for making my book come to life, page after page. With an imagination like mine I need someone very special to team up with, to make my ideas work.

I owe special thanks to Mij Stephens. Mij is an amazing photographer and all the personal images of me in this book are down to this talented specialist in her field.

I'd also like to mention Richard Bowler. While I always recommend working from our own photographs as often as possible, there are some that pull at our artistic heart strings and we can't help falling in love with them. Richard is a wildlife photographer, responsible for inspiring my mouse demonstration, and I call him 'an artist with a camera'.

I owe huge thanks to the manufacturers of stunning watercolour products that make my life as an artist a sheer joy. I'd like to thank Daniel Smith, Schmincke Horadam and Winsor & Newton for their gorgeous watercolour shades, and St Cuthbert Mill for the best watercolour paper there is to work on.

But the biggest thank you of all has to be to you, the reader, because without you there would be no point in writing this book. Thank you for being a part of my life as an author. Thank you for giving me the reason to wake each day thinking of what wonderful tips on watercolour I can share. And to every single artist worldwide who has attended my workshops in the USA, Europe, Australia, Norway and Mexico: thank you for being a constant source of enthusiasm, inspiration and encouragement. Amongst you there are artists who have touched my heart, supported me from the very beginning of my art career and generously shown how happy they are when things have gone so right for me. My heart overflows with the love I have been given by so many. And I know how truly lucky I am. Thank you, from the bottom of my heart, for being you, and for encouraging me to be me.

Jean

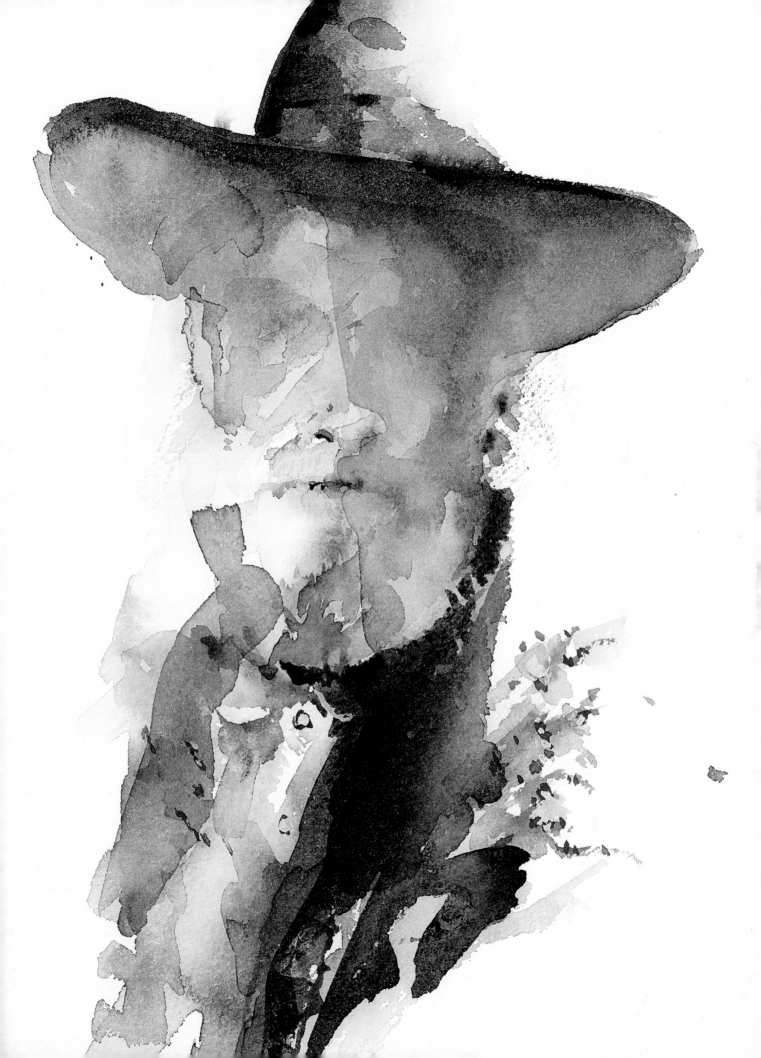

Contents

Page 1
Jenny Wren
33 x 28cm (13 x 11in)

Pages 2–3
Koala Kalm
42 x 32cm (16½ x 12½in)

Page 5
Cowboy
28 x 38cm (11 x 15in)

Opposite
Red is for Love
Geranium painted in Italy.
26 x 36cm (10¼ x 14¼in)

Author's welcome

"The journey is about to begin. Welcome to my world."

Whenever I teach a workshop I always introduce myself and give an idea of how the session is going to run so that everyone attending knows exactly what to expect. To open this book, I wish to share with you, in a few short words, what the content will be. This will give you an idea of what to expect as you turn the pages.

But I hope that this will be no ordinary book. I want it to read like an adventure. An incredible exploration of the world of watercolour – a world that holds me completely captive. It is full of colour and wonder. Days never pass – and never will pass – when I don't see something new to paint or find myself fascinated by the discovery of new techniques.

Painting has changed my life. I hope, by turning the pages that follow, you will feel my enthusiasm and passion for this most intriguing medium. Whether you paint or not, whether you work regularly in watercolour or are thinking of learning, I hope that you as the reader cannot put my book down and that you can't wait to read each new chapter. The journey is about to begin. Welcome to my world.

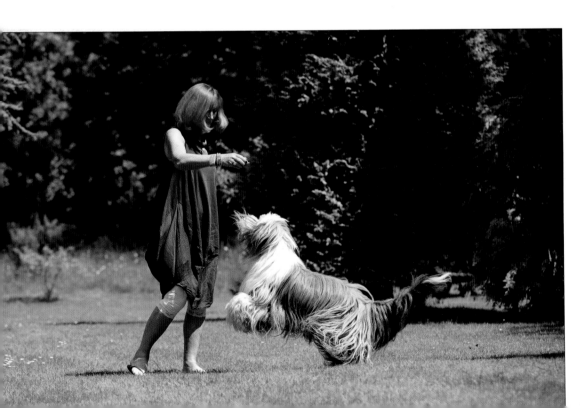

Relaxing in the garden with Bailey, my bearded collie.

Little Hedgehog

All wildlife and animals worldwide
become a fascination for the artist who
enjoys creating in watercolour. Explore
as many techniques as possible to bring
your subjects to life in unique paintings.
20 x 23cm (7¾ x 9in)

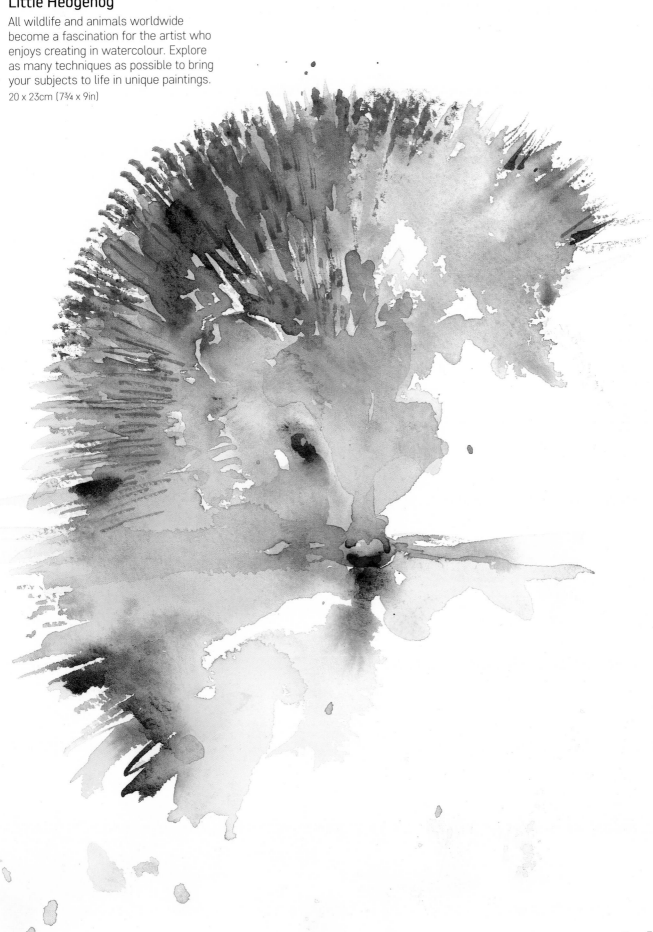

Introduction

"When we keep our imagination open we never know what we may achieve."

Taking time out to relax in my peaceful garden lifts my soul and allows me to absorb the beauty of nature around me.

I have always loved painting, but I never realised just how this passion would become such a huge part of my life. Especially in the exciting way that it has.

For as long as I can remember I have loved creating – from the moment I first held a chunky wax crayon in my hand, drawing dogs and flowers as a toddler, through to my adult years painting while travelling all over the world. Not a day has gone by when I haven't seen something I wish to paint or admire because of its beauty. From the little girl eagerly watching a tiny ant move on a pavement to the grown woman admiring colourful costumes in Thailand or glorious yellow sunflowers in France, I have always seen through an artist's eyes and yearned to capture life in my art.

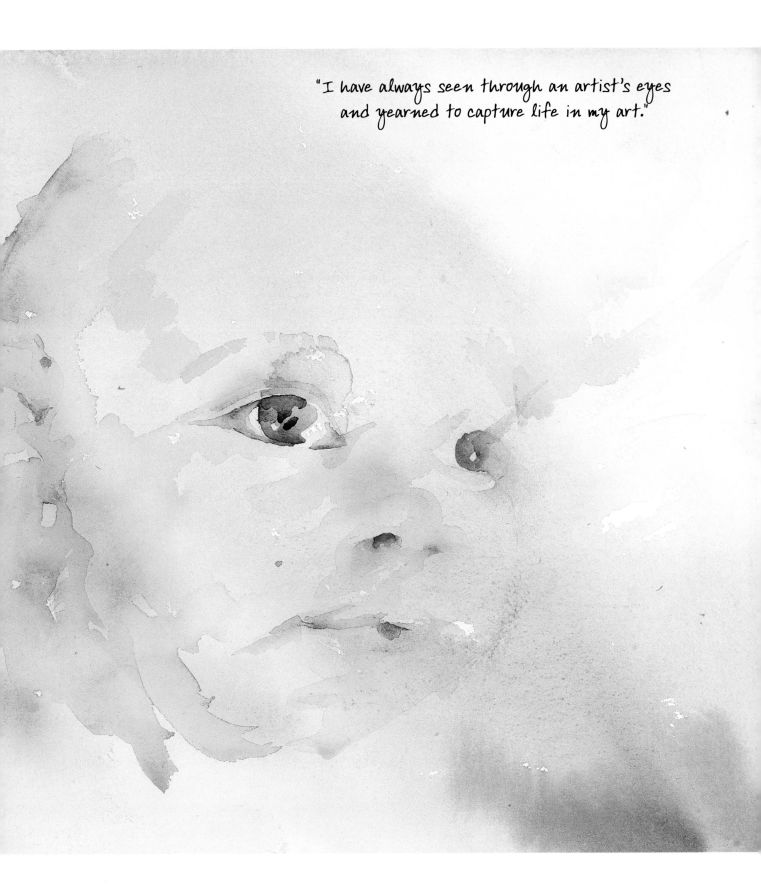

"I have always seen through an artist's eyes and yearned to capture life in my art."

Bright Eyes

The sweet innocence of a child – my beautiful god daughter Amy.

38 x 28cm (15 x 11in)

I started life in England but, due to my husband's career, travelled worldwide meeting incredible artists who have inspired me on so many levels. I have seen unforgettable sights like the Great Wall of China and the glorious Taj Mahal. I know how lucky I am. I have seen stunning architecture in Venice, been mesmerised by Arabian faces in the Middle East and adored the wildlife of Africa. From East to West, my artist's soul has been enchanted by incredible moments that will last me a lifetime, with fascinating images stored in my mind to paint in watercolour.

I wish to welcome you into my world – my haven where only colour and beauty exist – and to show how, with the touch of a brush, you can be transported wherever you wish to go. By turning each page, I want you, the reader, to be excited about watercolour in a way that will inspire you to paint with enthusiasm and from your heart, in the way that I do each day.

Life is a journey to be enjoyed, and working with watercolour can become an integral part of it. Every single thing that you do, from the simple opening of a fridge door in your home to travelling across the globe, can lead to precious moments of creative inspiration.

This book is not intended to provide just step-by-step instructions on how to paint. Its aim is to motivate you to feel free to create paintings with fabulous colour combinations, bringing life into your work by opening your imagination to its highest level. Without even packing a suitcase you are able to leap from country to country and enjoy the thrill of painting all manner of subjects without even leaving your front door. You don't need a passport but you will need a sense of adventure, and if that is missing in your life I hope to help you find it. Our journey into a world of watercolour, mine and yours, is about to begin.

"Life is a journey to be enjoyed, and working with watercolour can become an integral part of it. Every single thing that you do, from the simple opening of a fridge door in your home to travelling across the globe, can lead to precious moments of creative inspiration."

"I have seen stunning architecture in Venice, been mesmerised by Arabian faces in the Middle East and adored the wildlife of Africa."

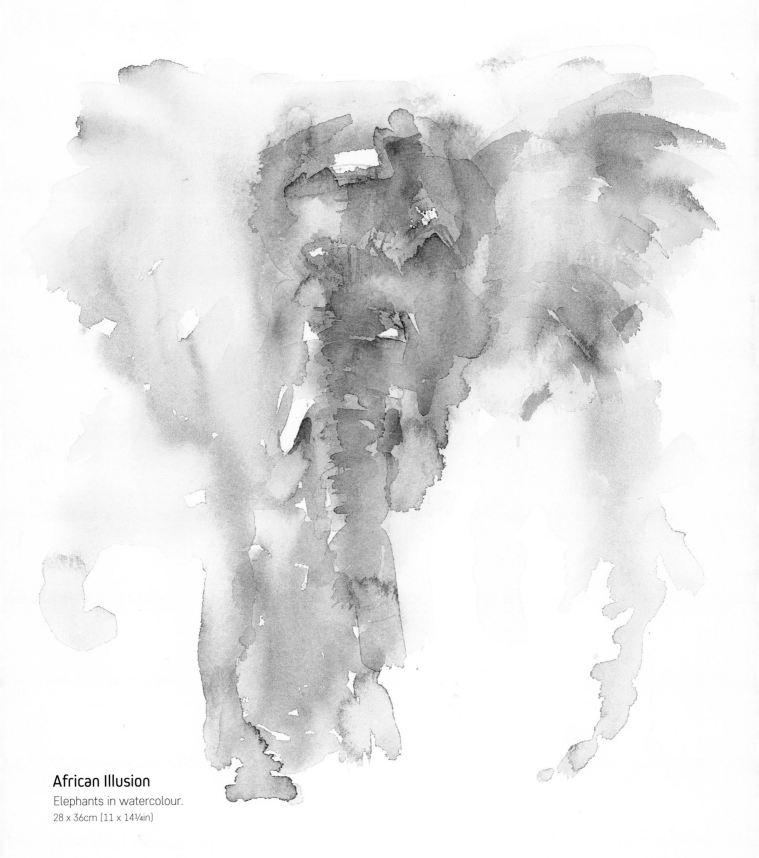

African Illusion
Elephants in watercolour.
28 x 36cm (11 x 14¼in)

My journey into watercolour

Influences on style

> "Life as an artist is an adventure, with each new blank piece of white paper being an invitation to a new journey of creative excitement."

To welcome you into my world of watercolour I would like to invite you to take a trip down memory lane, so that you can understand how my style has evolved and discover how I fell in love with watercolour as a medium.

This may come as a surprise, but I started my artistic career as a botanical artist. I used to painstakingly add every intricate detail to every single flower that I painted. This was obviously very different from the style I am now well known for. Maybe childhood years of observing beautiful colours in my grandfather's garden instilled in me this love affair with flowers, as floral compositions have always played a huge part in my art life. I used to admire longingly the delicate hues of the sweet pea flowers that he grew. Row upon row of pinks, soft blues and violets would last all summer long and their perfume would fill the air. I can close my eyes and still see them. I still regularly paint flowers, although my style has changed dramatically. I now work far more loosely. How did this change in style come about and why?

I wanted to grow as an artist and so I moved from painting botanical flowers to classical landscapes. My watercolours then were perfect without a single watermark in sight, as that was how I had been taught. I painted in the same way as everyone else on every art course I attended at that time. Each student ended up with similarly perfect images of a church or village scene that had been painted a million times before in almost the same colours and using exactly the same techniques. My inner artistic spirit was fading.

Watercolour: pure colour and simple brushwork.

Luckily at that time we moved to Hong Kong.
Here my life changed dramatically and my passion
for art was to be renewed, but by accident.
A charity needed an artist to illustrate a cook book,
and I invented a 'Chopstick Bear' character to
help raise funds for an orphanage. This little bear
became well loved very quickly and later appeared
in greetings cards. While his popularity grew, my
love for painting was reborn with a much stronger
need to find a style that made me happy.

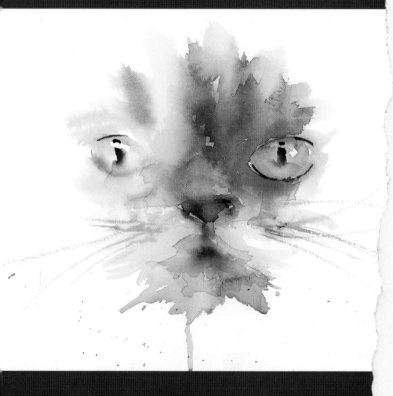

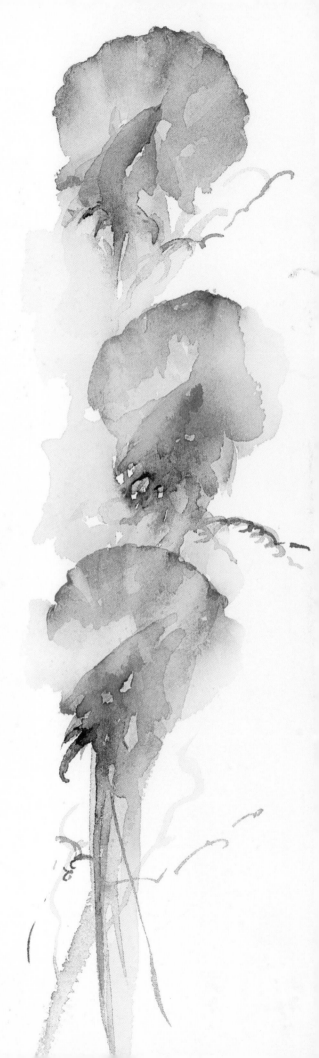

Sweet Pea Sensation

An English garden.
14 x 38cm (5½ x 15in)

I decided to study Chinese art and I became entranced with Asian brushwork. I studied under a wonderful mentor who would hit the back of my hand with bamboo if I laid my brush down or held it up at the wrong angle. I became adept at allowing my brush to glide over antique silk or paper under their tuition. I learned to listen to pigment when it was gently encouraged to tell a simple story. Like 'The Karate Kid', I studied under a master and whatever they told me to do I followed eagerly, because I knew this was going to help me become a far better artist. I practised holding my brush, picking up pigment and releasing it with just the right pressure on my brush as I held it. There is so much I want to share from this learning, and I will, throughout the pages of this book.

"I practised holding my brush, picking up pigment and releasing it with just the right pressure on my brush as I held it."

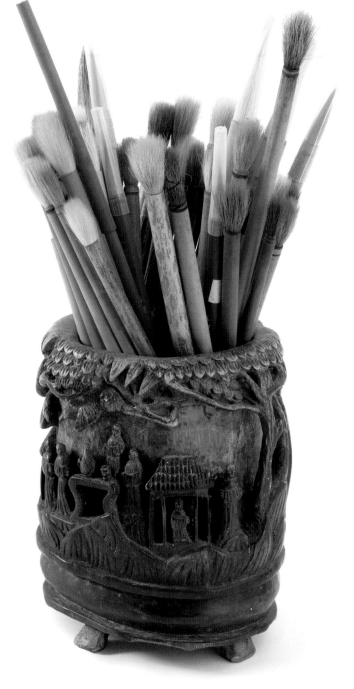

My Chinese brushes were given to me as a gift while I was studying watercolour in China.

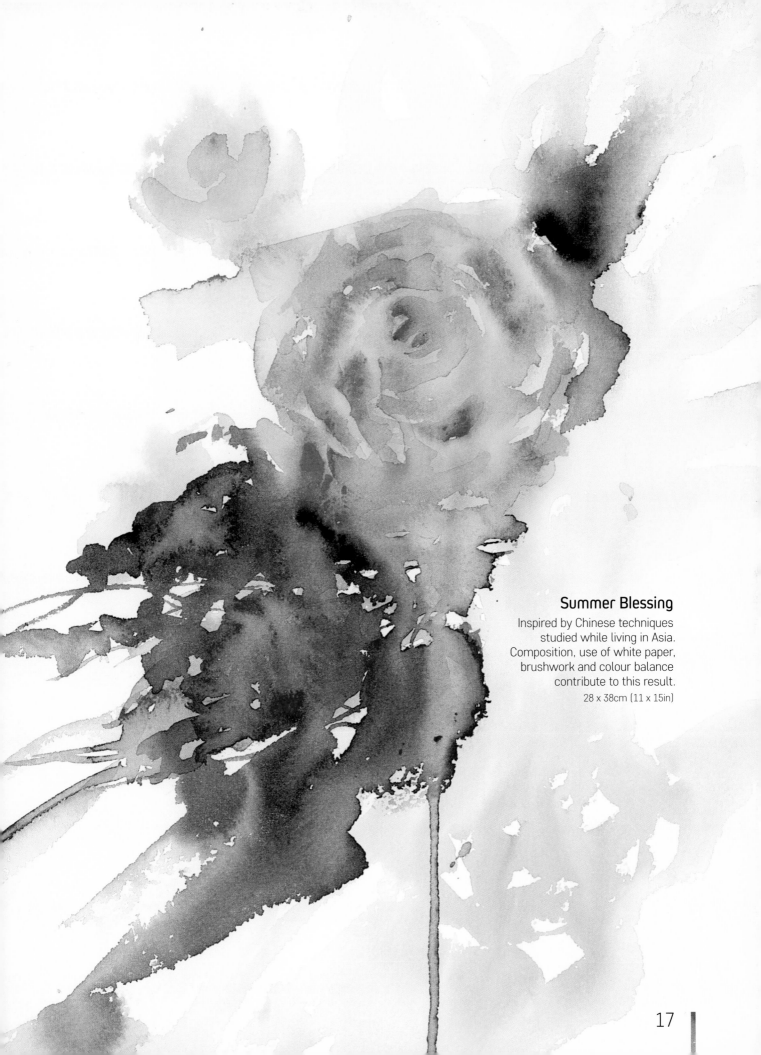

Summer Blessing
Inspired by Chinese techniques
studied while living in Asia.
Composition, use of white paper,
brushwork and colour balance
contribute to this result.
28 x 38cm (11 x 15in)

From Asia I moved to Dubai. This is where colour truly came alive for me for the very first time. Gone were the washed out blue skies of my English painting past. Now there were skies full of colour, camels in the sandy deserts along with old forts and buildings. These were my thrilling new landscapes. My heart burst with excitement as each day there was always something even more fantastic to paint.

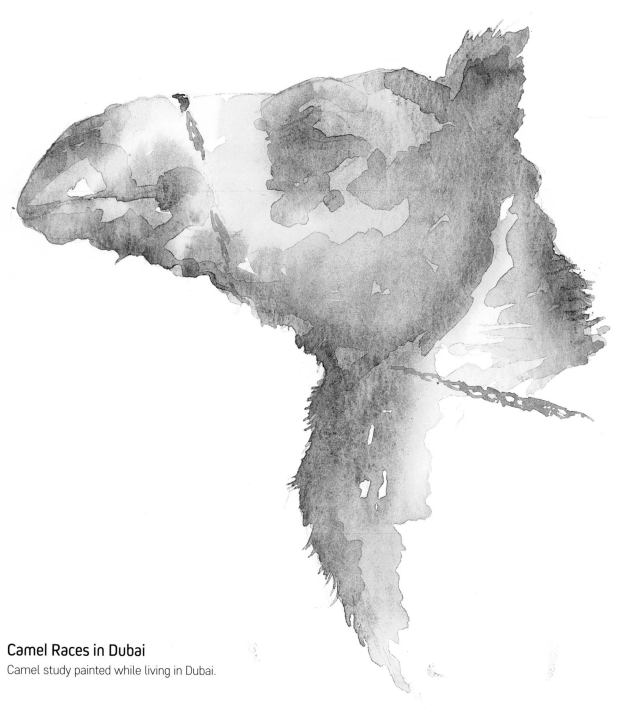

Camel Races in Dubai
Camel study painted while living in Dubai.

Here I was asked to teach at the Dubai International Art Centre. I created workshops with themes and many artists would ask for information about the inspirational music I was playing during the sessions. Often this was Celtic, and I still play it in my international workshops and courses today.

As well as teaching in Dubai I studied under oil masters, specialising in portraiture. I loved it. My thirst for creating and learning grew continually, and I also worked in pastel for animals and faces. But nothing held my attention for long in the way that watercolour, as a medium, did.

I stopped using a pencil. Instinctively I knew I could gain a far freer effect that would thrill me and give me the excitement that had been missing for some time in my artistic life. I was on an adventure. If only I knew at that point in my life how wonderful it was going to be, and how fulfilling.

"Living in Dubai opened my eyes to many new subjects."

Arabian Whispers
I often painted in soft, quiet colour in my early years as an artist.

19

I started to work directly with colour, using no preliminary sketches. A strange thing happened. I started to adore my work long before it had reached the finished stage and so did others viewing it. Sometimes an animal or face would look perfect long before I felt a painting was completed, without the addition of further definition. My style was evolving, but at that point I was simply experimenting. I knew that I loved what I was doing and I couldn't get enough of it. I jokingly called myself a watercolour addict, and I still am. I used this new-found style, mixing it with my learning under the masters from India and Pakistan. They became fascinated by my approach and encouraged me to continue. I did.

From Dubai I moved to France. I had already begun to add life and movement in my watercolours by losing the preliminary sketch method. I had by now completely fallen in love with watercolour as a medium. I was capturing my subjects with colour and brushwork alone, combining the techniques I'd gained from Asia and the Middle East. However France added another element. Here I lived in the countryside and was surrounded by flowers, mainly roses. I came across the work of an artist called Madame Blanche Odin. I was also introduced to the work of an artist called Jean Louis Morelle. Their use of watercolour fascinated me.

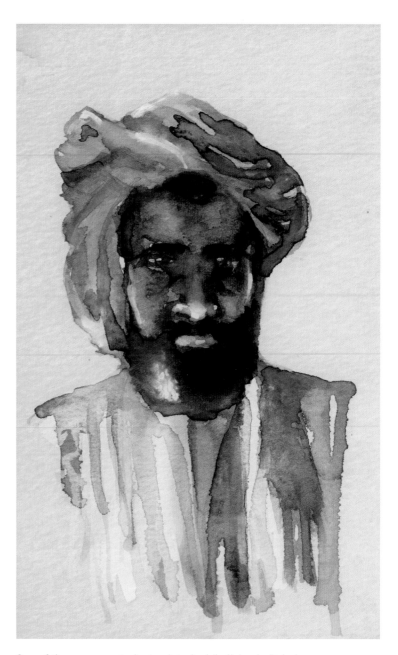

One of the many portraits I painted while living in Dubai.

"I knew that I loved what I was doing and I couldn't get enough of it. I jokingly called myself a watercolour addict, and I still am."

Market Seller, Dubai
No sketch, just colour bringing my subject to life with an atmospheric result.
15 x 25cm (6 x 9¾in)

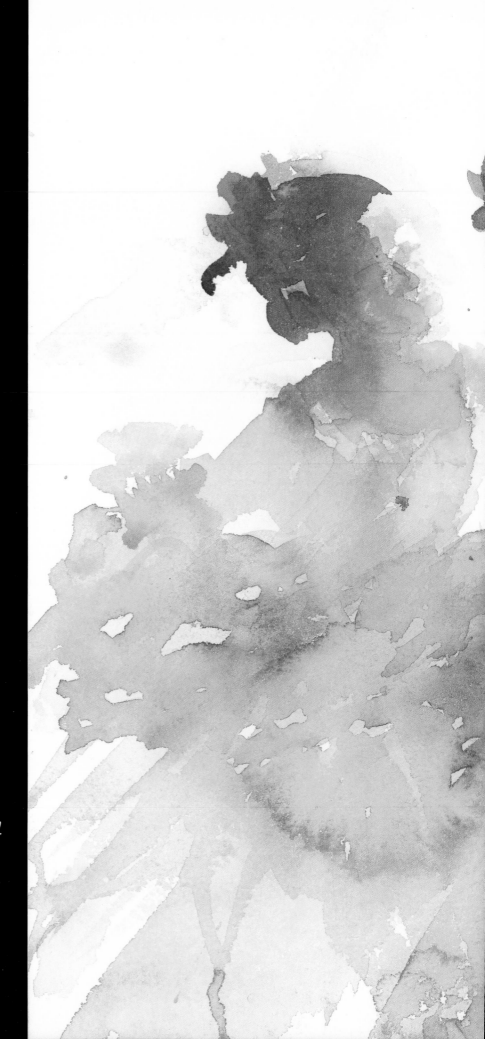

"I gradually lost the
inner artist who loved
painting intricate detail
and became the one
who loved capturing the
essence of a subject."

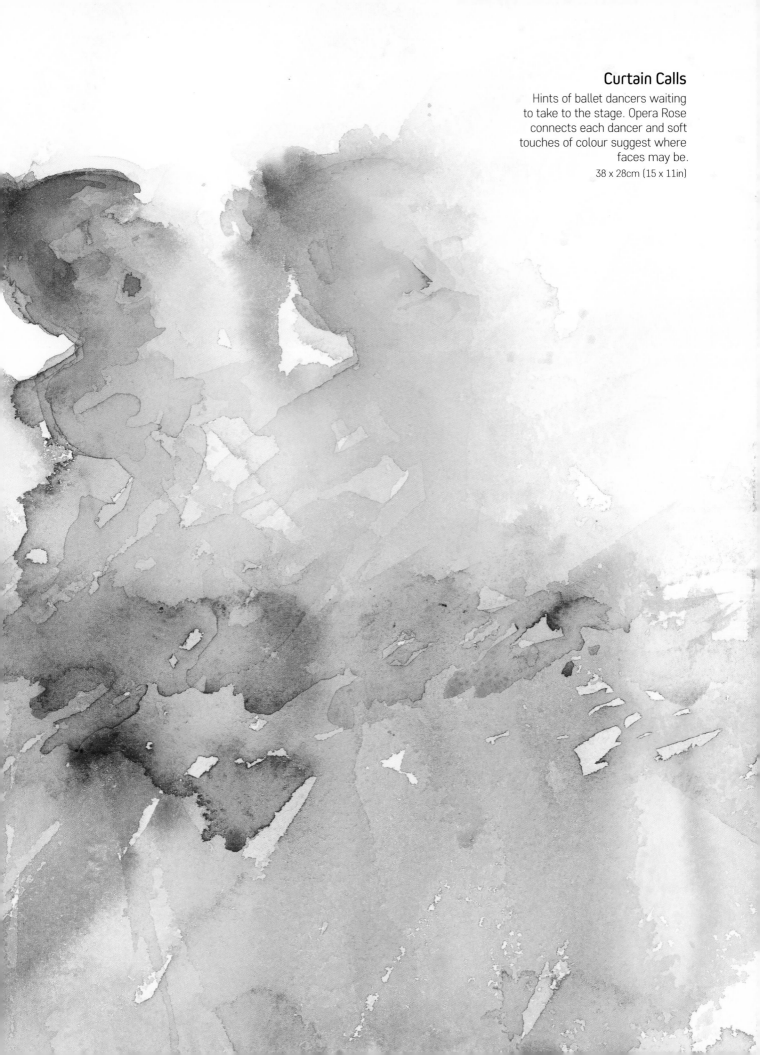

Curtain Calls

Hints of ballet dancers waiting
to take to the stage. Opera Rose
connects each dancer and soft
touches of colour suggest where
faces may be.
38 x 28cm (15 x 11in)

An artist's treasure

Materials

"The materials we choose to paint with can make our creative journey even more exciting."

I have a confession. Looking back over the years, the materials section of any art book was always the one that I would race through quickly. I would merely glimpse at the images on these pages purely to get to the 'action' of the more interesting step-by-steps or demonstrations that followed. I have grown up! I now realise that this part of any art book is the real treasure chest, because these pages hold the key to the author's success as an artist. Furthermore, without this information, the paintings that follow would be impossible to achieve.

I have also changed my opinion greatly on which materials I choose to work with. My eyes have been opened to fabulous products that I hadn't discovered before, especially when it comes to watercolour pigments.

So let's start at the beginning. My collection of art materials is like an amazing treasure chest to me. The vibrant jewels in it have to be my watercolour shades. I have so many that I love. And to think that years ago I painted absolutely every subject with just three shades. How I have changed!

In my garden, where I find endless inspiration and gorgeous subjects to paint.

"My collection of art materials is like an amazing treasure chest to me. The vibrant jewels in it have to be my watercolour shades."

Tip

Holding a tube of colour next to your subject gives you an idea if the pigment is the best shade to use. Try matching the colour band on the tube to your chosen subject.

Interesting subjects, vibrant watercolour shades, my favourite brushes and beautiful paper all assist a great painting result – and more enjoyable time spent creating.

I believed then that it was good practice to mix all of my shades from a simple red, yellow and blue pigment. I was so strict with myself. I always worked with Alizarin Crimson, Cadmium Yellow and Cobalt Blue. I never bought a green shade as I would always mix my own. Looking back I can see I was stuck in a rut. Thank heavens I escaped. But that time in my life was great training for discovering how pigments interact with water and with each other.

I have always preferred to work with pure watercolour, and this time in my art life enabled me to learn about the qualities of each pigment. For example, I observed which transparent pigments were best for layering techniques and glazes. I gained an insight into how useful opaque shades could be for adding depth. I loved discovering which pigments created granulation effects. This is all information I may otherwise have missed had I not taken time to simply study colour rather than continually paint subjects.

When I initially lived in England I often painted quiet landscapes. The softer use of colour in my work at that time suited the subjects I was painting, and I was greatly influenced by watercolour masters who also painted in these soft shades. Over time my collection of colour charts grew as I built up my collection of watercolour shades. But even after all this time I still look at my old shade charts and learn from them. They remind me of how I worked in countries with hotter or cooler climates, and where humidity always had to be taken into consideration.

One of my early watercolour shade charts. As you can see, I used to work with very soft colours.

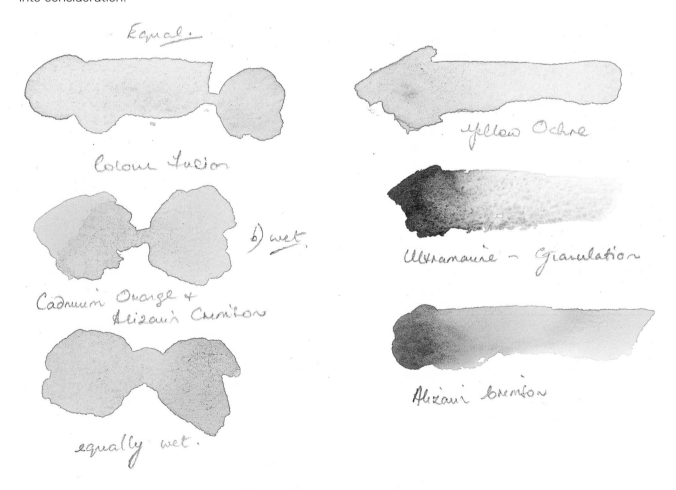

Equal.

Colour fusion

Cadmium Orange + Alizarin Crimson

b) wet.

equally wet.

Yellow Ochre

Ultramarine – Granulation

Alizarin Crimson

Interestingly, one of the very first colour combinations that I fell in love with for painting portraits is the same today as it was then. I love using Yellow Ochre with Alizarin Crimson for skin tones. I use a watery combination of these two shades when painting portraits of children. When working with darker skin tones I substitute Perylene Maroon for Alizarin Crimson, a mix that gives me stunning results. I only discovered this information from creating shade charts specifically for painting portraits. I could possibly write a book on creating valuable shade charts for watercolour painting of specific subjects!

I must explain that these shades charts weren't simply to record colour. When living or teaching in different countries I found these charts invaluable for checking drying times and the speed of pigment interaction. When I teach workshops abroad now, I still create a few quick shade charts before I demonstrate to ensure I know how long my work will take to dry. This drying time is vital to my results, as I now celebrate watermarks. If my pigments were to dry too quickly, these magical patterns could be lost. Too slowly, and the watermarks or 'blooms' could spread over too large an area.

Knowing all this information aids the skill of a watercolourist and, sadly, it is far too easy an area to skim over when you first start painting. So please, if you are new to working in this medium, take time to learn about the products you are using. Learn how watercolour dries paler than when first applied, how pigments interact and how they can be enhanced by weakening or strengthening the amount used with water. All of this brings me to my favourite materials: the watercolour products that I use.

Top right: An old shade chart showing how I used to work with three pigments to achieve different shades.

Bottom right: Daniel Smith watercolour, 2014 – the more vibrant shades I use today.

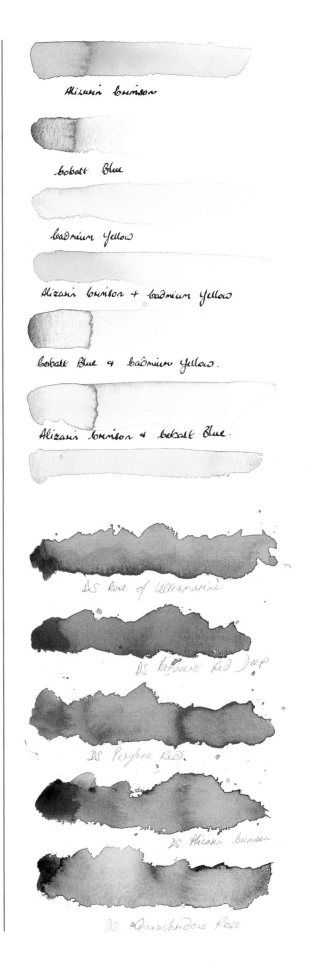

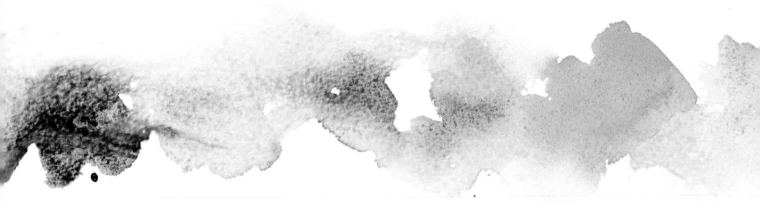

Watercolours

I use many manufacturers' products for different reasons. I have been a Winsor & Newton artist for many years and I am still a huge fan of their paints. I love their shades and rarely move away from them. That was until a few years ago when I discovered Schmincke Horadam products, in particular their Translucent Orange. This colour was so excitingly vibrant, and what's more it interacted well, was transparent and could layer beautifully. Its qualities were very different from the opaque Cadmium Orange that I had used previously. This led me to look into more shades by the same manufacturer and I discovered wonderful new favourite colours such as Helio Turquoise, which is perfect for my kingfisher paintings.

I am touring all over the world with my popular workshops, meeting artists who eagerly share their favourite colours with me. In the USA I fell in love with Daniel Smith watercolours, whose colour range is out of this world. The impact of each dramatic addition to my now overflowing artist's treasure chest containing tubes of colour was mind blowing. I always used to mix my own greens, but for the first time in my life I now love using purchased green shades. Daniel Smith Cascade Green and Undersea Green are superb, and Moonglow is spectacular as it creates gorgeous effects. Daniel Smith Opera Rose is magnificently vibrant. While I am mentioning different manufacturers, do try Old Holland's Baroque Red, which I find brilliant for painting my roosters.

Had I not travelled and come across artists using different product ranges I could still have been stuck in my three-colour shade mixing phase. My favourite colours change constantly, which makes my life as an artist so exciting. There is so much to explore that each new day painting is always an adventure.

> **Tip**
> *Try a new colour or product as often as possible and experiment with it. Don't ever let yourself get stuck in a rut!*

"There is so much to explore so that each new day painting is always an adventure."

Kingfisher Blue
Painted with Schmincke Horadam
Helio Turquoise.
28 x 38cm (11 x 15in)

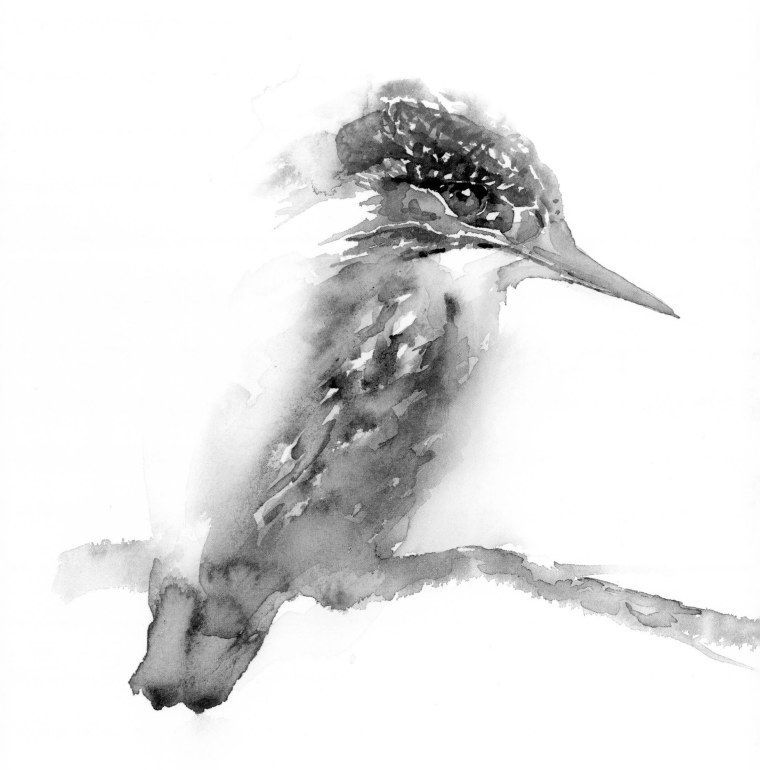

"I discovered wonderful new favourite
colours such as Helio Turquoise, which is
perfect for my Kingfisher paintings."

Watercolour palette

I have seen artists use white plates and all manner of surfaces as palettes. I prefer to use a large round sorting tray that has room for lots of juicy colour in each section. In my workshops, I dread seeing artists place tiny dots of pigment onto a palette and then expect it to cover a large piece of paper. I squeeze whole tubes into each compartment on my palette and get excited just by looking at the array of vibrant colours before my eyes, all ready and waiting for me to dip my brush into them.

Tip
Make your painting life exciting at every single opportunity.

If you look at your own palette and don't feel excited at the colour range there, something is very wrong. Start by rethinking which pigments you are using and why. If necessary, choose new ones that make you feel more alive. If you feel great at this stage of working you will enjoy painting far more. Make your painting time enjoyable from the minute you pick up a brush, and keep looking at your selection of thrilling colours on your palette as you work.

"I squeeze whole tubes into each compartment on my palette and get excited just by looking at the array of vibrant colours before my eyes."

Paper

This is an area I could talk about for ages. Firstly the paper you use has to be suitable for watercolour, and secondly it has to be the correct weight. Good quality paper makes a huge difference not only to your results but to your enjoyment while creating. Always use a weight of 300gsm (140lb) or over. Many new artists experiment first on practice paper that buckles the minute it is wet and then, sadly, they give up. Using the right products leads to the best outcome, not only during the creative process but also in the finished results.

I enjoy using Saunders Waterford 638gsm (300lb) Rough paper for my gallery pieces. Bockingford is a wonderful paper for studies, experiments, and for large compositions in which large sections are left as white space.

While good quality and the right weight of paper are important, so is the paper surface. I love using rough paper so that the watercolour pigments sit in the surface pockets. This gives me wonderful textural effects. If I am painting subjects that require a silky look, poppies for example, I opt for using smooth paper. Take time studying more about paper quality. Look into hot and cold press papers. Enjoy making yourself into a far better artist by improving your knowledge of what you are working with. There is a lot to learn!

Water containers

I use two water pots. I keep one container for clean water and a second for cleaning my brushes as I paint. However, I will unashamedly admit I often get so excited while I am working that I often don't look at which container my brush dips into. But I do change the water regularly! I love clear containers as you can see easily when this needs to be done.

Tip
You will never achieve vibrantly clean watercolours if you work with dirty water.

Brushes

In my studio I have many brushes that I have bought over the years in response to adverts and promotions that claim they will magically help me paint, for example, leaves or branches. Following my time studying in China, I know now that I need very few brushes to get the results I want to achieve – just a few wonderful sable brushes in a range of sizes. My brush set is really important to me and I would be lost without it. While teaching I have found that many new artists are unable to invest in good quality brushes, though I strongly recommend buying the best that you can afford. I have designed my own personalised brush range so that everyone using them can enjoy painting as I much as I do. My brush set consists of:

Size 10

I use this brush for painting subjects directly. I hold the brush in a number of positions to create a variety of beautiful brushmarks. It loads and releases pigments beautifully and glides over the paper surface, which is really important for my watercolour effects.

Rigger

I use this brush to pick up small amounts of pigment to drop into washes. I also use this brush for adding fine detail, usually towards the end of a painting. It is also perfect for fine line work such as cats' whiskers.

Size 12

This personally designed brush has a beautiful point and can be used in many ways on larger paintings.

Mop brush

I couldn't live without my mop brush (also known as a wash brush). Brilliant for washes and wonderfully comfortable to hold.

Tip

I use very little pressure while painting, which allows pigment to flow freely from my brush across the paper surface. The lighter your touch the better the pigments flow, interact and sing.

Easel

I work with my paper at an angle and find a table easel really useful for my more detailed work. But I also often stand to paint at my main easel. I enjoy moving to music while I create. I often observe artists who sit still, never moving while they are painting, apart from their wrists. To really gain a sense of fluidity and movement in our work we need to genuinely feel that movement. Brushstrokes are far more free when the whole arm is used. This action encourages a full flow of movement, which in turn can infuse the artist's creative spirit with a sense of well-being. Imagine the actions of Tai Chi experts and consider how they work on the human mind and body.

I stand back from my easel occasionally to study what is happening with each evolving painting. This is a wonderful tip – to move back from your work and look at your paintings through the various developing stages. Half-finished paintings can sometimes tell you what steps are needed next, if you learn to observe. My advice is to take breaks frequently to allow time to study what you are working on. The main point, though, is to always be comfortable, whether standing or sitting; find a position in which to paint that suits you.

Sitting at my table easel working on a painting of summer flowers using Opera Rose and my size 10 brush from my personalised brush range.

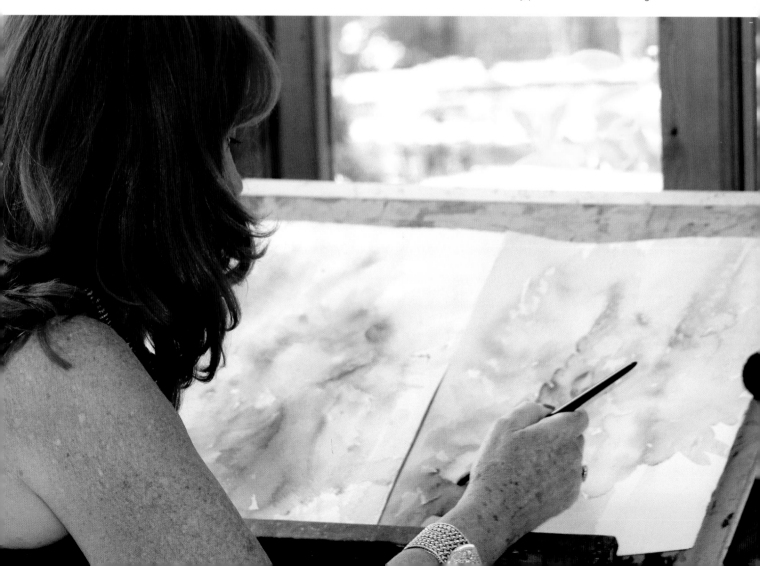

Resource images

I am a keen photographer. I collect memories of places I have seen, animals I have fallen in love with and seasonal flowers in beautiful light. I love colour. If I see something glorious I always try to capture it with a photograph so that even if I am painting from life, should the light change suddenly I have a permanent record of what I was trying to capture in my art. I keep inspirational photograph albums that I can fall back on at any given time to paint subjects I am in love with.

I don't just keep photographs in these albums. I paint colours I see from life on scraps of paper and keep these shade charts in my albums alongside the photographs. This means that if I want to paint spring flowers in the middle of winter I not only have the images to work from but the exact true-to-life colour chart to aid my success in gaining believable results.

> ## Tip
> *I always advise artists on my workshops to work from life or their own photographs as much as possible. Painting from other people's photographs is like trying to repeat a story that has been told to you by someone else. Painting what we know, see and understand is far more exciting, definitely more personal and, more importantly, more unique.*

Accessories

I try to be a purist while working with this terrific medium. I don't use masking fluid or pencils. Colour alone guides my creations. I sometimes fall back on the smallest amounts of Designers Gouache in Permanent White for additional touches such as eye highlights, should I lose the original white from the paper. I must add, the effects I am gaining nowadays without the use of any of these products is far more pleasing to my creative soul. I am allowing watercolour to sing in all its glory, minus the influence of watercolour accessories that can often take away from what this magical medium can do on its own. But I do like occasionally using plastic wrap (Clingfilm) or salt for texture effects.

On this note, let's turn to the next page and explore technique, because talking about painting is never as thrilling as actually doing it! After that we will look at something else which many artists worldwide can't work without: gorgeous subjects. You are now about to walk into my world, starting with my daily routine in watercolour.

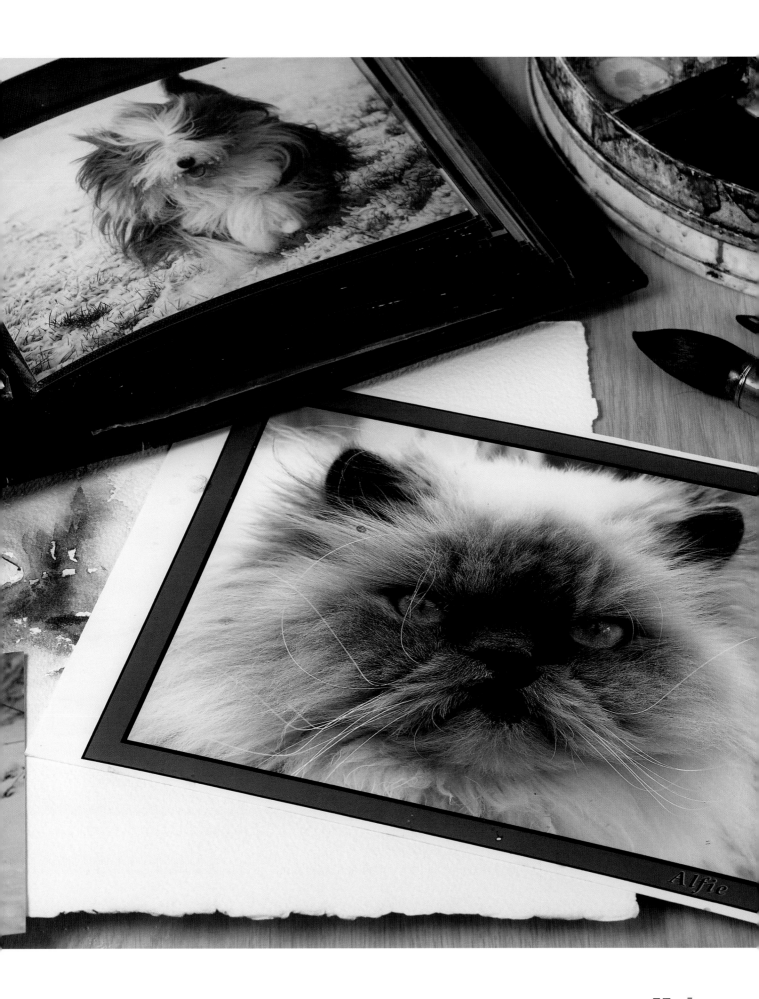

Alfie

A brush with brushes

"Studying how to handle brushes makes a huge difference, not only to our confidence as artists but also to our pleasure when creating."

Getting to know how to use your brushes is vital as an artist, but it is a skill many don't master correctly. Using the right size brush at the right time can make a big difference to both your art and your painting results. I was fortunate to have studied Asian brushwork, which makes a huge difference not only to my confidence as an artist but also to the pleasure I gain from creating.

I hold my brushes at a variety of angles to the paper. I also hold my brushes in a number of positions. When working on fine detail in paintings, I place my hand close to the sable tip, which gives me more control. But when painting long, fine lines I often hold my brush at the furthest end of the handle. This gives me more freedom, which is even more beneficial when using my whole arm rather than just my wrist to paint. I gain movement when doing so. Studying brush handling has enhanced my skill as an artist and I am so grateful for my time studying this skill while living in China.

Mostly I work with my size 10 brush. I can paint by holding the brush vertically to use just the tip. When held against the paper with the length of the brush on its side, I can achieve wider brushstrokes, and it is brilliant for my 'working from a starting point' techniques.

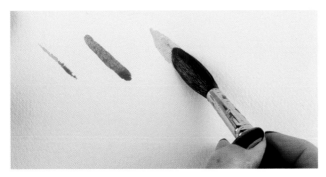
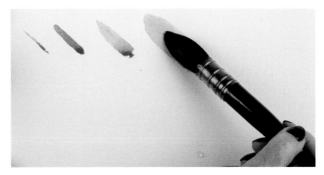

The larger the brush used, the larger the brushstroke will be. I simplify and make life easier by selecting the right brush for the area I wish to cover on paper. My size 12 brush is used in the same way as my size 10. This means I can paint a subject covering a larger area more easily. I also use this brush for washes on medium- to large-sized paper.

Every artist has favourite brushes which they enjoy using. Sometimes it takes time to work out which work best for you, but four brushes are all I need to create my watercolours – and I would be lost without them! The four brushes I use for all of my work are the rigger, size 10, size 12 and, the largest of all, my mop brush for larger paintings. A mop brush is invaluable for painting washes covering large areas of paper.

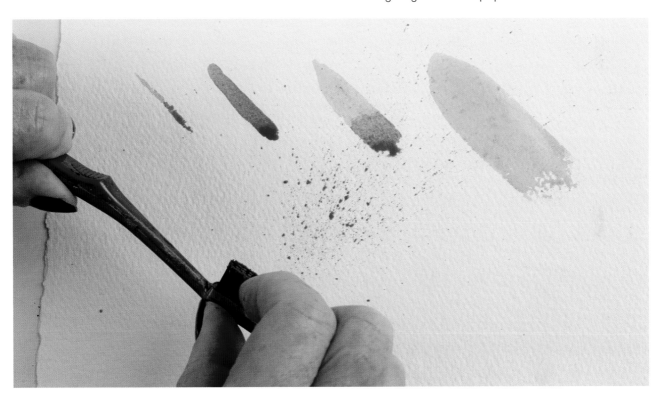

The only other addition to my brush collection is a well-used toothbrush for splattering techniques. It takes time to mould a toothbrush to splatter just the way you want it to. I splatter at an angle onto wet or dry paper, which gives me wonderfully unique results. Splattering onto dry paper will give you neat dots of colour, while splattering onto wet paper will allow the colour to fuse softly with the water. Try splattering onto wet paper. Allow this first application to dry completely then splatter again onto dry paper with the soft fusions from the previous application of dots acting as a backdrop. The results are beautiful.

As a rule, I usually start with my largest mop brush for a background wash. I use a size 12 for painting larger subjects or a size 10 for working from a starting point, and I mainly close the painting with my rigger for the last few details. My mentor from Shanghai made me practise painting bamboo for months before they allowed me to paint any other subjects. This was purely for me to gain the ability to move my brush in many directions and know them well. I hold my brushes in many ways for different techniques. These I will discuss further as we work through the book. For now, though, we need to start warming up ready to paint beautiful watercolours.

Tip
A small brush holds smaller amounts of water so is easier to work with in small sections of a subject.

Demonstration: Sweet peas

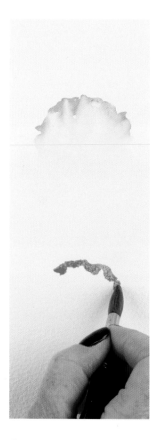

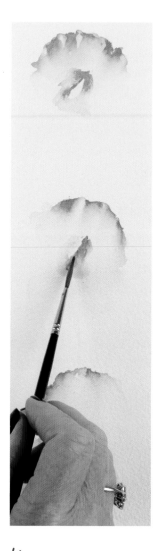

1 I often start painting a subject by using my size 10 sable brush to create a starting section. For the sweet pea flower, I use it to paint the upper edge of the flower.

2 Next I place the same brush on the still damp line of colour to blend it towards the centre of the flower using a curved brushstroke. The sable will glide easily, leaving a curved brushmark when the pigment is dry. My touch is very gentle, allowing colour to flow softly across the paper.

3 I use my rigger for fine detail work. In this demonstration, when the first stage is dry I add a fine line of stronger pigment to define the outer edge of the flower. I then repeat the process of merging the damp colour into the centre of the flower on top of the first layer of colour.

4 Next I use my rigger to form the centre of the sweet pea with an upright line. I can blend this line with water to give a softer illusion. By using my rigger to merge colour with water, the effect will be less than if I had worked with a larger brush in this small section.

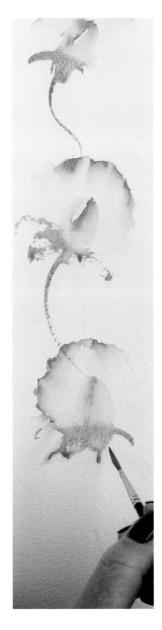

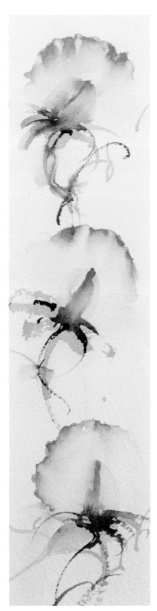

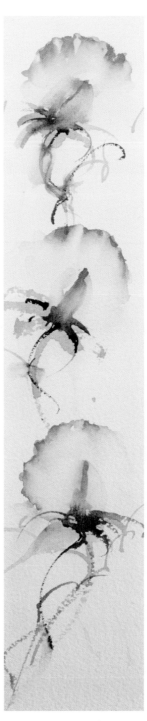

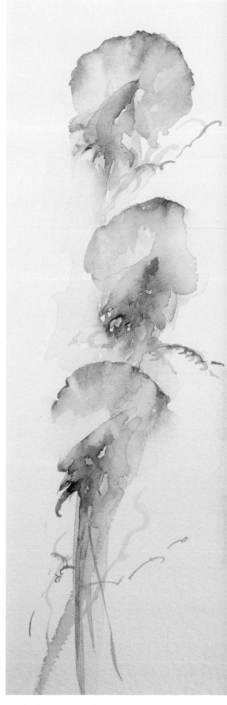

5 The rigger brush is great for adding fine foliage detail at the base of flowers or stems. Drawing the brush gently downwards on the paper for a flower stem forms an interesting brushmark that can be placed directionally, straight or curved. Practise gliding your brush over paper in a number of movements.

6 I often use my rigger brush towards the end of a painting to add the fine, dark definition I need to make my painting carry more impact.

My sweet pea study, completed.

Each time you paint, aim to make your results different. As you improve as an artist your results will get better.

Demonstration: An easy rose

My Shanghai mentor made me realise that there was far more to handling a brush than I originally thought. An easy way to explain this further is by demonstrating how I paint roses in a loose style.

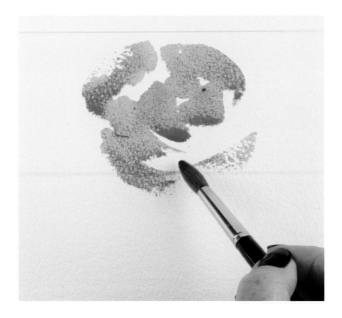

1 Using my size 10 brush at a slight angle to the paper, I make curved marks around a central starting point to form the base for a painting of a rose.

2 Once I have a centre to work away from, I use radial brushstrokes to form the outer petals of my flower. Here I can use my brush almost flat to the paper as I work on the larger outer petals. I can repeat the inner petal shape but in a larger size purely by changing how I hold my brush. I am not painting detail just yet as that will come later. I like to leave white sections of paper, as I find they enhance my results.

3 Interestingly, I don't always work with pigment on my brush. Having removed all traces of pigment from my brush, I now use clean water only applied in curved brushmarks on the still damp first colour placement. This technique forms beautiful watermarks that, when dry, I can build detailed petal edges on.

Tip
I don't lift colour by using tissue. I find that technique can damage the paper surface too much and can sometimes disturb the watermarks I am eagerly aiming to achieve. I merely use a very slightly damp brush to encourage pigment to move where I wish it to, and where I can visualise petals forming in the painting.

4 Once I have the rose flower in place I can think about working on the surrounding green foliage. You need to study a real rose to gain an idea of where this should be. Roses are beautiful and it is great fun learning about the different varieties.

5 I work on opposite sides of my rose painting, using side-on brushwork to bleed the green colour away from the pink rose, deliberately taking it to the outer opposite corners of the paper. I am influenced by Chinese compositions, where a subject is strategically placed, leaving large amounts of space around it. This has always been one of my favourite ways of working in watercolour.

6 Next, as the pink flower section is still too wet to work on, I focus on the outer foliage. I continue to add to the green pigment around the rose, using wet-on-wet techniques. I add colour randomly where I feel it will add to the composition. It is at this stage when working loose that newer artists to this technique tend to panic! In the creative process, loose watercolour paintings can look messy and frighteningly out of control. But never give up, even if you are unable to see what the painting will become. It is what happens next that turns a loose painting into a defined subject, rather than it having an abstract appearance.

"A loose painting is often finished before the artist knows it is. So, when you can see what the subject is, grab another piece of paper and work on something else."

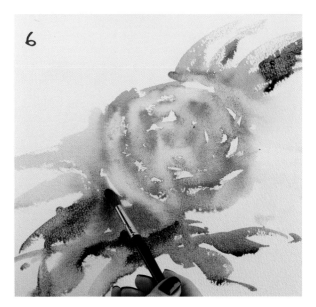

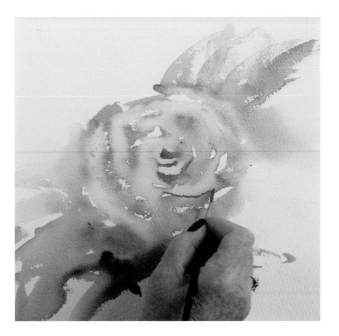

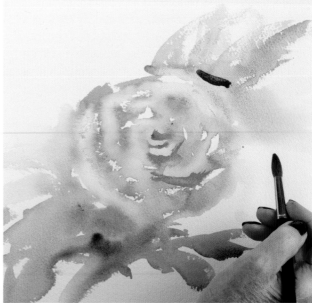

7 I allow this loose first wash to dry completely and then I go back in to work further with my rigger to add detail. Moving from the size 10 brush means I am almost at the completion stage of my painting. Just a few more brushmarks now should make all the difference. Starting by adding depth to create a centre, I build up my rose by radiating towards its outer edge, painting definite lines for each petal edge. I don't add every single petal or piece of detail – just enough to show it is a rose.

8 Now I add dark foliage on the outer edge, keeping the painting simple. I work with a size 10 using the brush sideways on the paper or by using the tip only.

> ## Tip
> *Once you have mastered this technique, try painting white, yellow or red roses. This does become quite addictive in time, as your paintings get better and better with practice.*

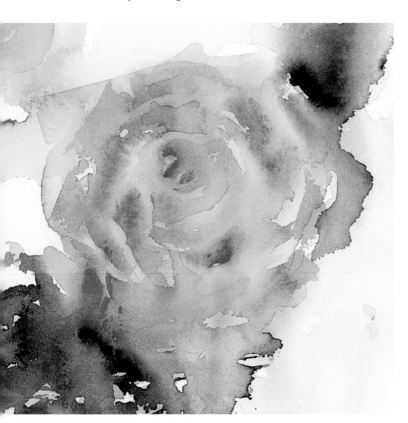

Once you have mastered the technique of creating paintings of roses in a loose style by practising on small studies, you will be able to create beautiful full paintings like *Summer Blessings*, where detail has been added to bring the flower to life in a beautiful composition. The complete painting is shown on page 17.

Please note that if you keep adding definition you may overwork your painting and 'lose the looseness'. My biggest tip when working loose is to always finish long before you think you should. A loose painting is often finished before the artist knows it is. So, when you can see what the subject is, grab another piece of paper and work on something else. So let's do just that!

Demonstration: Simple kingfisher

Just holding a brush makes me feel excited. It's the thought of what magic can be created with it. As an artist, one minute you are looking at a blank piece of paper and the next something is appearing right before your eyes. It is a fabulous, heady feeling when everything goes right in a watercolour painting, and it is even more terrific when you feel your artistic skills improving – so much so that you can tackle painting anything you see. And with my technique, to be honest, you can. But you have to fall in love with the idea first and you need to really want to paint. I am lucky in that ever since I was a child, painting has been a passion of mine. But I am meeting many people from all over the world who are only just discovering this fantastic way of life; people of all ages who are now 'seeing' and creating by the touch of a brush.

'Seeing' is the key word here: observing something so well that it becomes easier to paint. Observation is important, but so is believing. And I believe lack of confidence is what holds many new artists back, or those who would love to try painting but believe they can't. I have never worried about this. I love creating so much and it is the joy I feel when holding a brush that is important to me. A joy I desperately want everyone to share and experience.

Let's go back to that wonderful small brush, the rigger, and see how easily it can be used to create a stunning subject – a kingfisher.

"I love creating so much, and it is the joy I feel when holding a brush that is important to me – a joy I desperately want everyone to experience."

> ### Tip
> *You can avoid dull results by keeping your watercolour brushes clean in between loading each new colour from your palette.*

1 A rigger can pick up small amounts of pigment. This brush is also perfect for working with small areas of detail, such as the eye in this demonstration. Painting a small circle of colour and leaving a tiny section of white forms an eye. This is the foundation of this simple demonstration of a kingfisher. I paint many birds using this technique, including parrots and cockerels.

2 Next I work around the eye, painting the orange plumage. I take care to keep my pigment application clean and fresh. Keeping your watercolour brushes clean by rinsing them in between picking up new colours is vital for achieving that 'singing' effect where the colour shines perfectly.

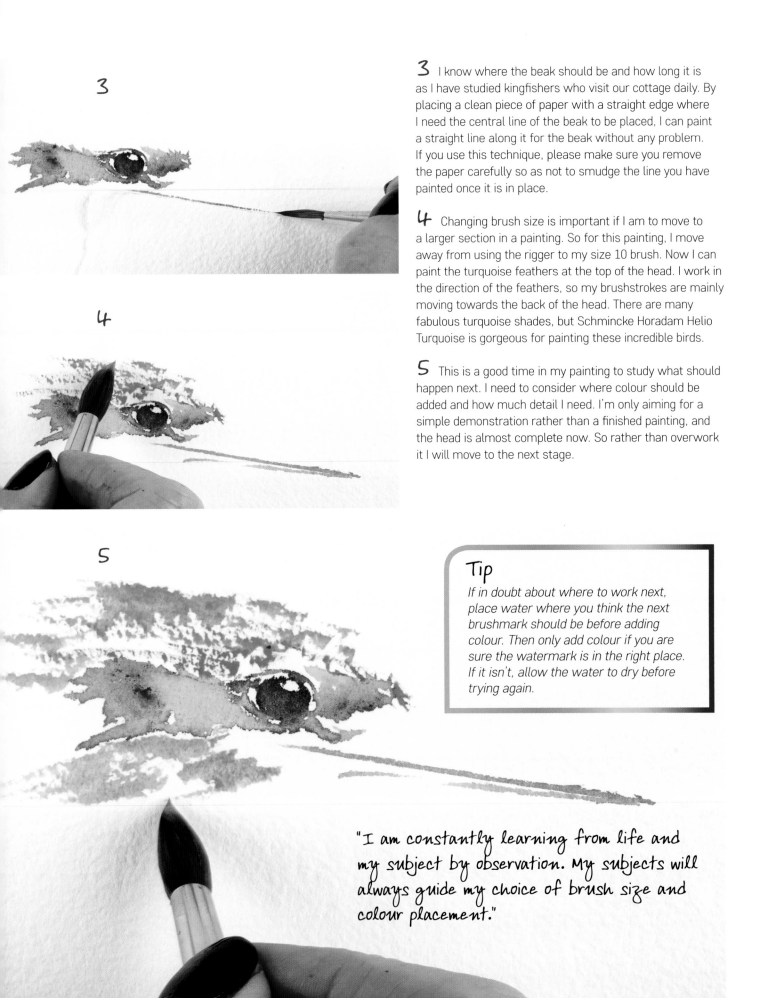

3

3 I know where the beak should be and how long it is as I have studied kingfishers who visit our cottage daily. By placing a clean piece of paper with a straight edge where I need the central line of the beak to be placed, I can paint a straight line along it for the beak without any problem. If you use this technique, please make sure you remove the paper carefully so as not to smudge the line you have painted once it is in place.

4 Changing brush size is important if I am to move to a larger section in a painting. So for this painting, I move away from using the rigger to my size 10 brush. Now I can paint the turquoise feathers at the top of the head. I work in the direction of the feathers, so my brushstrokes are mainly moving towards the back of the head. There are many fabulous turquoise shades, but Schmincke Horadam Helio Turquoise is gorgeous for painting these incredible birds.

4

5 This is a good time in my painting to study what should happen next. I need to consider where colour should be added and how much detail I need. I'm only aiming for a simple demonstration rather than a finished painting, and the head is almost complete now. So rather than overwork it I will move to the next stage.

5

Tip

If in doubt about where to work next, place water where you think the next brushmark should be before adding colour. Then only add colour if you are sure the watermark is in the right place. If it isn't, allow the water to dry before trying again.

"I am constantly learning from life and my subject by observation. My subjects will always guide my choice of brush size and colour placement."

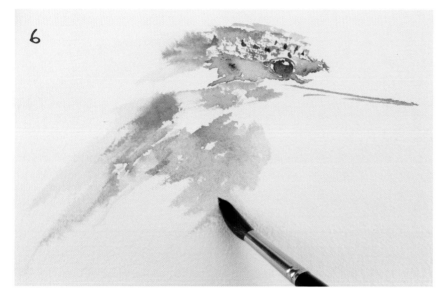

6 Just like the rose painting in the previous demonstration, I have worked away from a starting point. With the rose I was working all around my starting point, whereas with the kingfisher I am working downwards in direction, adding section by section until the story is told. My size 10 brush used on its side in diagonal brushstrokes gives me a soft feather effect on the kingfisher's chest area.

7 Once my subject is complete I can go back to using my rigger to strengthen small sections of my painting if I wish to. Just as in my sweet pea demonstration earlier, just a few final touches for hints of definition are all that are needed to bring this painting demonstration to a close.

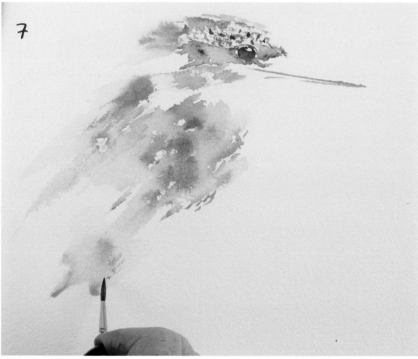

Getting used to working in a way that suits us as individuals is gained by practice. Tips such as keeping colour fresh by working with clean brushes, knowing how to load the brushes with the right amount of pigment, then considering how and when to release the loaded pigment are all skills that come with time. I have found the more I paint the more I discover, and the more I discover the more I want to discover. Working in watercolour is an endless journey full of wonder. Nothing is out of our reach if we genuinely wish to succeed in mastering this medium.

But now, let us move on to the next section of my book where we can get a little more carried away with colour and technique, and 'work out' with colour.

Watercolour workout

Colour gym

"It is a wonderful feeling to be so enthusiastic that you want to race to paint every morning."

This section of my book is to give you an insight into the way I work. I believe that the paintings we create reflect our mood and personality. I love life, nature and animals. I love colour that is alive and fresh. I also love excitement and the surprises that something new has to offer. It is a wonderful feeling to be so enthusiastic that you want to race to paint every morning.

However, when we pick up our brushes to paint regularly there can be a temptation to continually repeat what we already know and enjoy. Unfortunately, if we always work in this way, an element of boredom can creep into our painting time making it more of a routine rather than a thrilling experience. Even worse, creative time can then become a chore rather than a pleasure, to the point of us putting off wanting to paint altogether. Keeping an element of surprise and excitement is the best way to continue growing as an artist. Learning new techniques constantly and searching for stunning colour effects and combinations is my way of keeping my passion for working in watercolour alive.

Also, unless you are in the right frame of mind, the process of creating is not always as enjoyable as it should be. For this reason I have designed watercolour exercises that are simple, energising and inspirational, in keeping with my thirst for learning.

Fellow artists remark on my enthusiasm, which is as strong today as it was when I first started painting years ago. They ask me how I can stay so excitedly positive when constantly teaching international workshops, holding regular exhibitions and writing art features or my books. The answer is by continuously practising the exercises in the following pages, which I carry out religiously. I simply warm up before I start working seriously. I call this part of my painting day 'working out with colour' and I invite you to join me in my colour gym.

Puffin Study
Painting new subjects with enthusiasm enriches my life as an artist and keeps my enthusiasm for painting at an all-time high.
28 x 38cm (11 x 15in)

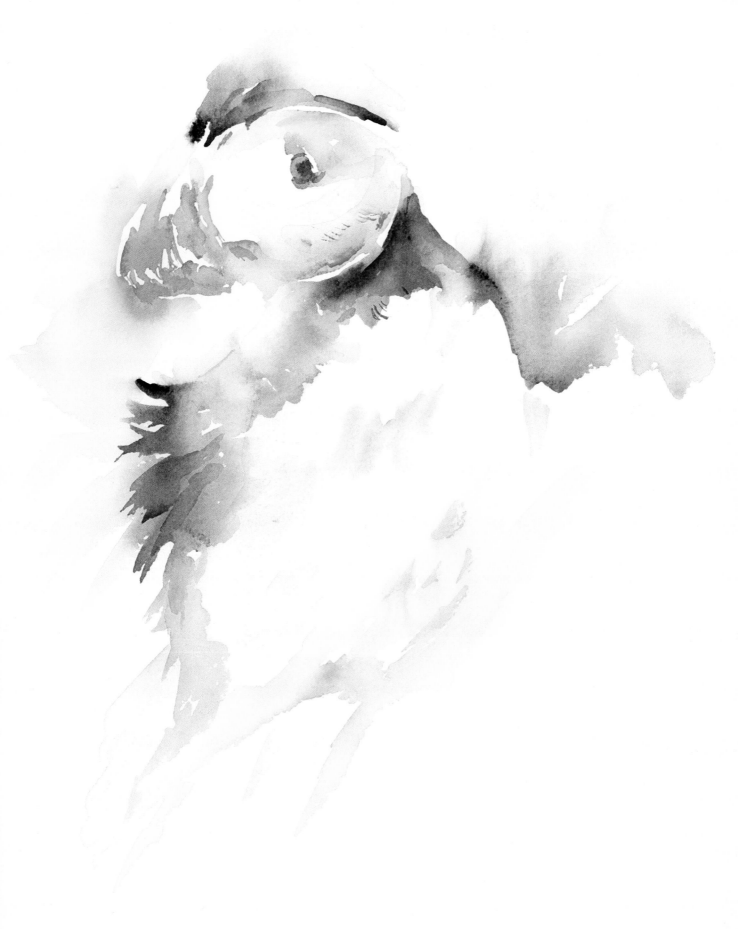

Colour warm-up exercises

"Avoiding constant repetition adds interest to an artist's life."

It is so easy to get excited about colour, and yet many artists don't. They work with the same colours repeatedly for years, which is such a shame. I adore colour and consistently search for new ways to add 'punch' to my work. This is why I am inviting you to share my daily routine – to show you how I grow as an artist, and to show you how you can too. No matter what level of experience we have, there will always be ways to improve our artistic skills. I aim to keep learning fun, with no pressure on my shoulders.

I think about watercolour in this way. If you saw a swimming pool and couldn't swim, you wouldn't dream of jumping into the deep end. Similarly, if you walked into a gym you wouldn't pick up the heaviest weights without warming up first. And yet when artists paint, they often work directly on a masterpiece without even considering the need to warm up beforehand.

Those who are new to art often feel intimidated by the challenge of painting their first landscape or building, when all that are needed are baby steps with colour to show them the joy of creating. If I consistently worked on paintings to sell, my thirst to learn could suffer. I need to keep my interest at an all-time high and my enthusiasm for exploring alive. Only then can I achieve work that is continually fresh, new and exciting, and encourage others to love watercolour as much as I do. Art to me is an endless, adventurous journey and we can love every step that we take. I certainly do. However, we should always push ourselves to be the best artist that we possibly can be.

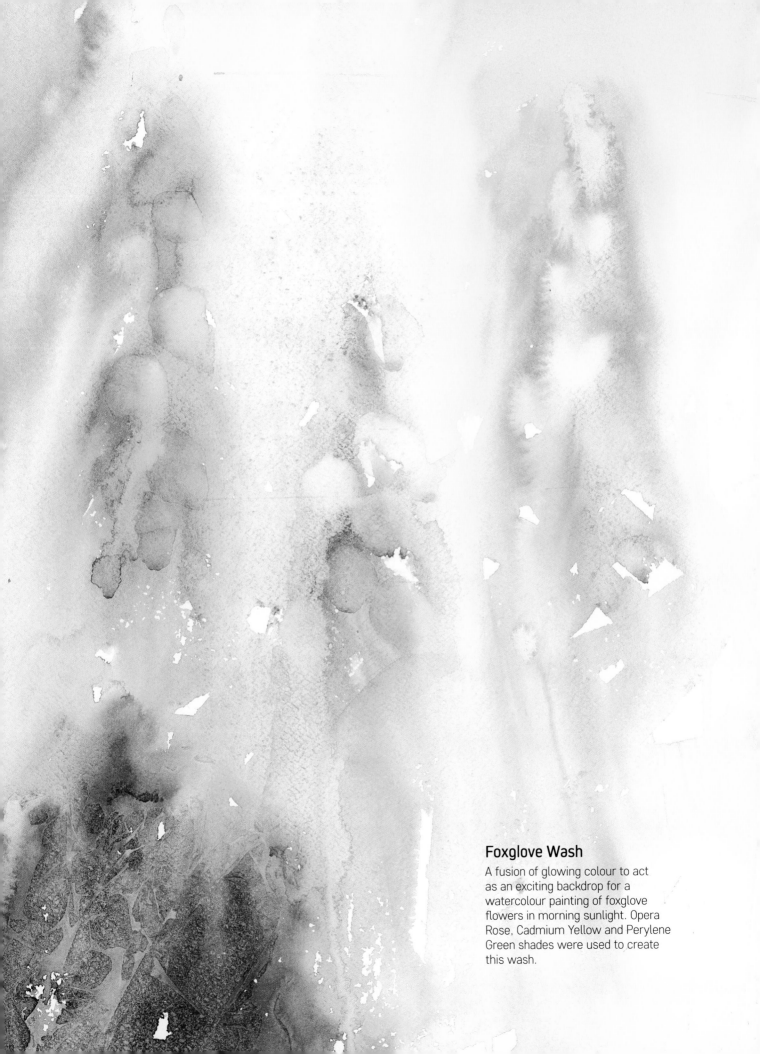

Foxglove Wash

A fusion of glowing colour to act as an exciting backdrop for a watercolour painting of foxglove flowers in morning sunlight. Opera Rose, Cadmium Yellow and Perylene Green shades were used to create this wash.

Lightweight exercises

Forget painting masterpieces for now. Instead, join me in my daily routine of learning about colour and enjoying the simple pleasures of pigment interaction. We are aiming for 'colour gymnastics'; making colour perform in beautiful ways. We want to feel the same adrenalin rush over fantastic colour results as an athlete feels winning an important event. We want to gain gorgeous 'lightbulb' moments when colours work outstandingly well.

My painting day begins with lightweight exercises to warm up before I move to serious painting. I take several scraps of paper to experiment with colour. I have no goal other than enjoying myself. This helps me to relax and get me into my 'painting zone'.

I apply colour in different ways to achieve a wide variety of results. These experiments often lead to fantastic ideas for new paintings. I enjoy applying different colours to opposite corners of the paper and allowing them to fuse in the middle where they merge. I select different pigments daily for these warm-up exercises by working my way around my palette.

I constantly search for new colours by different manufacturers and challenge myself to discover the most vibrant, exciting and interactive. This daily routine generates new ideas for further work and aids my serious compositions. This is a great way of using up those leftover tubes of unpopular colours that you have ignored for so long! I often find I fall in love with them all over again, or I discover fantastic colour combinations that I had previously never dreamt of. I deliberately put two colours together that I think won't work and find myself surprised that they do.

Watching two beautiful colours merge simply by encouraging their flow and interaction with water can lead to incredible results. These experiments improve our handling of watercolour as a medium and often lead to ideas that can be used in full compositions at a later stage.

Exercise: Colour and water

In the colour experiment shown on the right, I applied Daniel Smith Cascade Green in opposite corners of dry watercolour paper. I then encouraged them to merge in the middle of the paper by adding clean water in the space between the pigments. Just touching the corner colour gently gave the pigment the opportunity to flow into this area. The sample was then left flat to dry. The result was gorgeous watermarks. The turquoise you see is from the Cascade Green alone. Experimenting in this way leads to you obtaining the most amazing results. Use different colours for each daily warm up, and experiment not just with colour but also with how you apply water.

Don't throw these colour experiments away. I keep all my colour experiments in a box and work on them further by adding subjects. I was asked to demonstrate a building on one of my workshops, so I painted detail on top of an experiment. The result is shown below. This interesting architecture idea could lead to a stunning new painting if I started on a fresh piece of paper with a background of green and worked my detail on top. I would never have thought of using green as a background colour for buildings, so this was a really exciting discovery for me.

A few details added to another warm-up exercise in Cascade Green give the impression of a building. Can you see the hints of people in the doorway?

It is fun and educational creating fabulous effects on scraps of paper. Playing with colour helps me learn about new pigments from a number of manufacturers. Here I have used Daniel Smith Cascade Green.

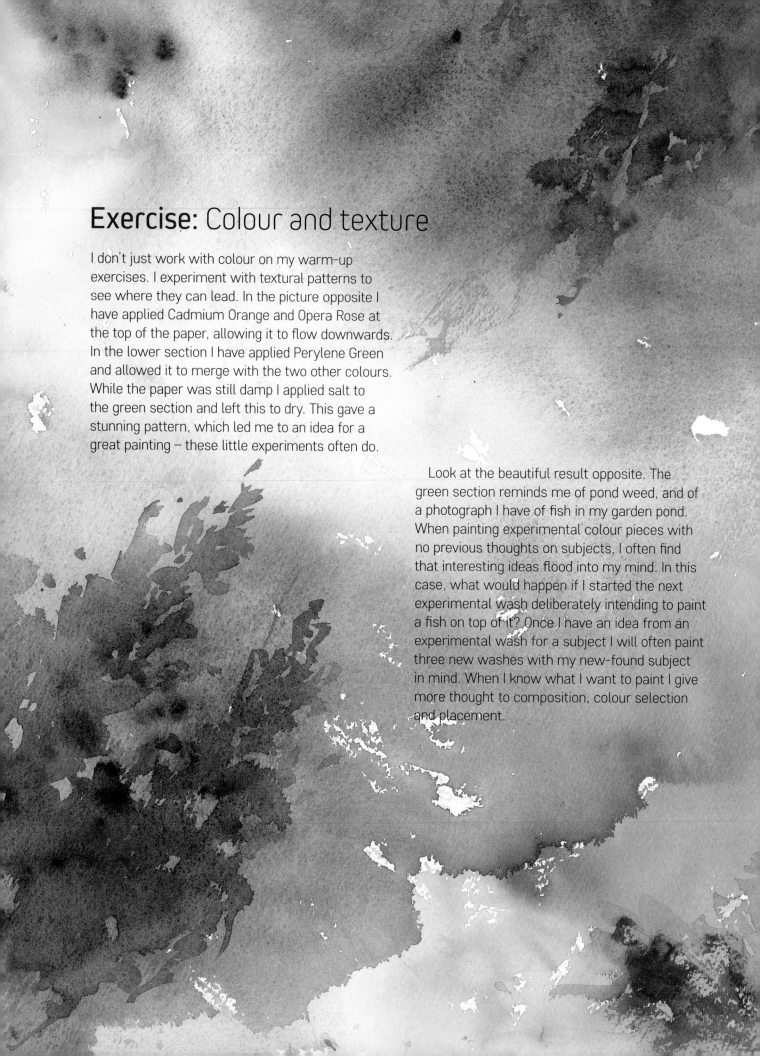

Exercise: Colour and texture

I don't just work with colour on my warm-up exercises. I experiment with textural patterns to see where they can lead. In the picture opposite I have applied Cadmium Orange and Opera Rose at the top of the paper, allowing it to flow downwards. In the lower section I have applied Perylene Green and allowed it to merge with the two other colours. While the paper was still damp I applied salt to the green section and left this to dry. This gave a stunning pattern, which led me to an idea for a great painting – these little experiments often do.

Look at the beautiful result opposite. The green section reminds me of pond weed, and of a photograph I have of fish in my garden pond. When painting experimental colour pieces with no previous thoughts on subjects, I often find that interesting ideas flood into my mind. In this case, what would happen if I started the next experimental wash deliberately intending to paint a fish on top of it? Once I have an idea from an experimental wash for a subject I will often paint three new washes with my new-found subject in mind. When I know what I want to paint I give more thought to composition, colour selection and placement.

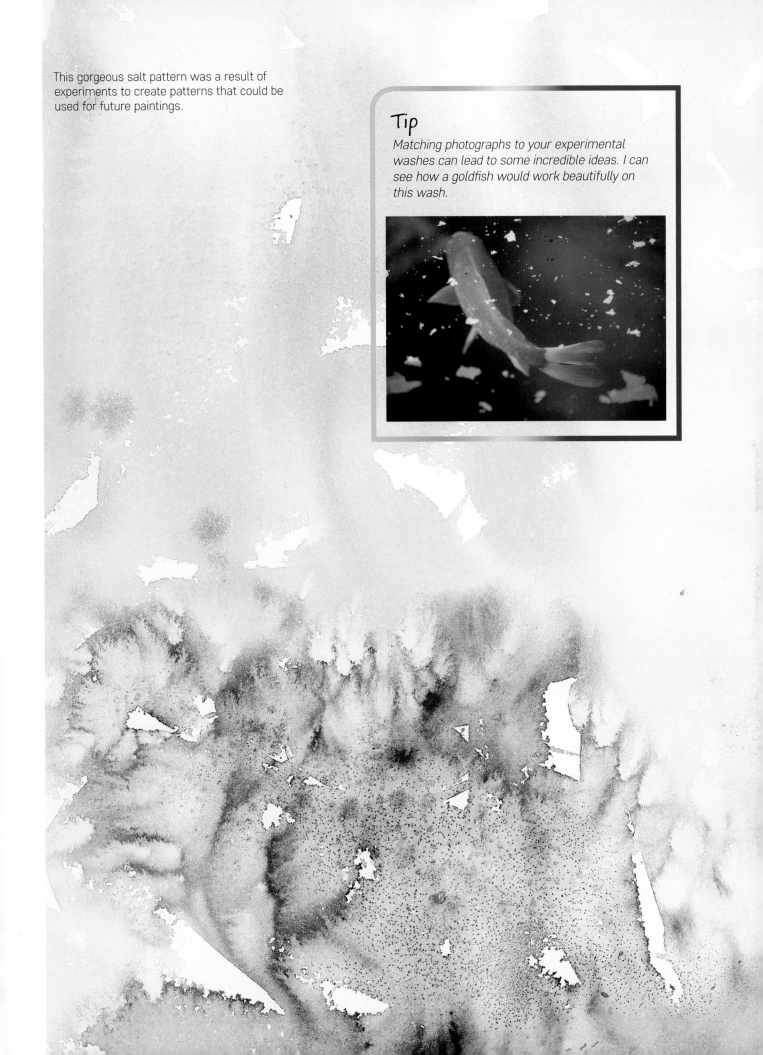

This gorgeous salt pattern was a result of experiments to create patterns that could be used for future paintings.

Tip

Matching photographs to your experimental washes can lead to some incredible ideas. I can see how a goldfish would work beautifully on this wash.

My thought process

Following on from the pattern experiment on the previous page, I now know that I want to paint a fish and that it will be golden. I chose to paint a merged wash as a background using orange and purple shades, placing them in opposite corners of the paper and allowing the colours to fuse in the middle to an almost white section. I dropped a small amount of green on top of the purple while it was still wet, to give the impression of pond weed as a back drop for my subject. When this first wash was dry I painted a goldfish in the middle space.

The direction of a subject is very important, so I decided my fish should swim to the light, represented by the orange corner. The head of the fish matches this golden corner while its tail matches the purple corner. Using the warm colour as the direction in which the fish is headed gives a subliminal message of hope and optimism; of going somewhere better. This may sound strange, but colour choice can tell a huge part of the story for any painting.

Part of the fish is missing, and this gives a sense of sunlight on the water surface that reflects nicely on the fish. It also allows me to involve the viewer in my art, leaving them to fill in the detail, and I love the sense of mystery this invokes.

Placing my golden fish subject so that it is seen to be moving away from the purple corner towards the warm orange corner gives a sense of connection between my subject and background and a sense of movement as if the fish is headed somewhere. Also leaving part of the subject missing gives illusions of sunlight hitting my focal point.

From this exercise I have gained ideas for many future paintings. I could, for example, paint three or four fish in a bigger composition. I know I can add exciting textural patterns from my colour exercise on page 57, but could I successfully change the background colour?

Testing colour options

As a result of my many warm-up exercises, I know that this particular use of orange and purple leads me to great 'singing' colour results. But there is another tip I can share. Always hold onto your colour experiments. Keep some scraps of paper with just one colour on as they can be very useful information tools. For example, I have a scrap of paper that is purely purple. I can place this on paintings where I want to see if this colour would work as a background or foreground but without ruining my half-finished painting.

By placing this scrap of purple paper over the orange corner of my painting I can see if a background of purple would be interesting or not. I can ask myself questions, such as 'would the fish look more important if the background didn't harmonise so well with it?' I prefer the orange, but it is fascinating to see how a simple colour change in one corner changes the whole feeling of this composition.

Schmincke Horadam Brilliant Red Violet gives me an amazing purple, which acts as a great contrast to many shades. One of my many favourite colours!

Tip
Add substance to your art by knowing more about colour. Don't learn just from reading books. Practise, practise and then practise some more.

Checking whether a purple background would look better than the original colour choice.

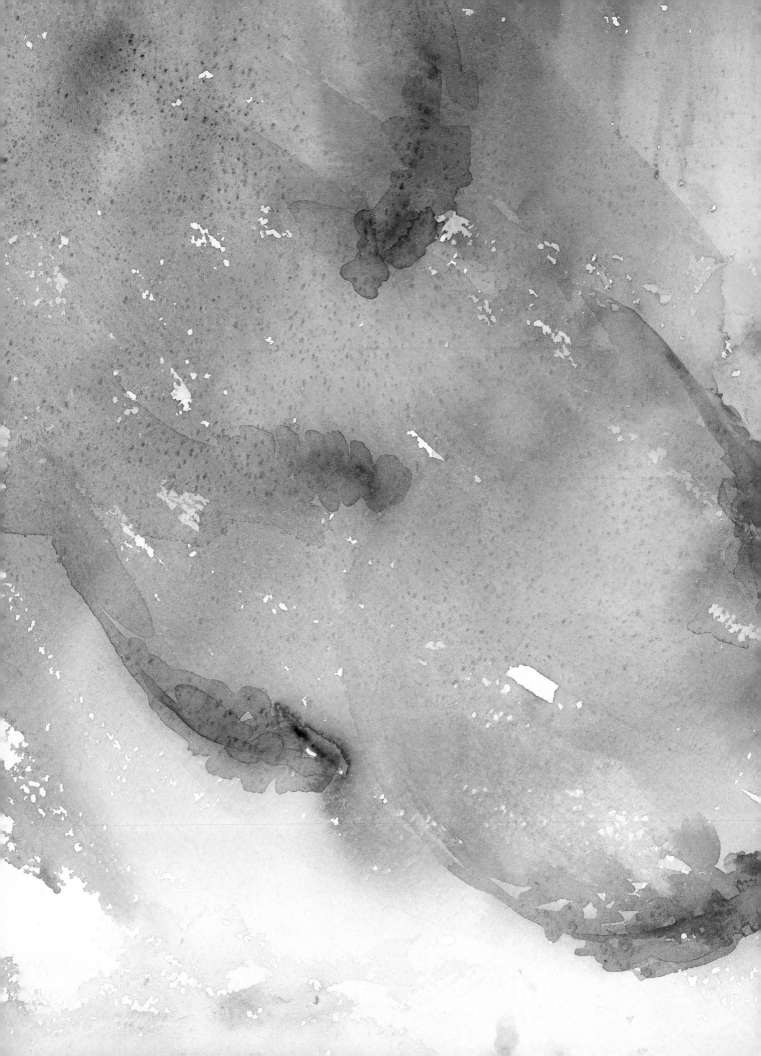

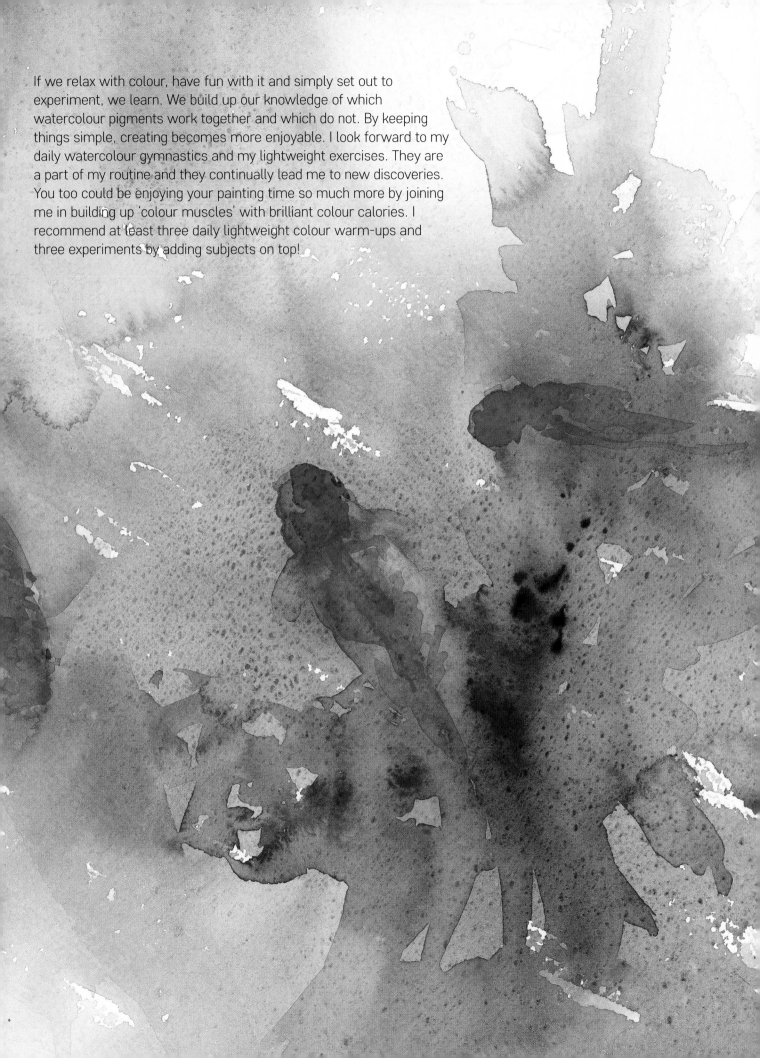

If we relax with colour, have fun with it and simply set out to experiment, we learn. We build up our knowledge of which watercolour pigments work together and which do not. By keeping things simple, creating becomes more enjoyable. I look forward to my daily watercolour gymnastics and my lightweight exercises. They are a part of my routine and they continually lead me to new discoveries. You too could be enjoying your painting time so much more by joining me in building up 'colour muscles' with brilliant colour calories. I recommend at least three daily lightweight colour warm-ups and three experiments by adding subjects on top!

Building up colour
Colour muscle exercises

"The more often someone works out in a gym, the healthier they become. Likewise, the more often you paint the better an artist you will become."

Let us imagine we are starting out in watercolour and we have never tried working with texture effects before. In my world of colour, I experiment continually and often see suggestions of subjects in the experimental warm-up washes that open my painting sessions.

Following on from the previous lightweight warm-up exercises, let's create a few washes with salt and see how they can lead us to new ideas for future work.

Exercise: Quiet warm-up using soft colour

I often refer to a very pale application of colour as a 'whisper'. For this warm-up exercise, apply a wash of pink and orange over a scrap of paper. Literally let colour flow from one corner to the other. While the paper is still damp, sprinkle a little salt in the lower corner and leave. When the paper is completely dry, gently remove the salt and observe the effect you have created. My result, shown opposite, could be used for a painting of ragged tulips or other floral work. If green shades had been used, this technique could be used for foliage effects in landscape compositions.

Salt applied in just the corner of a wash creates an unusual pattern formation. Alizarin Crimson and Cadmium Orange have been used in this exercise.

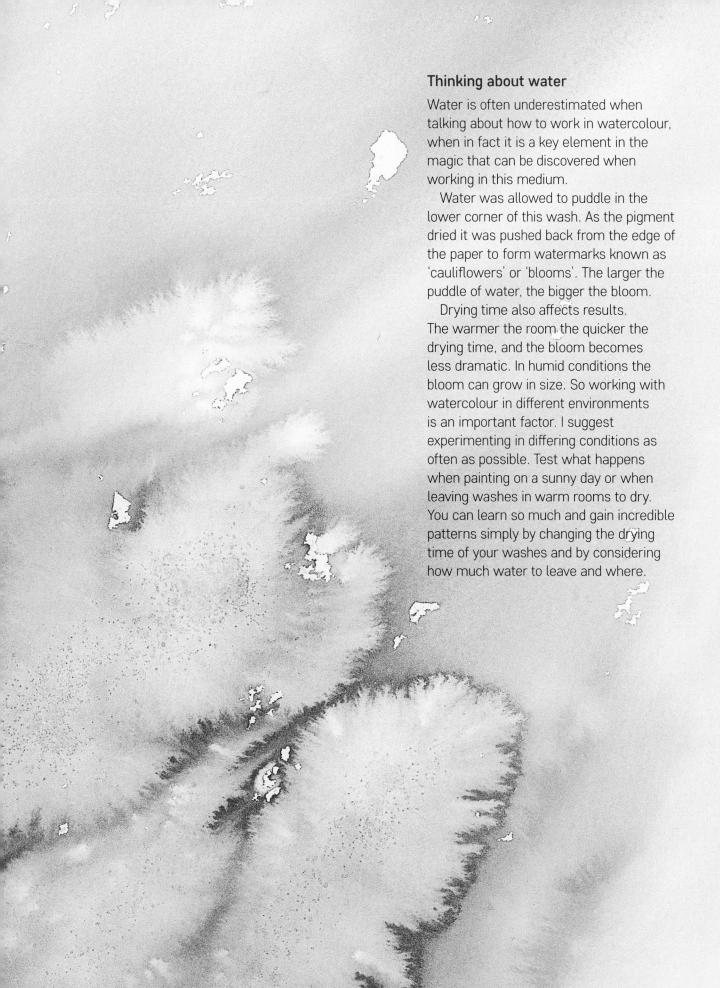

Thinking about water

Water is often underestimated when talking about how to work in watercolour, when in fact it is a key element in the magic that can be discovered when working in this medium.

Water was allowed to puddle in the lower corner of this wash. As the pigment dried it was pushed back from the edge of the paper to form watermarks known as 'cauliflowers' or 'blooms'. The larger the puddle of water, the bigger the bloom.

Drying time also affects results. The warmer the room the quicker the drying time, and the bloom becomes less dramatic. In humid conditions the bloom can grow in size. So working with watercolour in different environments is an important factor. I suggest experimenting in differing conditions as often as possible. Test what happens when painting on a sunny day or when leaving washes in warm rooms to dry. You can learn so much and gain incredible patterns simply by changing the drying time of your washes and by considering how much water to leave and where.

Exercise: Bold colour warm-up

Apply a bold wash of orange and violet to two halves of the same piece of paper. Allow the colours to merge in the middle. Practise allowing colours to merge so that you cannot see where one begins and the other ends. There should be beautiful harmony in the colour fusion. While this wash is still damp, sprinkle salt over the whole surface of the paper. Use fine granules of salt on one side of the paper and coarse rock salt on the other. Leave to dry.

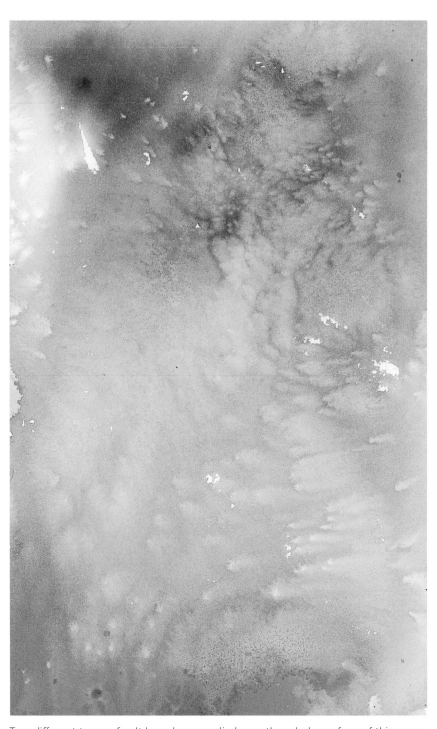

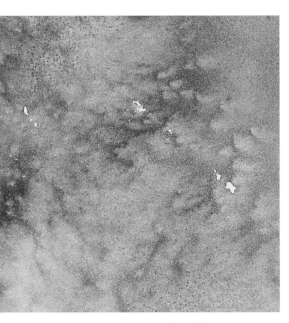

An enlarged section of the exercise shown opposite, showing the effects created by the salt application even more clearly.

Two different types of salt have been applied over the whole surface of this paper. Fine salt creates smaller patterns while the coarse salt creates larger pattern effects. I could use this technique for painting roosters, or animals with curly coats such as poodles or sheep. Schmincke Horadam Translucent Orange and Schmincke Horadam Brilliant Red Violet have been used in this exercise.

Exercise: More interesting effects

I often see artists simply applying salt to a wash without even thinking about how much better their result could be by using a variety of salt applications. Applying salt while the paper is flat will give you one pattern. How about holding your damp paper at an angle when applying salt to achieve a very different result? This 'sliding salt' technique is one of my favourites!

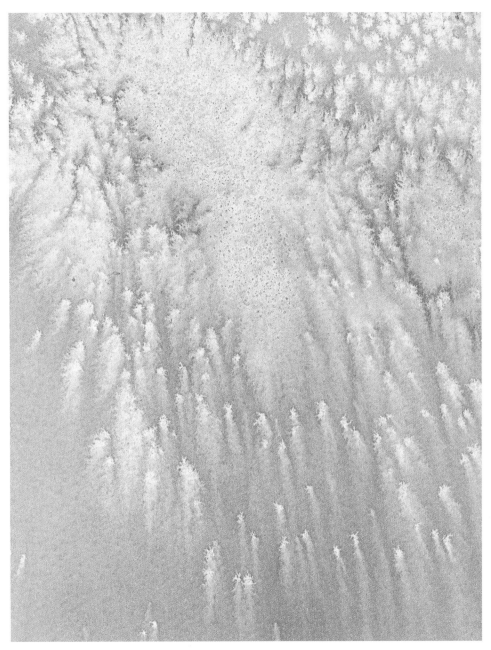

Sliding salt technique

Apply a wash of colour to a scrap of paper. With your paper at an angle, apply salt at the top of the paper while the pigment is still damp. Encourage the salt to gently slide through the pigment and then lay the paper flat. You should find a beautiful feathered effect once the pigment is absolutely dry. This is a useful technique for painting birds and wildlife.

Why experiment?

The point of these warm-up exercises is to open up your imagination to how texture effects and unusual colours can be used in larger paintings. I keep a box of these texture experiments and challenge myself to use each discovery in one of my next new paintings. For example, looking at the results of the previous exercises I immediately begin to imagine a subject they could be useful for. The image on page 63 is definitely suitable for florals, landscapes or feathers. When combined with the results on page 64, this could be a spectacular technique for painting flamingos. This is my creative thought process: in my colour gym, I 'warm up' with simple colour washes then 'work out' with texture patterns. Finally, I have ideas for suitable subjects based on these exciting outcomes.

Look at the photograph of the flamingo opposite and imagine using salt to achieve texture patterns on the bird's neck. It is the perfect technique for creating this effect, but without my experiments I might not have known this. So my next experiment is to use a combination of my warm-up exercise results on a subject.

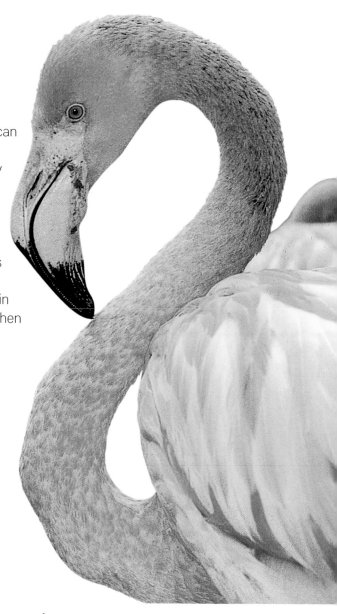

Flamingo with glowing colour.

Painting a subject using the colour workout exercises

Lightweight warm-up

Rather than starting on a large piece of paper, I want to warm up first on a scrap of paper – not only to check my colour selection but to get a feel for my subject. I need to study its shape and form. I will paint half the subject and consider which sections I can leave to the viewer's imagination. This is a 'lightweight' exercise in our colour gym; a warm-up workout. I am only trying to gain an insight into painting a flamingo, not aiming to paint the subject in full – yet!

> **Tip**
> *Start by working small and move to larger paper when you are more confident. You will not only learn more about your subject, but you will also have better knowledge of the techniques you are aiming to use.*

"Experiment on a few small studies before attempting a large painting of the same subject."

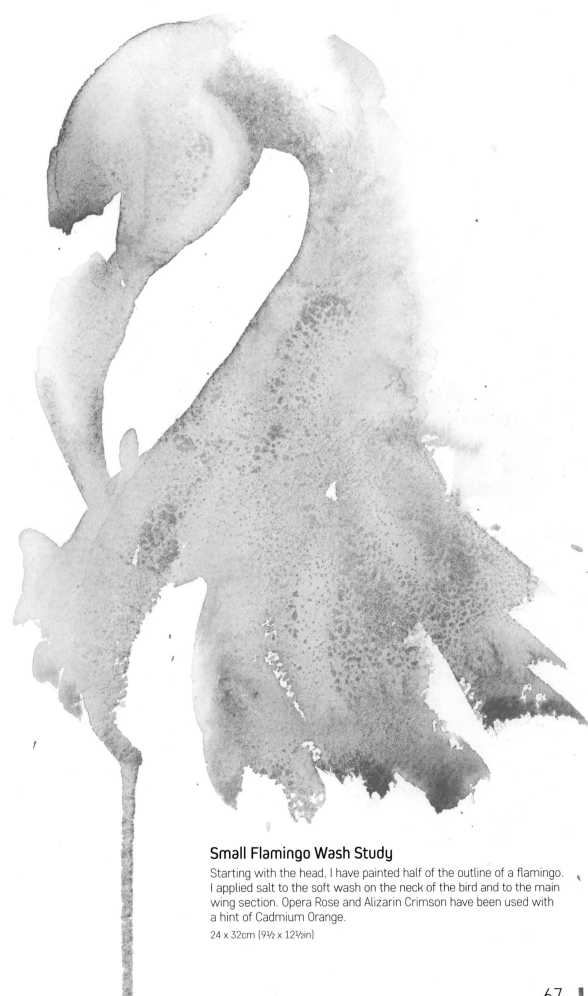

Small Flamingo Wash Study

Starting with the head, I have painted half of the outline of a flamingo. I applied salt to the soft wash on the neck of the bird and to the main wing section. Opera Rose and Alizarin Crimson have been used with a hint of Cadmium Orange.

24 x 32cm (9½ x 12½in)

Once you have a feel for the shape of the subject and its proportions, take a larger piece of paper and enjoy feeling the free fluidity of colour on a bigger area. Refer to your small studies to see what worked well. Encourage pigment to make patterns by applying salt where you feel it will be the most effective. Leave white paper to give the illusion of light on the beak, neck or wings. Create a wonderful foundation for adding detail at the next stage.

This should be a beautiful first wash, where you can tell what the subject is but without all the information that can be added at the next stage. Once you have created a pleasing first wash, adding detail to tell the rest of the story should be quite simple.

Exercise: Pretty flamingo

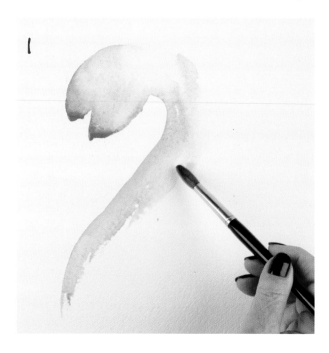

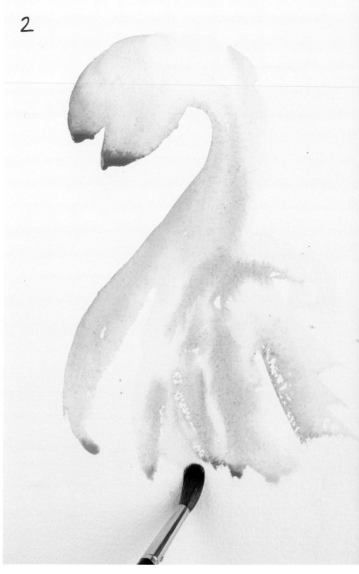

1 Starting with the head and neck, work with heavily diluted Daniel Smith Opera Rose.

2 Gently add feathers for the wing.

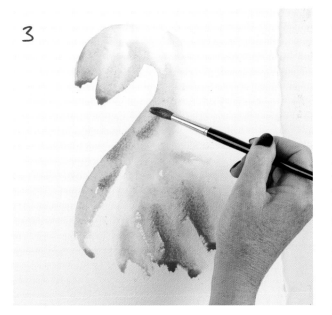

3 By gradually strengthening colour where you feel it is needed you can build up your painting.

4 By using the 'sliding salt' technique (see page 65) you can create a texture effect for feathers.

5 Splattering strong pigment from a toothbrush adds more patterns and interest in this section (see page 39).

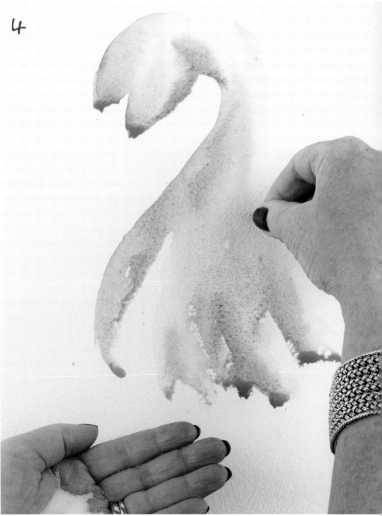

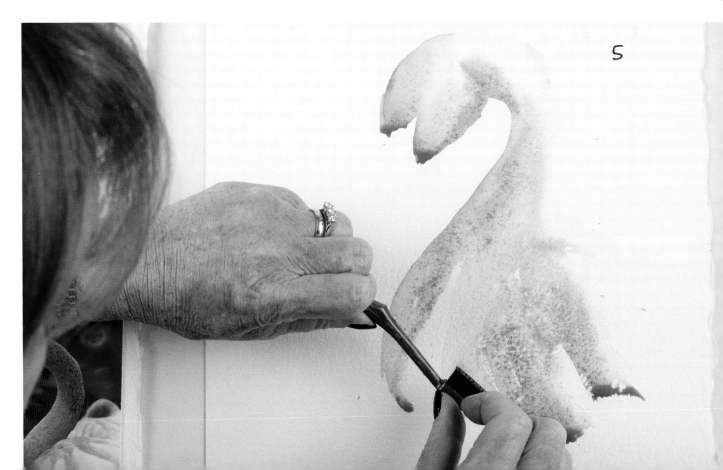

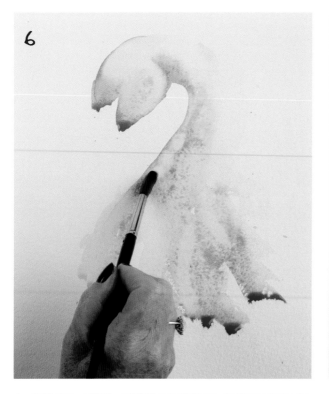

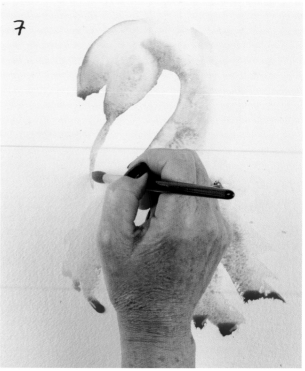

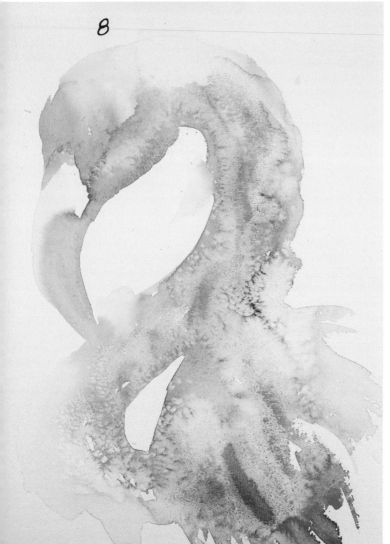

6 By touching the painting gently with a clean, damp brush you can enhance the existing patterns.

7 Use the puddle of colour at the base of the head by touching it softly and allowing it to flow, forming the beak. Use a size 10 brush in a curved downwards sweep towards the neck.

8 By adding colour where it is needed and using the texture techniques from the colour muscle exercises, you can create gorgeous first washes like this. To complete, you just need to add the final detail.

Tip
Imagine using this technique on other birds such as ostriches, parrots and roosters. There are endless possibilities!

Pretty Flamingo
My finished painting of the flamingo with detail added.
42 x 56cm (16½ x 22in)

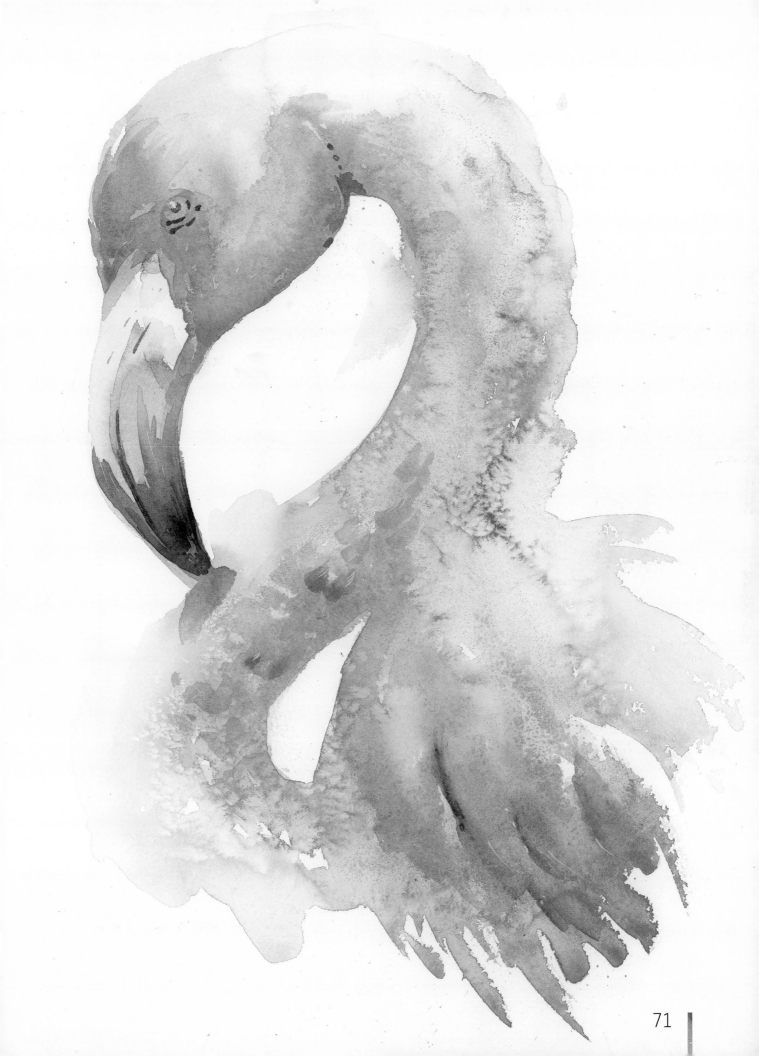

Moderate warm-up

The salt technique is a brilliant method for adding interest to a painting. It can be used in the corner of a large composition or to make the patterns needed in the subject itself. My favourite use of salt is in spring, when I find myself eager to paint lambs!

It really is worth gaining 'muscle' in colour knowledge. Experiment to discover which pigments give you the best salt patterns – some will be more amazing than others. Build up a treasure chest of results that you can fall back on for more serious painting.

Don't be a colour weakling. Keep building your colour muscles and texture techniques so that you become a truly strong artist – one that is full of confidence and definitely not colour shy.

Sweet Lamb

Salt was used on the main body of this lamb to create the texture of the curly coat. Yellow Ochre and Opera Rose were the main body colours, along with French Ultramarine and Indigo on the lamb's face.

56 x 40cm (22 x 15¾in)

"Don't be a colour weakling. Keep building your colour muscles and texture techniques so that you become a truly strong artist – one that is full of confidence and definitely not colour shy."

Building up confidence

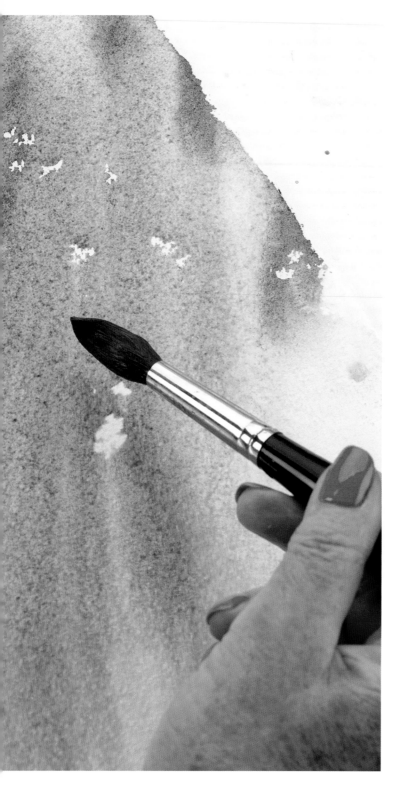

"Even for the most experienced artist there can sometimes be a fear of really letting go."

Maybe I should call this chapter 'building up courage when working with water', as I often meet artists who are scared of using too much. But if they use less water they can sometimes find they have less control of the pigment. I often use more water than pigment in my work, and I gain incredible results when they are allowed to interact naturally. We call this medium 'water' colour, and yet I feel we focus on pigment far too much when it is the application of water that allows colour to move freely in the first place.

I love deliberately making watercolour puddles or encouraging pigment to move by making water tracks through it. I can gain the most beautiful outcomes just by experimenting regularly. But knowing how much water to add and when to leave your paper at an angle to dry isn't always easy for those new to watercolour. Even for the most experienced artist there can sometimes be a fear of really letting go. So in this section of my book I am inviting you to be strong and build up your confidence by using water to get the best out of your watercolours.

Let's start with colour puddles. Where can they be useful? Certainly in foliage, but for a more unique way of using them I allow them to occur in eyes. A back run from a colour puddle gives me the perfect appearance of an iris. But let's start with simple experiments to really give an insight into my world of water, aided by colour!

Colour puddles

I have a lovely saying when I am painting: 'Life isn't always perfect, so why should art be?' In my world imperfections are gorgeous, so I am over the moon when they occur in my paintings. Over the years I have come to love them so much that I studied how to make mistakes deliberately!

Getting started

What do you do when you wake each day? Do you open your fridge at all? I do, and I set myself a fun challenge. As well as working on washes or texture effects in my colour gym, I always take a small object from the fridge and try to match the colour perfectly. I then find a way to paint it quickly, telling the story as easily as possible. This is a great way to warm up at the start of my painting day. By giving myself fun challenges, my serious painting time becomes far more enjoyable. I am continually stretching myself as an artist and trying to improve my own standards – but in a fun way.

Life Isn't Always Perfect

Life isn't always perfect, so why should art be? The painting below shows an effective use of back runs to form patterns in what otherwise could have been a boring painting of the simple tomato.

28 x 18cm (11 x 7in)

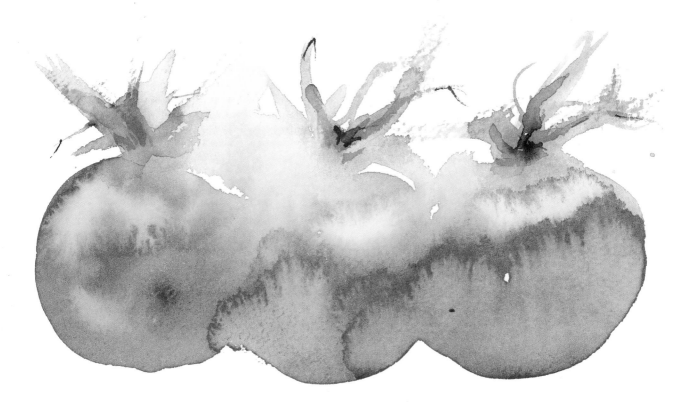

75

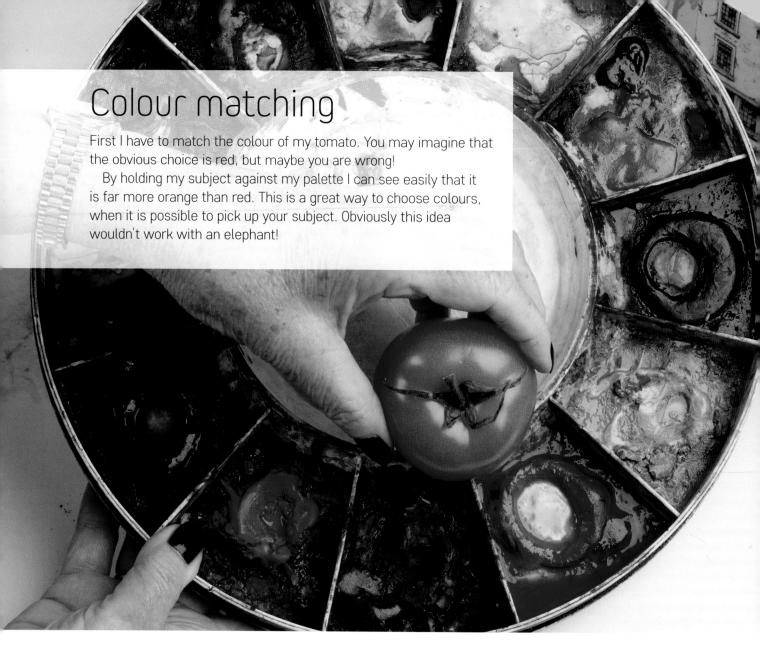

Colour matching

First I have to match the colour of my tomato. You may imagine that the obvious choice is red, but maybe you are wrong!

By holding my subject against my palette I can see easily that it is far more orange than red. This is a great way to choose colours, when it is possible to pick up your subject. Obviously this idea wouldn't work with an elephant!

Another way to select colour is to place small pigment samples on a scrap of paper and place the subject against them. Here, again, I can see the orange shade is far more suitable than the red.

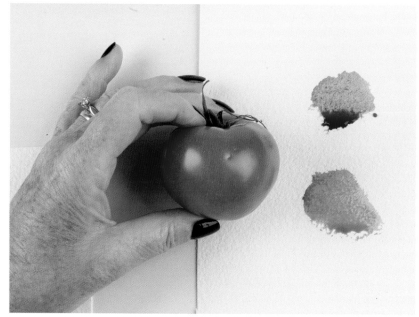

Exercise: Learning how to be bold with colour

Once you have selected your colour you can begin to paint your subject. The aim of this exercise is to use water to move pigment easily, forming the subject as a whole.

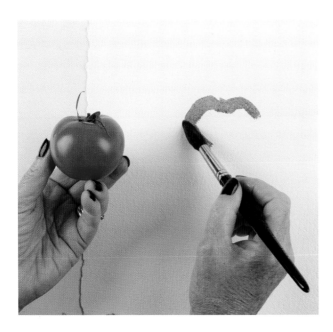

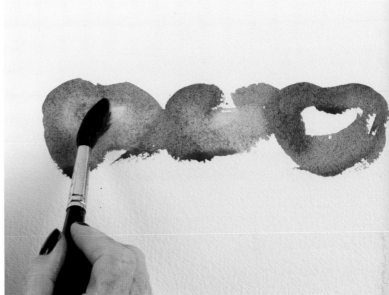

1 Without sketching, paint directly with colour to form an outline of the first tomato. I am going to paint three in a row. This first colour application has to be bold, as water is going to be added alongside it to move the outer colour into a faded centre.

2 Progressing to the outlines of three tomatoes, quickly fill in the centres with water, allowing the colour to flow inwards. By using a clean, damp brush and a curved brushstroke applied alongside the tomato outline, colour will flow inwards and dry in a curve, giving the illusion of a round shape. This is a clever and wonderful technique to use. Do practise your brushstrokes using many different directional applications for a variety of subjects.

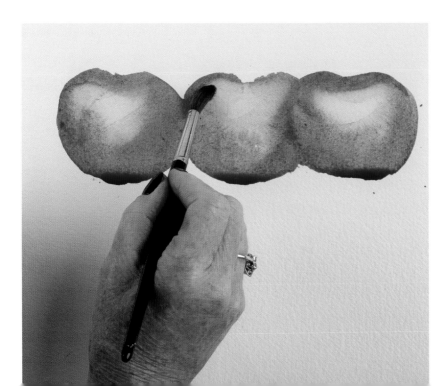

3 All the colour was applied only to the outlines of the tomatoes. By keeping the work wet and using soft brushstrokes, you can correct the outer shapes and work around the tomato highlights. These are the paler sections, which will give these subjects a beautiful sheen when dry.

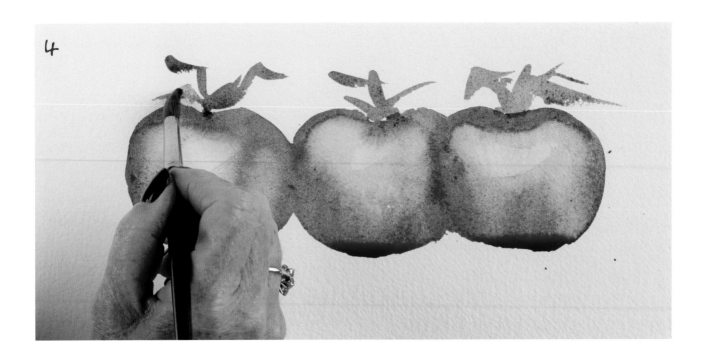

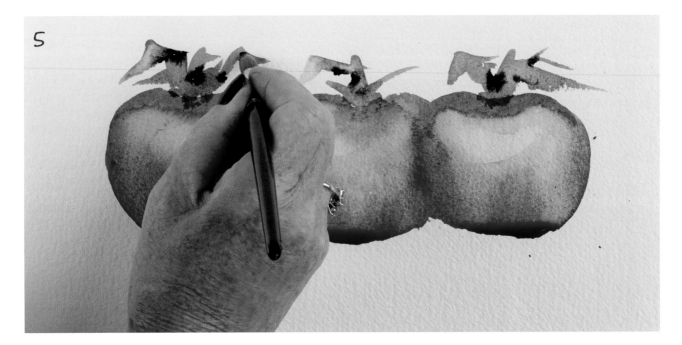

4 Adding green foliage to the top of each tomato while your painting is still fairly damp will allow this new colour addition to merge into the red. This helps create harmony and a sense of connection.

5 Adding a few darks to the foliage gives a better sense of depth in the painting.

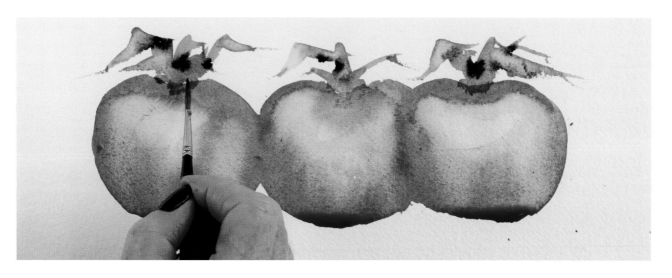

6 Finally, using a rigger, add the smallest of detail touches to complete your study.

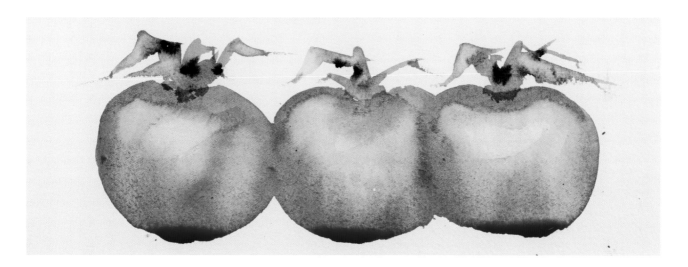

7 Puddles of colour sitting at the base of each tomato will dry, pushing the pigment back into the still-wet red area. These will form the wonderful patterns, as seen in the painting of tomatoes on page 75.

By leaving this piece to dry at an angle, pigment puddles will form at the base of each tomato and create a pattern (see the image opposite). The colour cannot run downwards onto the dry paper below, so it moves upwards on the paper instead. When dry, it will create the effect you can see in the picture above.

It really is worth thinking about how these wonderful watercolour effects can be used on other subjects. And don't forget to continually look in your fridge for new challenges, or even when you are out shopping in the supermarket. There isn't a day or time when I am not inspired to paint. Grapes make fascinating subjects, as do eggs. The challenge is how to make these exercises fantastically fascinating! And of course watermarks can be used for stunning effects on the petals of flowers, for examples poppies.

Watermarks created by puddles of pigment that were left to dry at an angle.

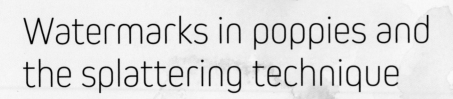

Watermarks in poppies and the splattering technique

By doing regular painting exercises and experimenting with colour and water application, over time you will build up a collection of ideas that can be used for a wide range of subjects. You will also discover new approaches to painting familiar favourites. I paint poppies in a similar way to the sweet peas demonstrated earlier in my book (see page 40).

Poppy Fusions

Poppy flowers with watermarks creating the ripples in each petal. I painted an outline of the petal, as seen in the tomato demonstration, only this time I touched the edge of the petal with a clean damp brush and encouraged water to flow inwards to create a rippled petal effect.

28 x 38cm (11 x 15in)

I often paint from nature as I find I gain such incredible inspiration from doing so. On one occasion, I sat in my garden quietly painting some wild poppies that had self-seeded in a woodland area. These gorgeous red flowers grow wherever they wish, in the same way that 'happy accidents' sometimes occur unexpectedly in watercolour. When we try to control things we often overlook their natural beauty and ruin what could have been beautiful. The splash of red poppies in an otherwise green section of my garden was delightful, but I would never have dreamed of deliberately planting flowers there. It was one of those 'happy accidents' that I thoroughly enjoyed at the time but hasn't happened since. We can learn so much from nature if we take time to observe and think about the natural colour combinations we see but have no control over.

As there was a soft summer breeze, the delicate flowerheads of the poppies I was painting appeared to be dancing in the wind. I started this exercise by painting each single flower as it moved, just capturing sections of each bloom. I began by painting the edge of one flower first, then bleeding the red colour inwards to the centre before repeating the process on the next poppy. Then when my first painted flower was dry I returned to it to strengthen the outline edge with my rigger. Allowing water patterns to form in the spaces between each poppy created a harmonious sense of connection and the feeling of movement. The silky petals put on a delicate display as they twisted and folded over in the wind. Sometimes there seemed to be only a quarter of each flower visible, or a half of one folded over. Just watching was a wonderfully peaceful way to spend my time, however as an artist a brush is often in my hand and capturing what I have fallen in love with is a habit.

I wanted to add the speckles of colour surrounding the poppy centres without covering the beauty of the already painted flowers. For this I fell back on an old trick. There are times while we are painting when we don't wish to disturb finished sections, so these can be covered when dry to allow further colour applications, in this case splattering. The following exercise takes you step by step through this wonderful technique.

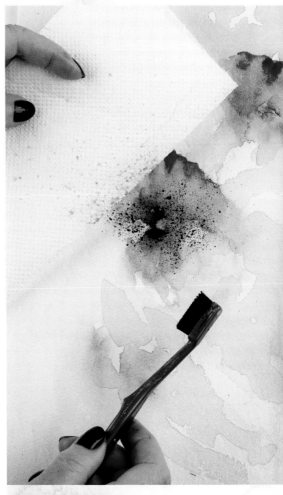

Splattering allows me to add detail without concealing these flowers' natural beauty.

"We need to appreciate life – not only what we see, but also our ability to see it and subsequently paint it – as we have no idea how long it will last."

Exercise: Splattering technique

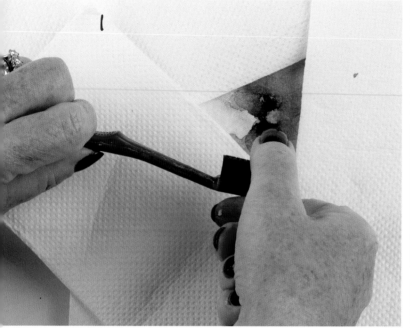

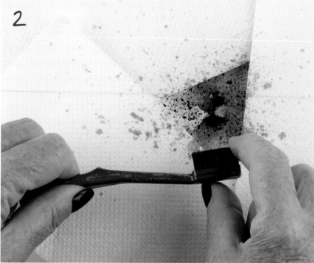

1 Start by covering sections of the painting that need protection from my splattering technique using scraps of paper.

2 Next splatter on dark Indigo using a toothbrush, holding it at an angle to the paper.

3 Carefully removing the paper you can see how effective the addition of dark splatter has been.

4 The finished flower looks far more interesting than before the addition of splatter.

Tip

Remember it is water that enables pigment to sing. Give your watercolours a 'voice' by experimenting with a variety of water application methods as often as possible.

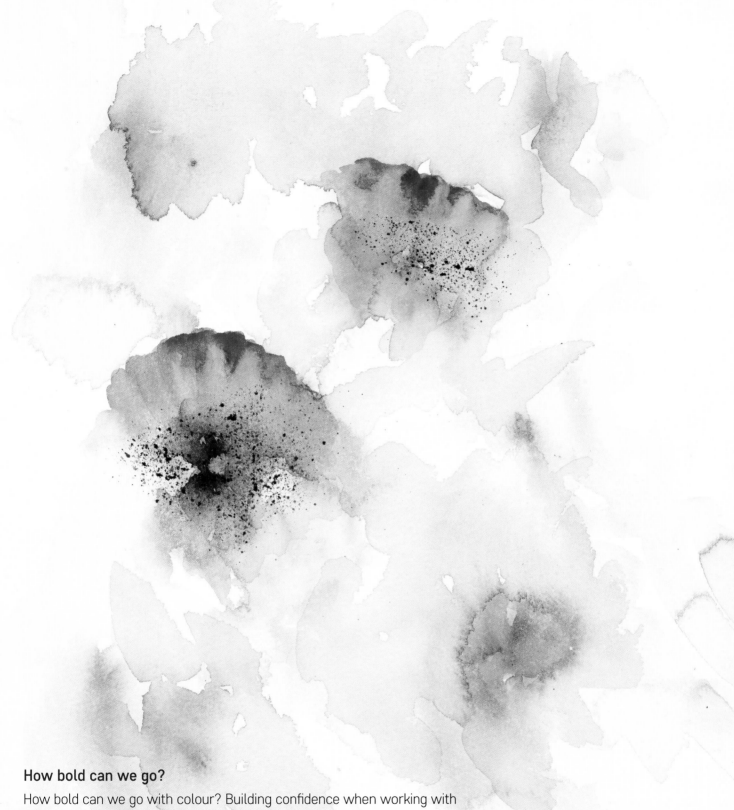

How bold can we go?

How bold can we go with colour? Building confidence when working with any medium is vital. Depending on my mood or the subject I am working on, I vary my use of colour constantly, leaping from soft pastel shades to deep bold contrasts, as in my painting of roses on the following page, 'Red is for Love'. But every single painting I create stems from my watercolour workouts and fun exercises in my daily colour gym routine, and I am constantly looking for new ways to use pigment. In fact my watercolour world would be dull without these exercises to look forward to on a daily basis.

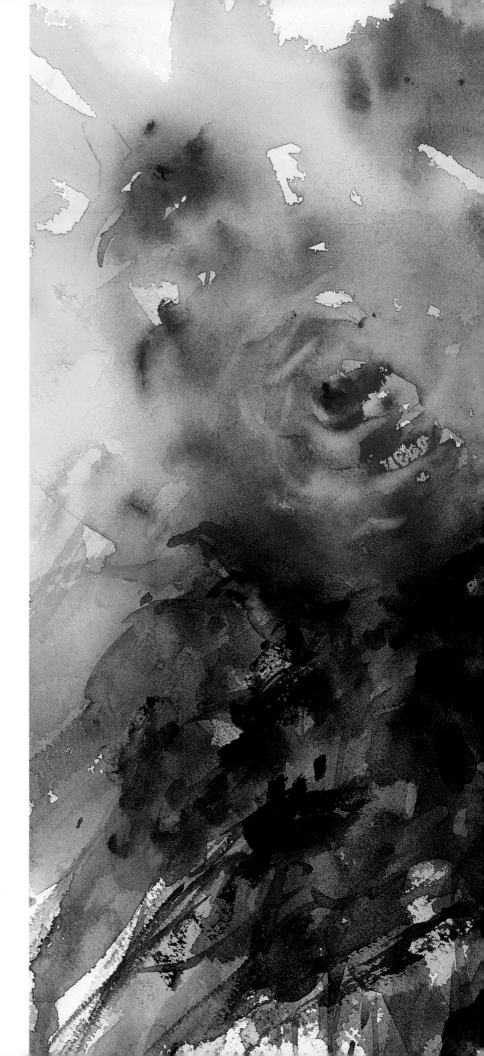

Red is for Love

The rose petals in this painting are formed using strong pigment application, with the application of water to form highlights on the petal edges. This is a similar technique to the exercise on painting tomatoes (see page 77). A variety of directional brushstrokes forms foliage sections. Watermarks at the top of the composition create the effect of sunlight hitting the subject.

58 x 38cm (22¾ x 15in)

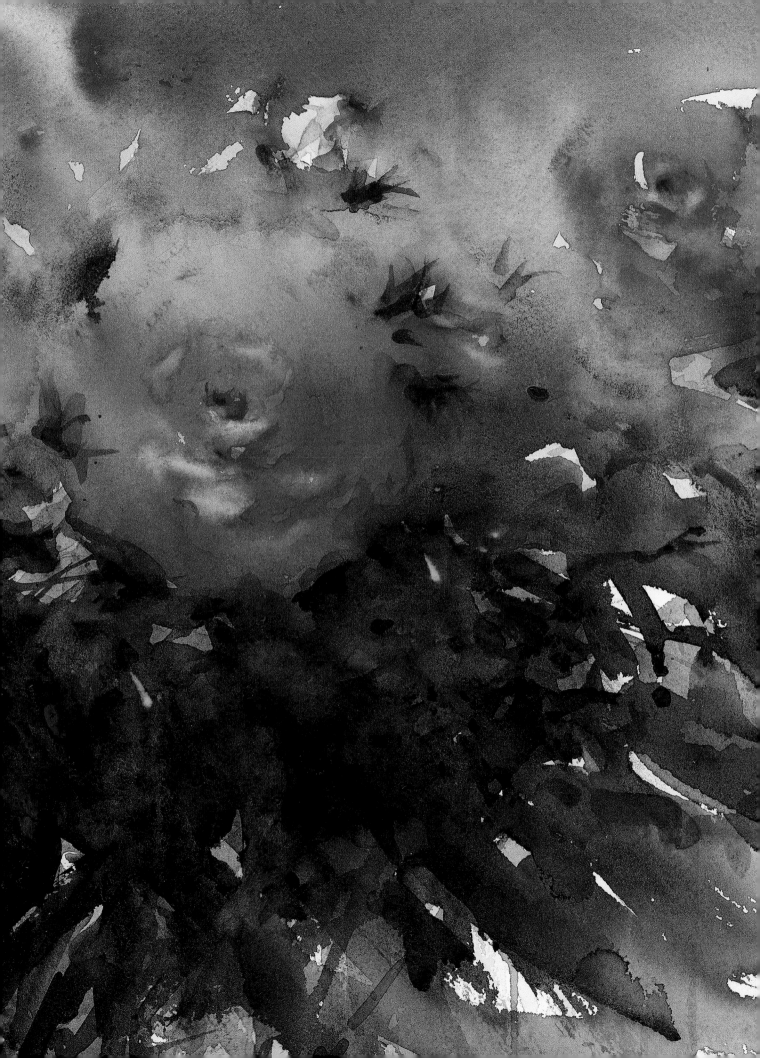

Addicted to watercolour

Pattern

"The joy in discovering new ways to achieve incredible outcomes is never ending."

Once you start experimenting with watercolour your life changes. You see everything as a new challenge and in a whole new light. When I experiment I often start by playing with colour, and I have absolutely no idea of where I am going to end up. My goal is simply to enjoy creating and it is obvious to everyone who knows me how passionate I am about painting. The joy in discovering new ways to achieve incredible outcomes is never ending. Even if I repeat each experimental process my results are always different because this fabulous medium has a will of its own, which can lead me to even more inspirational ideas. I look at the simple application of plastic wrap (Clingfilm) to create texture, for example, and can see how I have grown as an artist from when I first started using it.

No matter what I am painting, I always start each creative session with watercolour workout experiments. In the picture on the opposite page, I applied colour to opposite corners of a scrap of paper then applied plastic wrap on top, trapping the pigment underneath. The pigment then dried to create patterns once the plastic was removed. Here I have used a bold application of Schmincke Horadam Helio Turquoise for my subject, which is sat on a soft background wash of Winsor & Newton Cobalt Turquoise.

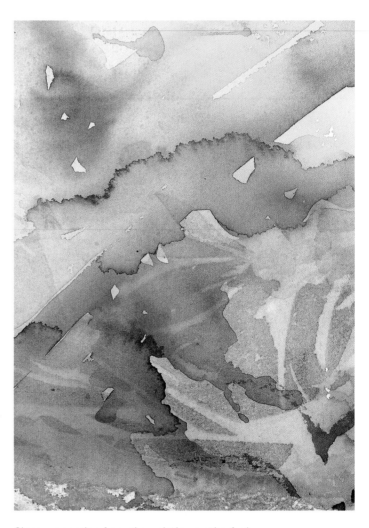

Close-up section from the painting on the facing page, where pattern has been created using plastic wrap and water application.

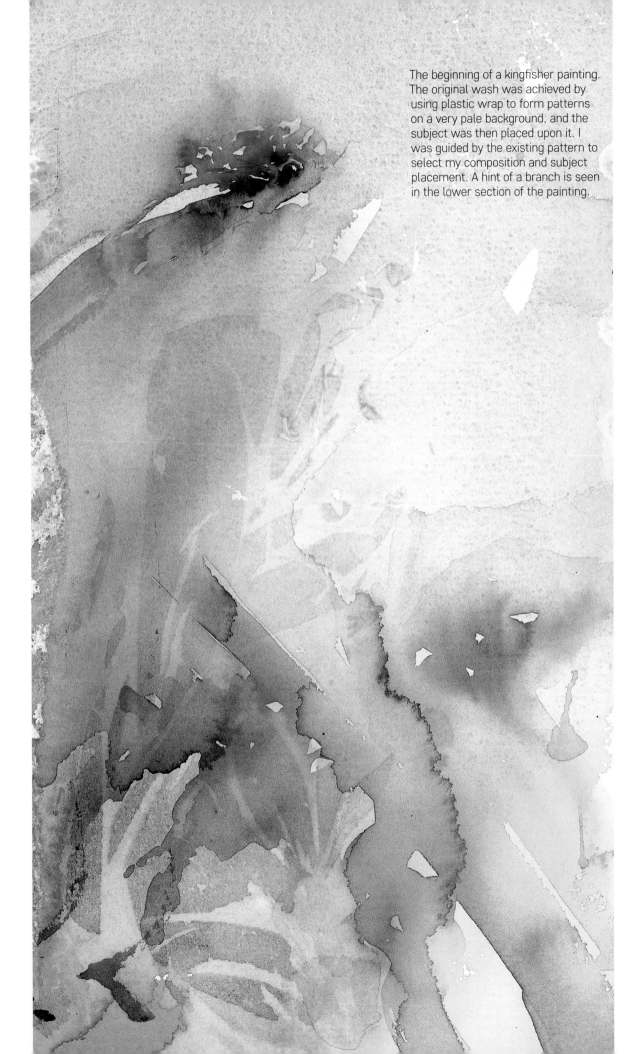

The beginning of a kingfisher painting. The original wash was achieved by using plastic wrap to form patterns on a very pale background, and the subject was then placed upon it. I was guided by the existing pattern to select my composition and subject placement. A hint of a branch is seen in the lower section of the painting.

Creating texture

By applying colour combinations to scraps of paper and then pressing plastic wrap on top while the pigment is still wet, I can create many interesting patterns – simply by changing how I make marks with my fingertips.

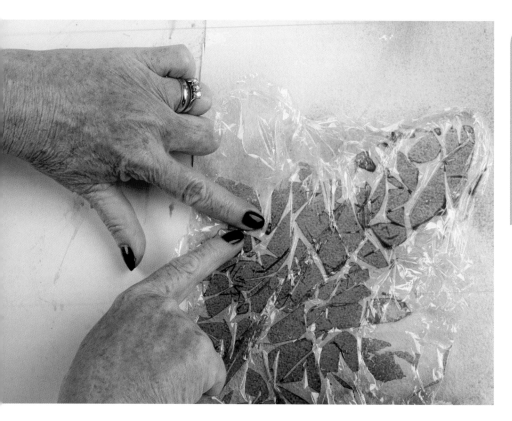

Tip

Try pleating the plastic wrap in straight lines before placing it on the wet paper. Alternatively, lay it in a curved arc or make simple fingertip impressions. The list of patterns you can achieve is endless and can be used in so many ways.

By pushing plastic wrap gently on top of wet pigment, I encourage pattern shapes that I can use as part of my composition.

Exercise: Plastic wrap (Clingfilm) curves

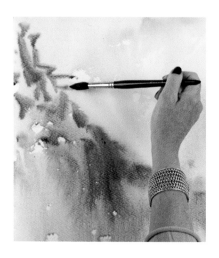

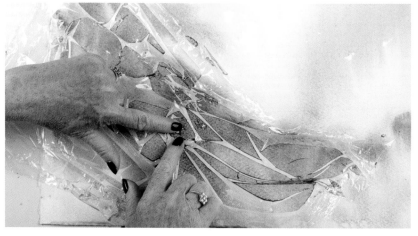

1 Apply colour in a curved shape on the paper.

2 Apply plastic wrap in a curved shape to enhance the initial colour flow.

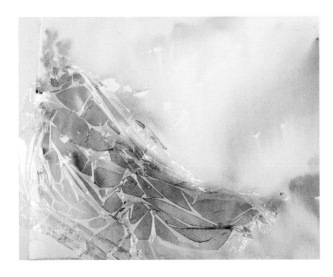

3 When the pigment is dry, remove the plastic wrap, revealing the curved pattern underneath.

A curved pattern created using plastic wrap could be useful as a backdrop for a number of subjects. For example, a kingfisher on a branch above water or koi carp swimming in a pond. This is where an active imagination is very useful! But please don't worry if you feel you're not as imaginative as you'd like to be. In time you will start to see things that appeal to you in your colour experiments. Often the results of these experiments look wonderful without adding anything more to them, but sometimes patterns emerge that simply beg to be worked on further. In the following exercise, for example, a carnation flower pattern was deliberately created with plastic wrap that could later be enhanced with the addition of outer edges to form the shape of the bloom.

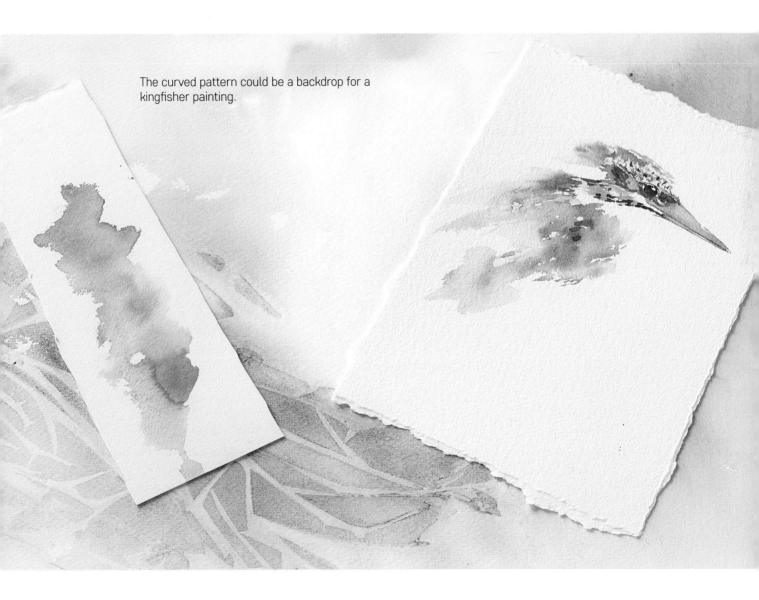

The curved pattern could be a backdrop for a kingfisher painting.

Working with texture

By thinking about the space around a subject we can make it come to life in far more interesting ways, and this is a great technique I often use.

Exercise: Creating carnation flower patterns

Plastic wrap (Clingfilm) experiments have led me to falling in love with painting carnations. Using plastic wrap is a great technique for easily creating the complex crinkled pattern of the petals.

1 First paint a dark pink section in the centre of a wash and place plastic wrap on it while it is wet, then leave this stage to dry completely. When dry, remove the plastic wrap. On the top left of the flower, begin to define an outer edge by placing colour around the flower and quite near to the previously painted red pattern.

2 I intend to use the white background at the top right of the flower as part of the carnation, which is why I place the outer edge definition carefully to ensure one side of my flower is in light. I am making the background become a part of the flower. This is a great tip for marrying the background to the subject and vice versa.

3 With a clean, damp brush you can now soften this hard outer edge and blend the freshly added colour towards the background.

4 You have to be quick when using the 'bleeding away' method of moving colour from a hard edge to another section. You need to bleed the line of colour away before it dries, otherwise the line will be too obvious in your results.

5 Use a rigger brush to make little fine marks at the petal edge to hint at the wonderfully intricate carnation formation. This also breaks up the hard line of colour and makes the flower painting look far more interesting.

6 Following the placement of colour and fine detail using the rigger brush, you can return to using your size 10 brush to bleed any surplus colour into the background and away from the flower.

7 The finished flowers. Using background space and washes is such a useful way to bring subjects to life, creating gorgeous results.

I am so addicted to working in watercolour that I constantly find new subjects to try my experimental ideas on. The next time you see light hitting a subject in real life, imagine how useful this way of working could be.

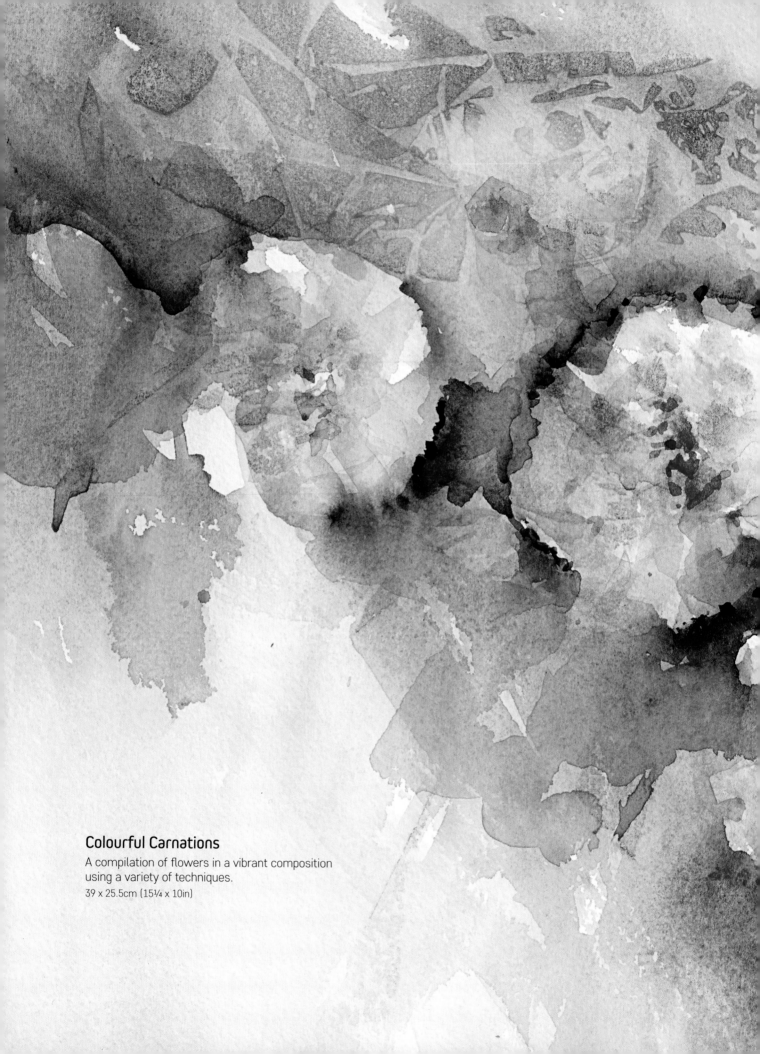

Colourful Carnations
A compilation of flowers in a vibrant composition
using a variety of techniques.
39 x 25.5cm (15¼ x 10in)

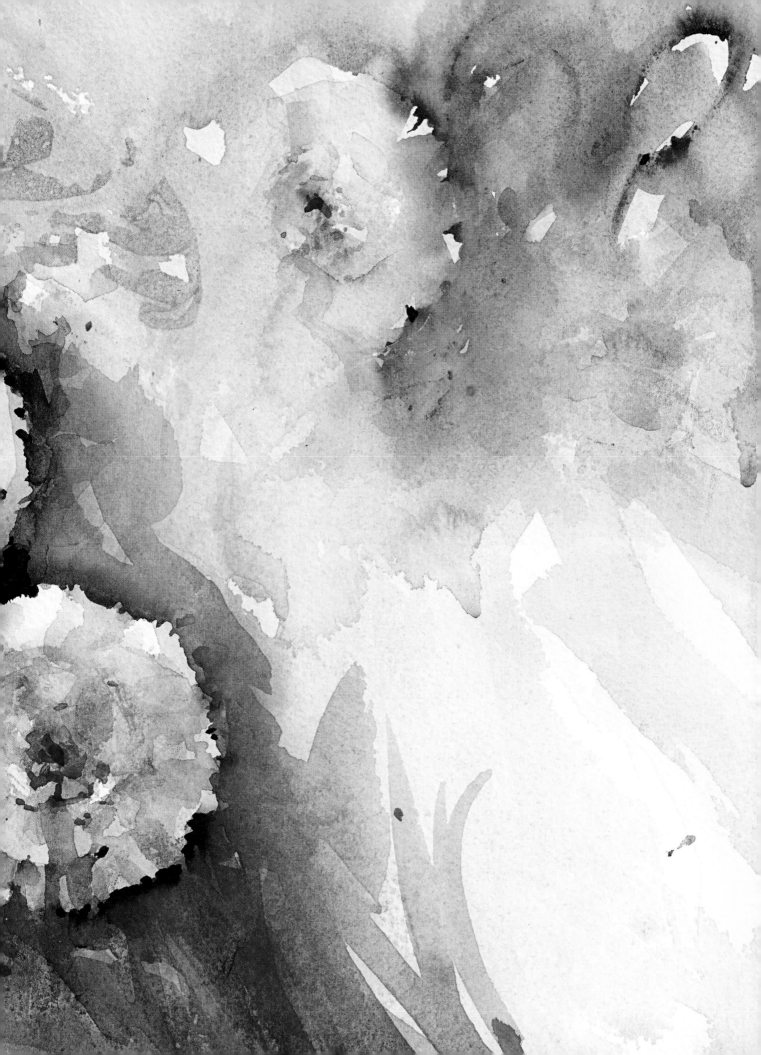

More watercolour workouts

I drag pieces of string through colour to see what patterns they will make. I place fine lace or gauze on top of my still-wet washes to discover if I can add new dimensions to my texture results. There isn't anything I cannot use to make my painting life more interesting. But the whole point of these workouts is to expand my knowledge and experience as an artist, leading me to paintings that are full of interest – not just for the viewer of my finished work, but for me as the one who is creating. I keep growing in my ability because I don't stand still in my field.

So where do we go from here? Working out regularly with painting exercises is pointless unless you put all the experience to good use. So now you have put your toe in the water, let's leap ahead to subjects from my watercolour world and see how the techniques can be combined, putting them together to 'sing' and make the most terrific watercolour music possible. If you use colour workouts regularly you should find yourself wanting more from your painting routine. So let's jump ahead to my world of subjects and techniques rolled into one!

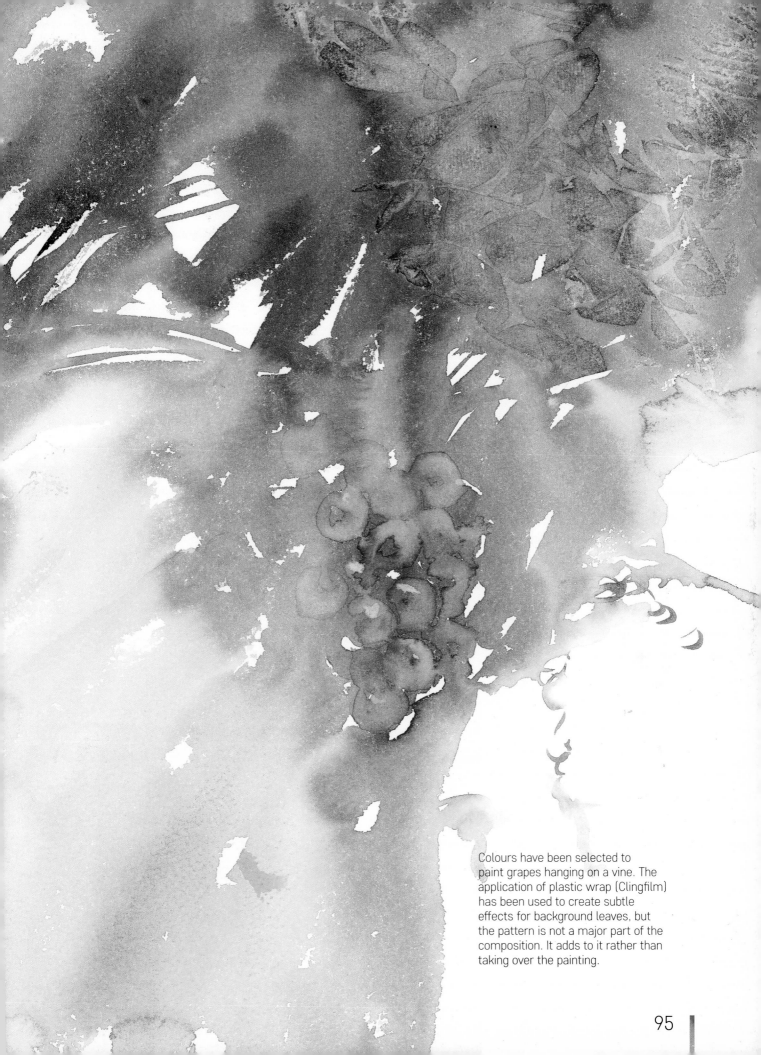

Colours have been selected to paint grapes hanging on a vine. The application of plastic wrap (Clingfilm) has been used to create subtle effects for background leaves, but the pattern is not a major part of the composition. It adds to it rather than taking over the painting.

Putting it
all together

Experiments to paintings

"When a painting goes right you can feel on the highest of highs."

I love so many things in life. My hobbies tend to merge, as I love photography as well as painting. I find myself continually taking shots of subjects I would like to paint in watercolour. I consider each new photograph with the eye of an artist, imagining how I would see a final painting composition. I sometimes avoid placing my subject centrally, which can be a rule in art, but I also know I hate rules. If I am advised not to do something I will take ages working out why it could be a problem.

I love gardening, and carefully select plants that would be excellent subjects for me to create paintings from. But I tend to mix colours and shapes in my flowerbeds, which are not at all regimented. They flow with colour, texture and form, creating a display that is fascinating to all who see it.

Taking Flight
28 x 26cm (11 x 10¼in)

Every hobby I have carries a fun element, making it an enjoyable addition to my life. This is also true of the way I paint. I have no rules, I simply enjoy creating in a way that enriches my life. This is the passion I would love to share with the world, because when a painting goes right you can be on the highest of highs. It is a heady, fabulous feeling – one of achievement, satisfaction and pleasure all rolled into one. And it is addictive. In life, when you experience something wonderful you always want more.

I love painting animals, florals, people and landscapes. In fact, everything. My technique of working with colour and shape rather than worrying about sketching beforehand allows me the luxury of being able to approach many subjects. I am in love with the medium, so allow it to shine on its own. I often simplify to tell the story of what I am seeing, but with just enough detail to bring each subject to life.

So, welcome to my world of watercolour, where my favourite subjects come alive with the use of techniques described in previous chapters.

Starting small

"I always recommend starting with something small as a subject, and what can be smaller than a mouse?"

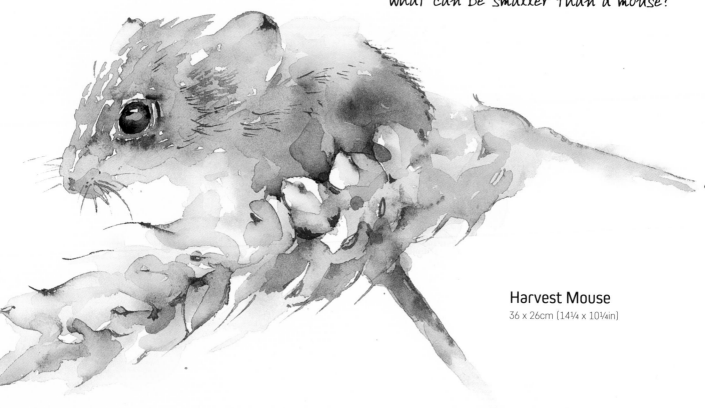

Harvest Mouse
36 x 26cm (14¼ x 10¼in)

I meet so many new artists who are daunted by starting to paint in watercolour, along with many professional artists who are bored with how they work. To the new artist, I always recommend starting with something small as a subject, and what can be smaller than a mouse? To the professional artist, I always ask what new subjects they have painted recently. Keeping our enthusiasm high is such a great way to make painting a wonderful experience rather than a chore.

For the next demonstration, I was inspired by the wildlife photography of Richard Bowler. My cats are constantly bringing in live mice and so I have plenty of opportunities to study them, but Richard shows mice as they appear in the wild. By combining my observations with the colours seen in his photographic compositions, I created the painting of the harvest mouse shown above.

I often start new paintings by exploring colour options, and fell in love with Quinacridone Gold, Cadmium Orange, Opera Rose and Schmincke Horadam Brilliant Red Violet for this step-by-step.

Demonstration: Harvest mouse

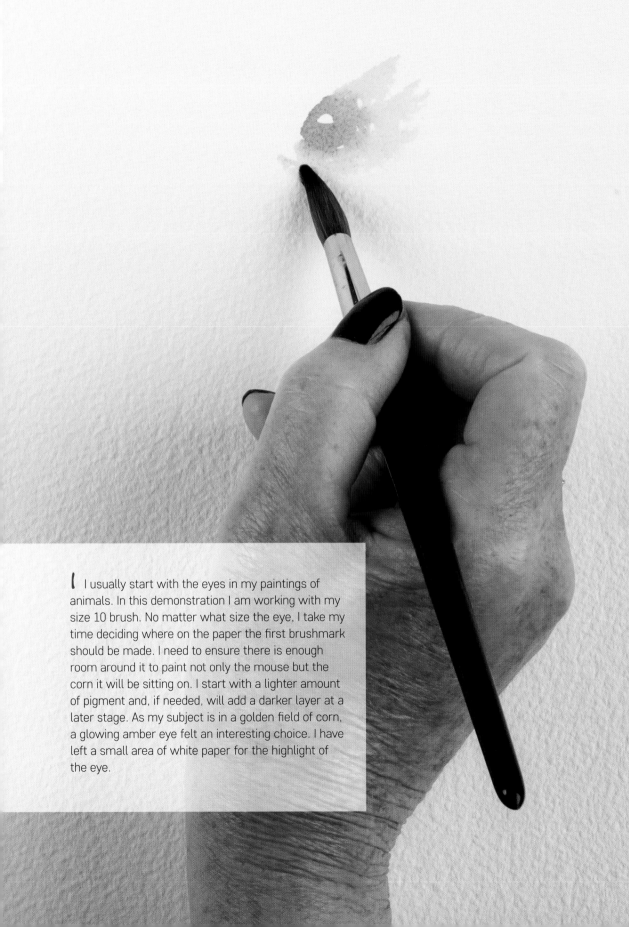

I usually start with the eyes in my paintings of animals. In this demonstration I am working with my size 10 brush. No matter what size the eye, I take my time deciding where on the paper the first brushmark should be made. I need to ensure there is enough room around it to paint not only the mouse but the corn it will be sitting on. I start with a lighter amount of pigment and, if needed, will add a darker layer at a later stage. As my subject is in a golden field of corn, a glowing amber eye felt an interesting choice. I have left a small area of white paper for the highlight of the eye.

2

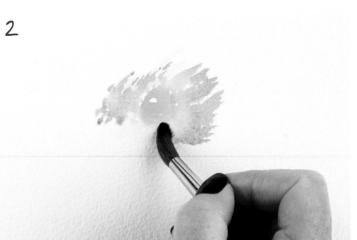

3

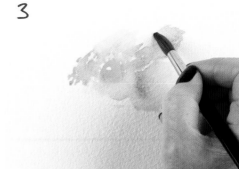

4

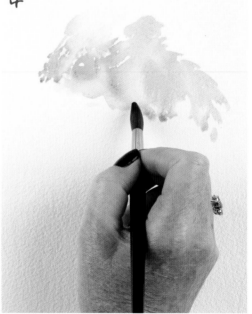

2 Once the painted eye is in place I can move towards painting the surrounding area to build up the face section of my subject. I use brushstrokes in the direction that the fur will be growing. My touch is gentle as if I am almost stroking the tiny creature. I often think about how a subject would feel to the touch when I am working, as this determines the strength of pigment I select and the pressure I use in applying the colour. This was a tip given to me while I was living in China and it has stayed with me ever since.

3 I now move to the ear of the mouse: a gentle soft pink in a neat curved brushstroke. I must confess I love painting the ears of small creatures like this. I imagine the texture to touch and try to paint that feeling.

4 I take my time to gradually build up a painting of a subject. I carefully move from one area to the next, ensuring each connects to the other in both colour harmony and accurate proportions, using directional brushwork when helpful.

> **Tip**
> *A great tip to remember is that curved subjects require curved brushwork.*

5

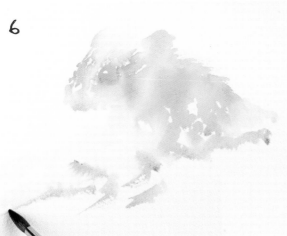

Tip

I have stayed with my colour choice of Quinacridone Gold for the mouse, introducing heavily diluted Opera Rose for the ears. Because this is a small animal subject, I am keeping my colour selection very soft.

5 As I build up the face and body of the mouse by working away from the eye, I continue to use directional brushstrokes as if I were stroking the small creature's fur. If you use curved brushstrokes over the shape of the face and body, this will add a wonderful almost three-dimensional effect to your results.

6 Next I begin to add the ear of corn that my little mouse will be perched upon. Initially I make a line where the central core of the corn will be, bending with the weight of the mouse on top of it. Staying with the Quinacridone Gold here will add a sense of connection to the colour previously used in the subject, the mouse.

6

7 I allow the colour from my subject and the corn to merge. Later I could separate this area with detail added on top if I wished to, or I could leave it as it is because it looks very pleasing already. But these decisions will come down to each individual artist's choice. Sometimes I prefer more detail and at others I prefer less. When demonstrating and trying to help artists who are new to working in a loose style, I often stop working as soon as the subject emerges. This encourages them to avoid overworking and going too far in a piece. In time, we learn to know when the last brushstroke has been added to a painting, but this knowledge only comes with experience gained by practice.

7

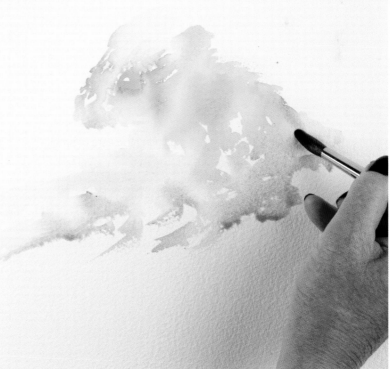

103

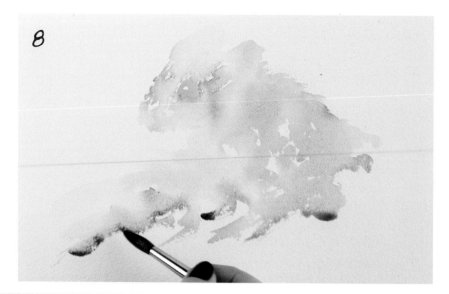

8

Tip

Always connect your subjects to backgrounds, other nearby subjects or shadows.

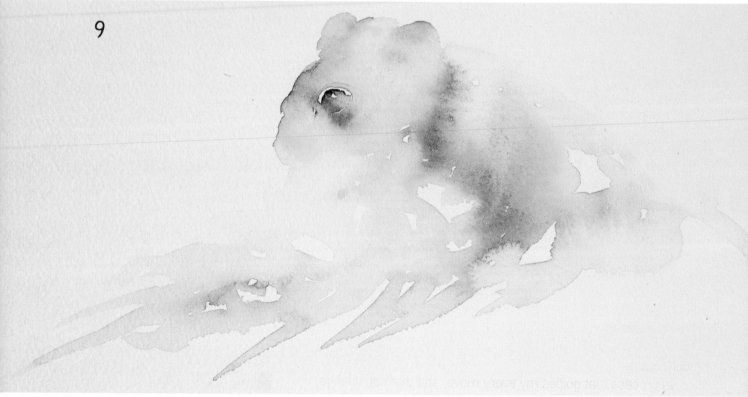

9

8 Connecting my subject with colour to the corn it is sitting on could also harmonise with the surrounding background, should I decide to add one. Deliberately encouraging this new section of colour to merge with the mouse will avoid the creature looking as though it is floating on top of the corn. My subject at this stage actually becomes one with the corn. As I work, I make sure I regularly apply water where needed to soften small sections of colour. This will form interesting watermarks and give an illusion of light hitting sections of my painting.

9 A soft first wash of a harvest mouse, full of light as a gentle first whisper of my subject. This soft first wash is my guide for the further addition of detail and a background, if I decide to add one.

Learning from a half-finished study

Studying the painting at this stage is a valuable process in learning how to work in a loose style, making the most of watercolour as a medium, and also helping to understand why taking breaks between painting stages can improve our skills as artists.

Observing this study at this stage of the creative process helps us see how transparent watercolour sections work. These add a sense of light, create interest and bring beauty to this study of a harvest mouse. Seeing the white of the paper through translucent watercolour occurs when clean, fresh translucent colour is applied and encouraged to work by the addition of the right amount of water. There isn't anywhere yet in this piece where solid pigment has been added, but bold colour could now be applied to the eye or by the addition of detail, as seen in the painting on page 100.

Taking breaks

It is by taking breaks when painting that I learn how and where to add detail. I study what is needed next before racing to complete my paintings, and this has aided my journey as an artist, possibly more than anything else.

I have come to realise that when I am demonstrating I often have to stop in between painting stages to describe my thought process to the group of artists watching my every move. By sharing my thoughts about the way I work and each new addition of colour, I have become more acutely aware of what I am aiming for and why. This has aided my way of working enormously, and I wish I could emphasise to every new artist that thinking before you pick up a brush is as important as picking it up in the first place.

Not every painting has to be a quick, loose piece that just happened to appear on the paper. Many loose-style paintings are actually well thought out, but possibly not in the way that you imagine. It is the creative process that guides my every move, and that can change direction at any given point. For example, if I felt a second mouse would make this composition look more fascinating I would add one. I have no hard-and-fast rules. I create and enjoy creating.

"Thinking before you pick up a brush is as important as picking it up in the first place."

Tip

Take breaks during the creative process when painting. Stand back from your work and take time to think about what your next additions of colour should be. Is your work too light? Too dark? Has it too much detail or not enough? Think before you pick up the brush!

At this stage the painting becomes very personal. You may like it as it is or wish to work on it further. If you are unsure of what to do next I suggest leaving the painting for a while and looking at it again later with fresh eyes. Often a painting will tell you what it needs if you learn to 'listen'. Waiting also avoids the urge to overwork!

10 I felt my painting needed more, so I have strengthened the eye slightly and started building up the lower curve of the cheek on the face. This is the time to gradually add darker colour to sections of your subject or more detail.

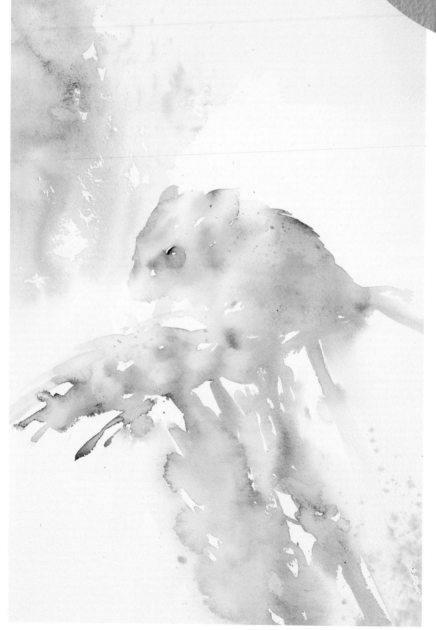

Adding a background

11 Sometimes paintings look fine without a background, as in my painting on page 100. At other times we feel a need to add more to a composition. In this case I have added similar colours to my subject at the top corner of my painting. While the pigment was still wet I applied salt to create an interesting texture for contrast.

Next, I repeated this technique in the opposite lower corner to connect the two sides of my composition in a diagonal line across the paper. In the foreground I am hinting at stems of corn. My aim is for my subject to act as the main focal point but at the same time I want to draw the viewer's eye to my mouse by using directional brushwork around it.

> ### Tip
> *Directional lines, texture effects and clever use of colour can draw attention to a focal point in a subtle way.*

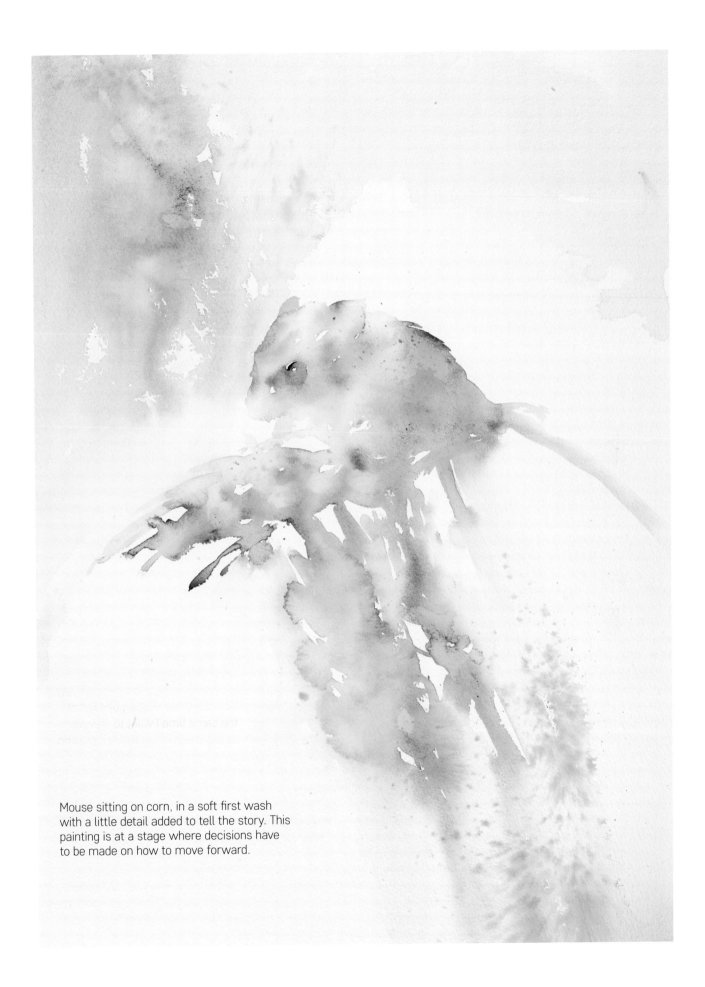

Mouse sitting on corn, in a soft first wash with a little detail added to tell the story. This painting is at a stage where decisions have to be made on how to move forward.

Practise, practise, practise

Repeat this process when working on new paintings, but aim to improve each piece by gradually mastering the techniques or by altering sections that didn't work in your previous pieces.

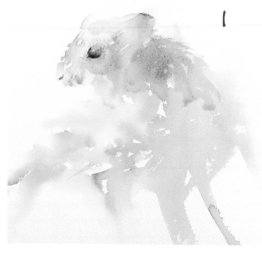

1

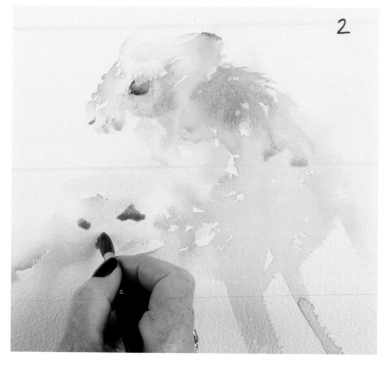

2

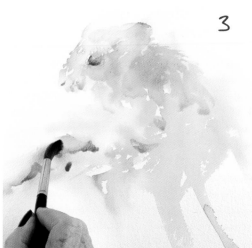

3

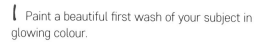

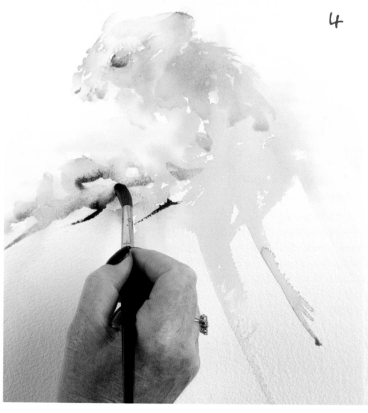

4

1 Paint a beautiful first wash of your subject in glowing colour.

2 Gradually add bold colour detail.

3 Soften new colour additions as needed.

4 Add final details where you feel they are necessary and only where you wish them to be.

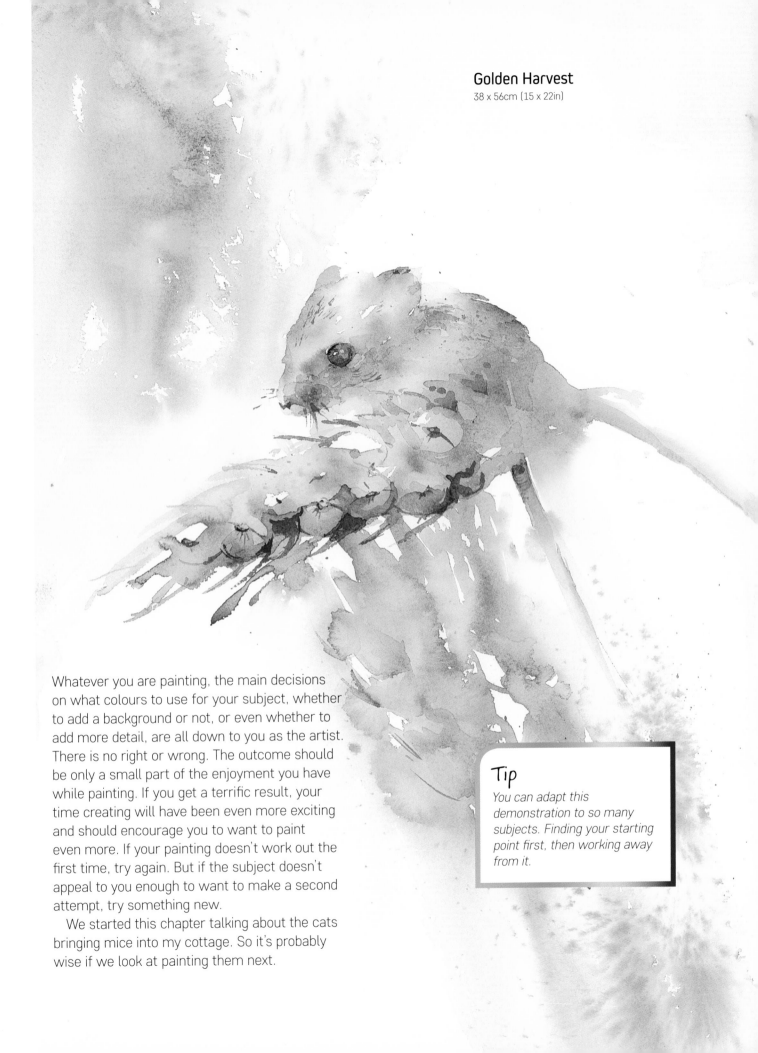

Golden Harvest
38 x 56cm (15 x 22in)

Whatever you are painting, the main decisions on what colours to use for your subject, whether to add a background or not, or even whether to add more detail, are all down to you as the artist. There is no right or wrong. The outcome should be only a small part of the enjoyment you have while painting. If you get a terrific result, your time creating will have been even more exciting and should encourage you to want to paint even more. If your painting doesn't work out the first time, try again. But if the subject doesn't appeal to you enough to want to make a second attempt, try something new.

We started this chapter talking about the cats bringing mice into my cottage. So it's probably wise if we look at painting them next.

> ## Tip
> *You can adapt this demonstration to so many subjects. Finding your starting point first, then working away from it.*

Working loose and getting it right
Cats' eyes and more

"Without a preliminary sketch, there are times when working loose means you have to really stop and think about where to add the next brushstrokes."

I love painting animals. Over the years I have taken time to improve how I initially approach painting eyes, because if they are not right, the finished painted animal will seem lifeless. In this section I am going to show you how I paint eyes and connect them to subjects, starting with a simple cat's eye.

Adding life to a subject simply by watermarks and colour combinations.

Exercise: Cat's eye

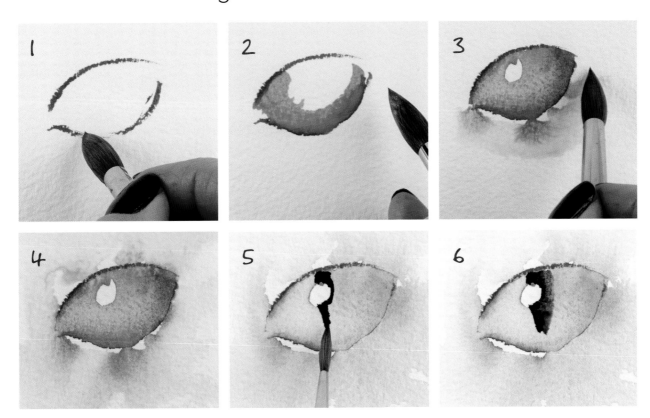

1 Start by creating a simple outline. Use the colour of the eye for the outer edge. Make sure your outline shape matches that of your subject.

2 Add the inside colour, allowing it to merge with the outside colour on the original edge line. Use a curved brushstroke for the lower section of the eye and work upwards, leaving a small white area for the highlight. Keep your pigment watery so that you have soft rather than bold colour. This creates a more 'glassy', lifelike effect.

3 When almost dry, gently add a line of water with a clean, damp brush underneath the lower edge of the eye. Softly touch the colour randomly along the still-wet outline to allow it to flow into the newly formed water line underneath. Use a sweeping movement of a clean, damp brush to 'curve' this new colour section, following the lower outline of the eye. This section will act as a base, forming a layer underneath the fur colouring to be added later.

4 Allow the eye to dry at this stage, and do not be tempted to overwork it.

5 Now work around the white highlight of the eye to add the dark pupil.

6 The eye is complete. The soft green outer area will act as a beautiful base for adding, for example, ginger fur as another layer of colour at a later stage.

> **Tip**
> *Connecting eye colour to surrounding facial sections adds interest to results.*

Practise painting eyes in as many colour variations as possible as these exercises will improve your painting of animal skills.

Once you have mastered painting a cat's eye, consider how to measure where the other eye would be placed. Without a preliminary sketch, there are times when working loose means you have to make yourself stop and really think about where your next touch of colour will be placed. This is especially true when it comes to portraits, where an accurate likeness is needed.

For this next demonstration I first worked on a quick shade chart of colours for painting a slightly more unusual cat's face. A French ultramarine blue, vibrant violet and a turquoise looked beautiful together and became my three main shades.

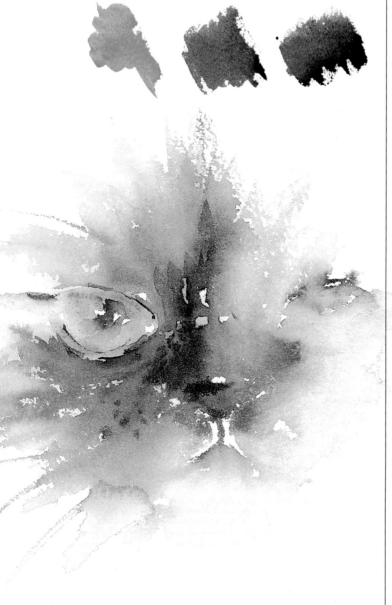

Demonstration: Cat's face

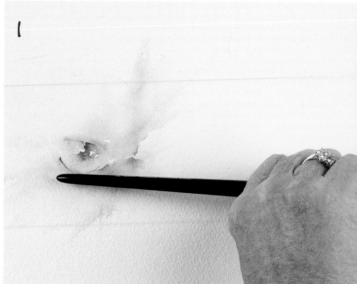

1

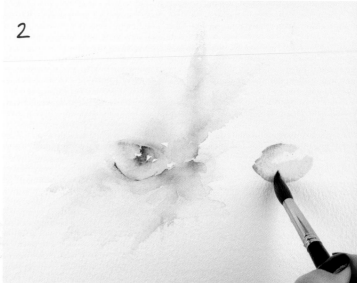

2

1 I use my brush to measure. I line up my brush to see where the next eye would look right, as well as measuring by observing my subject.

2 Once I am sure where my second eye will be placed, I repeat the painting process. I often vary eyes slightly, for example if the head is turned towards me the closest eye could be more detailed or stronger in colour.

3

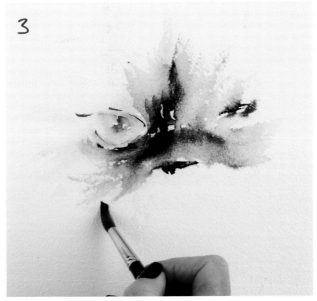

4

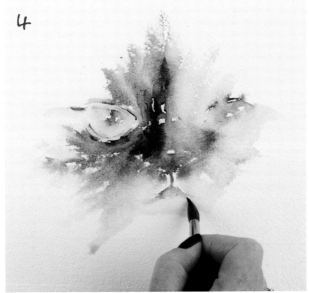

5

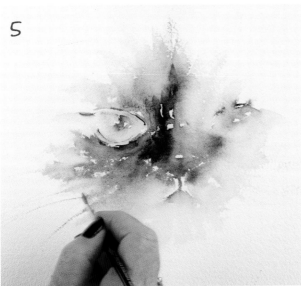

3 In this demonstration the second eye is of less importance to me, so I am losing it slightly in the surrounding fur space. By working section by section I can gradually bring the face of my subject to life. In each new area I use directional brushwork to not only build my subject slowly, but also give it a more dimensional appearance.

4 By adding the mouth I can make my cat look grumpy or happy. Now is the time to add 'cattitude'!

5 Finally I add the whiskers. These are in the same colour as the fur as this works to bring harmony to the painting.

> ### Tip
> *Observe fur growth direction. Notice how the brushwork under the eyes is curved outwards. Over the nose it is curved to mimic how the fur would grow in this area, and above the eyes the fur is aimed upwards towards the top of the head.*

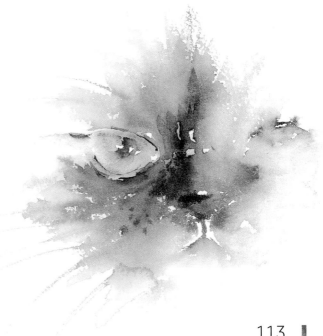

My grumpy cat!

Demonstration: Adding definition

The aim of this demonstration is to look at how far we can go with a painting without overworking it, and to look at how choosing alternative colours can be a fascinating way to paint familiar subjects but with a more unique outcome.

I often paint with vibrant colours, but for animals I opt for softer shades. Even so, perhaps pink would not be your first choice for painting a cat, but why not? If we always paint what we see we are only repeating what is already there. How about adding impact to your work by jumping out of the expected into the unexpected.

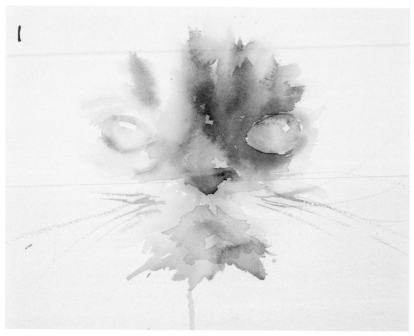

1 I have painted my cat following the same technique as the previous demonstration – painting and measuring the eyes and adding the face section immediately surrounding them. At this stage the painting is a very loose and needs to include more information before it is complete. But this is the stage we often overwork. To avoid this, I always add detail gradually until I feel my painting is finished.

2 Starting with the eyes I add the dark iris, carefully leaving a highlight in the same position in each eye.

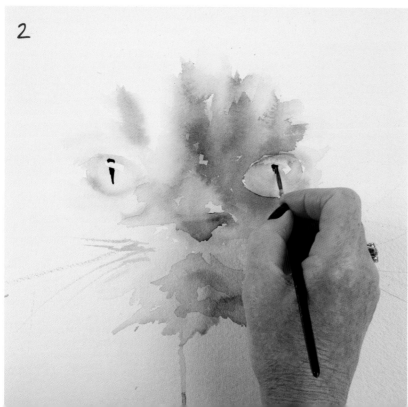

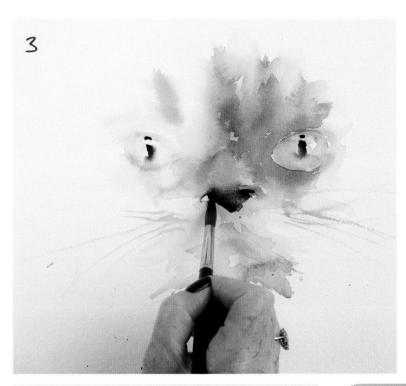

3 Next I strengthen the position and colouring of the nose using strong colour.

4 I add a fine outline to the eyes using my rigger, but not all the way around each eye – just enough definition to make them more interesting. While working with my rigger I also add little marks to the cheeks. These can be softened with water to keep them looking as though they sit well in the fur.

5 Finally, I leave my work to dry and at this stage my cat face looks soft and interesting. The watermarks created by applying water from my brush with a clean brushstroke through the still-wet colour has dried - to a beautiful pattern. This technique is also seen in the painting on page 116.

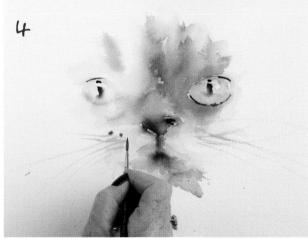

Tip
The nearer a section of a subject is to you, the darker in colour it should be.

Tip
Using only water on your brush to enhance directional brushstrokes, simply pushing pigment out of the way is a wonderful way of creating great fur effects.

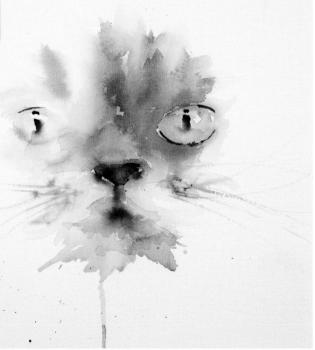

Putting it all together: painting a cat

Once you have mastered painting cats' eyes and faces, the next stage is to learn how to paint fur in interesting ways, so that you can build up to painting the whole animal, step by step.

Fur effects achieved by allowing water to run through pigment.

I depend very much on colour and watermarks to achieve fascinating watercolours that are full of intrigue, interest and unusual colour combinations. I rarely paint colours exactly as I see them. I will use vibrant turquoise, for example, to liven up a painting of a black cat, or stunning orange shades with touches of contrasting violet to paint a ginger or tabby cat. There are so many fantastic shades now available in watercolour. Experimenting with shade charts and working on scraps of paper to discover new techniques or watermark effects for fur can lead to some beautiful outcomes.

Part of the way I work is to sometimes leave sections of a subject out, so that the viewers of my completed paintings can use their imagination. When teaching I deliberately stop long before a painting is complete, so that followers of my step-by-step demonstrations can decide how they would work further on the painting if they were creating a similar piece on a similar subject.

My paintings are often loved as they are, in the unfinished stages, and this too has led to me finding my own style; I have learnt what I love and why. My art journey has been such a special part of my life, and the artists who have told me over the years what they enjoy most about my style have helped to develop it. This is why I feel so strongly about helping other artists. The enjoyment of painting is a gift we should all share, as it can bring so much joy to so many lives on so many levels.

In the image of the unfinished cat on the facing page, I have painted a very soft impression of the outline of the animal. I know where the fur markings are to be placed next. These details were achieved by side-on brushwork – laying the brush side-on to the paper and moving it backwards in the direction of growth of the cat's fur. I have encouraged watermarks to act as a foundation near the eye, and I have only hinted at the ear.

My second stage in this painting was to add definition with as little detail as possible, which is a great challenge. Here, I have made a forward-thinking choice to paint only one eye and one ear, and leave suggestions for the remaining sections. As in the previous cat demonstrations, I have added detail to the eye. Using my rigger brush, I have also added a few whiskers and lines to hint at individual hairs on the head and body. This fine detail sits on top of the loose background, which now acts as a foundation for the fur in my painting of a cat.

Interestingly, the white highlight of the eye looks far whiter now that the darks have been added to the iris in its centre. The watermark towards the lower part of the cat's body also looks more obvious due to the added emphasis on darker detail above it.

I have aimed to give the cat an expression that suggests it is watching something. In our cottage, our cats are constantly bringing in mice, letting them go then catching them again, so my painting is intended to give the impression the animal may pounce at any given time.

When painting animals, it is a great idea to think about their characters and personalities. Try to draw these factors into your work so that your painting is more than just a work of art. Aim to ensure it captures the memory of the time when the animal was painted, in its youth or older years. Tell a story with your work whenever possible.

Tip
Studying cats' poses is useful to the artist who loves painting pet portraits.

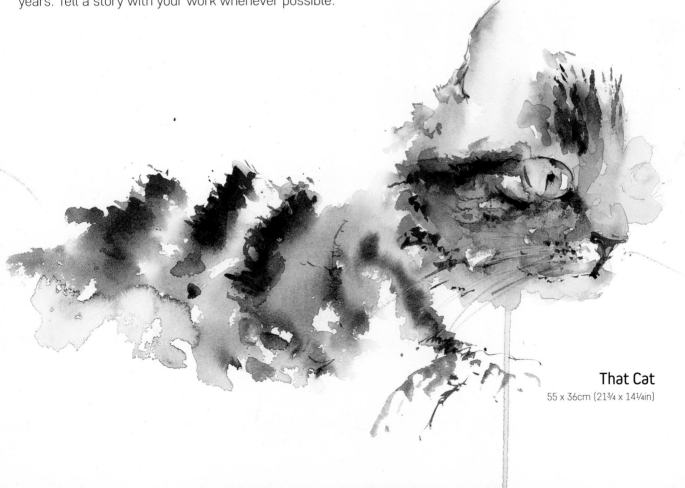

That Cat
55 x 36cm (21¾ x 14¼in)

Of course, it wouldn't be fair to have a whole chapter on animals in my book without the mention of a dog, so here is an example of how I would paint a cavalier King Charles spaniel using wonderful watermarks in both the eye and the ear.

But these are small studies; experiments to improve our skill in painting without the use of a preliminary sketch, and also to learn to paint subjects in an interpretative rather than realistic style. If we wanted to paint a full composition, how would we pull all these ideas and techniques together? On to the next section!

The use of colour, knowledge of pigment and knowing how it will react with water have all made this stunning section of a dog come to life in a truly unique way. As artists, we need to allow watercolour to shine in a way only it can. The results are magical.

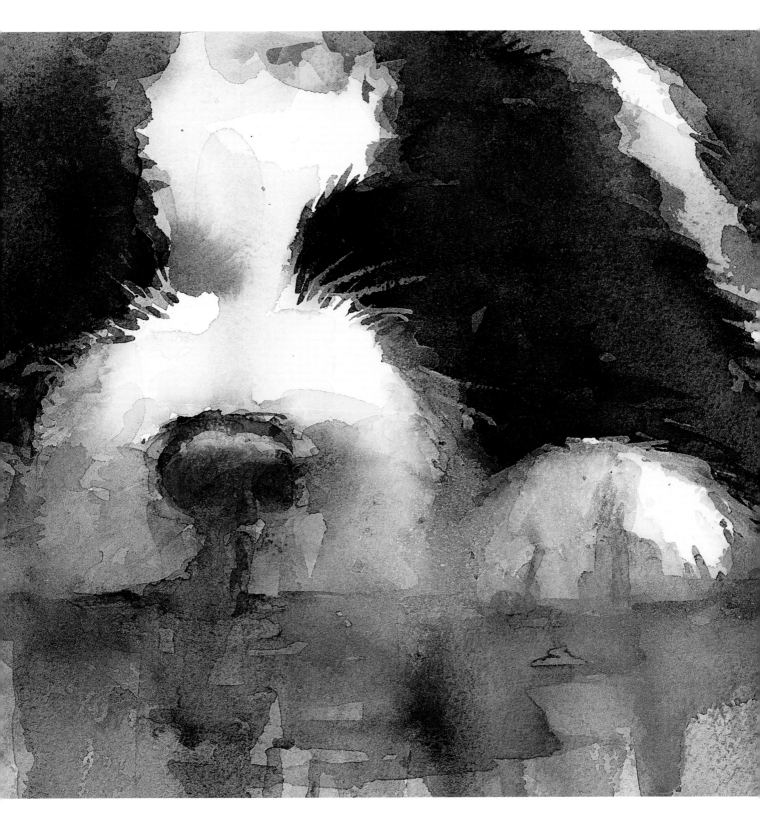

Dog Tired

32 x 19cm (12½ x 7½in)

From study to full painting

"Good artists possess – or work at gaining – the skill to place details accurately and in proportion."

Koala

I travel so much with my art career. This is a side to my life that I honestly never saw coming. I'm just one of many people who adore working in watercolour. It seems like a dream come true, and if it can happen to me there is no reason why it couldn't happen to you, if that is what you wish for in your own art journey. Meeting artists of all levels and sharing a passion for painting has become an exciting part of my existence; one where I find myself frequently accepting invitations to hold inspirational watercolour workshops all over the world.

One of my favourite book-signing and workshop tour destinations is Australia. Here, I fall in love with many gorgeous subjects, including beautiful scenery, vibrantly coloured birds and, of course, like many other animal lovers, the koala. I am sure telling you that I absolutely love koalas isn't a surprise. They are incredible creatures and their colouring is fabulous. But how to paint them? That is a great question.

I experimented at first with shade charts of colours that I thought may be suitable for an interesting painting of a koala. I opted for a turquoise, violet and ultramarine blue as my main colours. I then added gold for warmth, representing the sunshine that Australia always represents for me.

Aiming for full compositions

I enjoy painting all manner of subjects, often leaving them more or less as studies rather than full paintings. Using the white paper background to emphasise the beauty of a subject I am creating can be a very satisfying style, but on many occasions I want to add colour to a background. This is especially so if I have an exhibition ahead where I need a collection of work that is more varied and suitable for a gallery display.

Shade chart with possible colours for a koala painting.

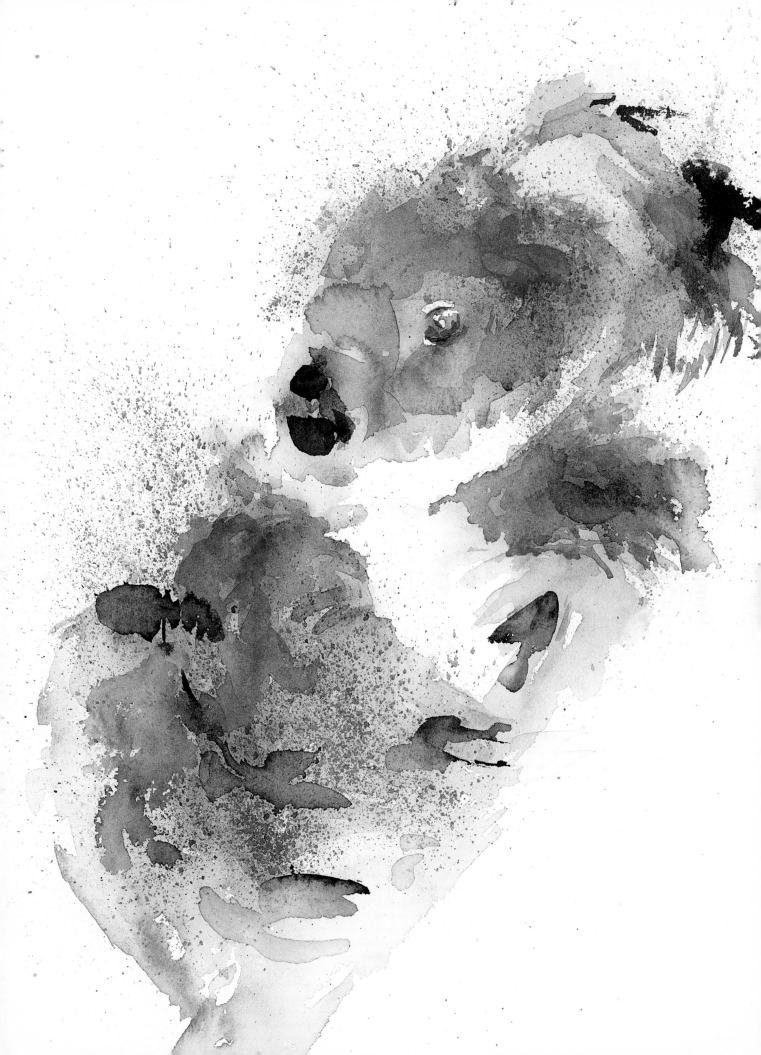

Studying a new subject

I used to be a botanical artist, so sketching isn't new to me. At that time in my art career I would always draw what I saw, taking in every detail. I still recommend you practise sketching as much as possible because it will aid your loose work, particularly when working on new subjects. Good artists possess – or work at gaining – the skill to place details accurately and in proportion. I have seen so many wonderful paintings ruined simply because the artist had no idea where a nose should be placed or how eyes should be distanced. Practice really does make perfect. But having said that, I am not necessarily aiming for perfection. I want my subjects to look as though they work but not with every single detail included.

I usually work without preliminary sketching. If ever I am unsure of where to place my next brushmark I can fall back on the technique of measuring with my brush, as seen in my cat's face demonstration (page 112). Alternatively I can make marks with water on my paper and, if I can see they look right, I drop in colour. I do this softly at first and, when it definitely looks right, I then strengthen with more pigment and detail.

How to take a study to a completed painting

There comes a time when it feels right to move away from painting studies and exercises towards creating full paintings; we feel ready to paint something that looks a little more professional. This is the time when finishing off a painting and knowing how to do so becomes very important.

Observe your subject first. This is important if you wish to be a good artist. My approach to painting a koala for the first time was to initially make a simple sketch to get a feel for the animal. But it didn't satisfy me. I wanted to create with colour, which I find far more enjoyable!

Sketch of a koala
28 x 38cm (11 x 15in)

122

Demonstration: Koala study

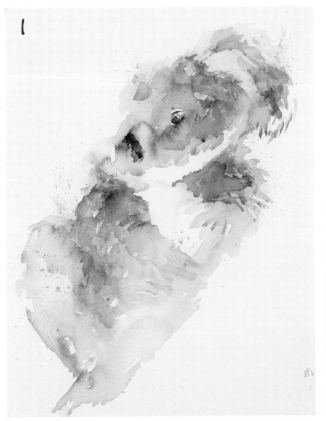

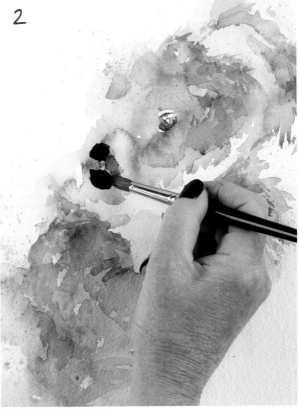

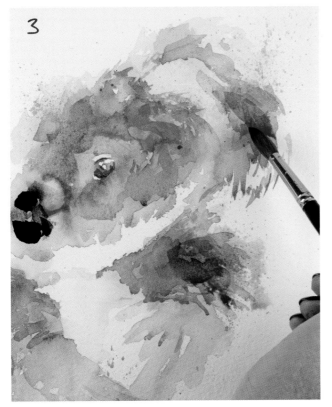

1 My initial study of a koala looks lovely and could be left as it is. Any further work could ruin it and we all, as artists, face this dilemma from time to time. But I feel this painting needs more definition. The added drama of just a few darks could bring it to life.

2 I start by strengthening the nose of my subject, using downwards brushstrokes in the direction of the curve in this area.

3 Next I add some very strong blocks of colour for more impact on the body. Using unexpected colour combinations in a subject is a great tip for unique results. Turquoise is perfect for adding drama here, but as my subject lives in a country known for wonderful sunshine I add gold too. At this stage, I only paint in sections that I wish to draw attention to, or because I feel they are too quiet.

4

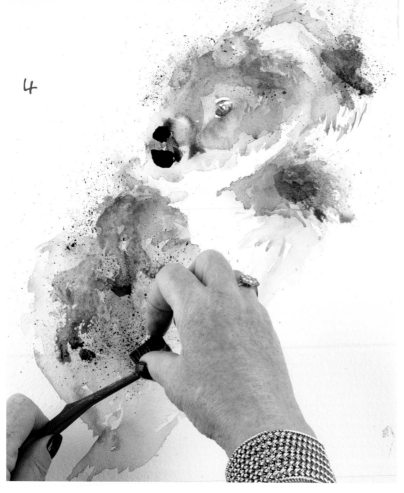

5

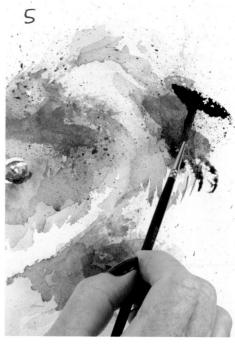

6

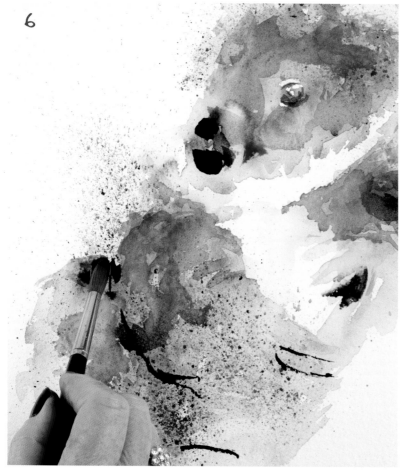

4 The fur of a koala is very dense. To create interest and break up the underlying colour, I carefully splatter with a directional application from my painting toothbrush, following the curves already in place in my work so far.

5 I add dark details on the ear edges.

6 Finally, I make a few last touches to my painting. I add a darker line to separate the lower leg from the body, and a few suggestive brushmarks to hint at the claws of the animal. This is where I would normally stop and study my painting with fresh eyes at a later stage, to see if it is finished or not. I never race to complete a painting in one go. I enjoy the creative process and learn from each brushstroke.

Koala Blue

Inspired by my workshops and book signing tours in Australia and my many artist friends there.

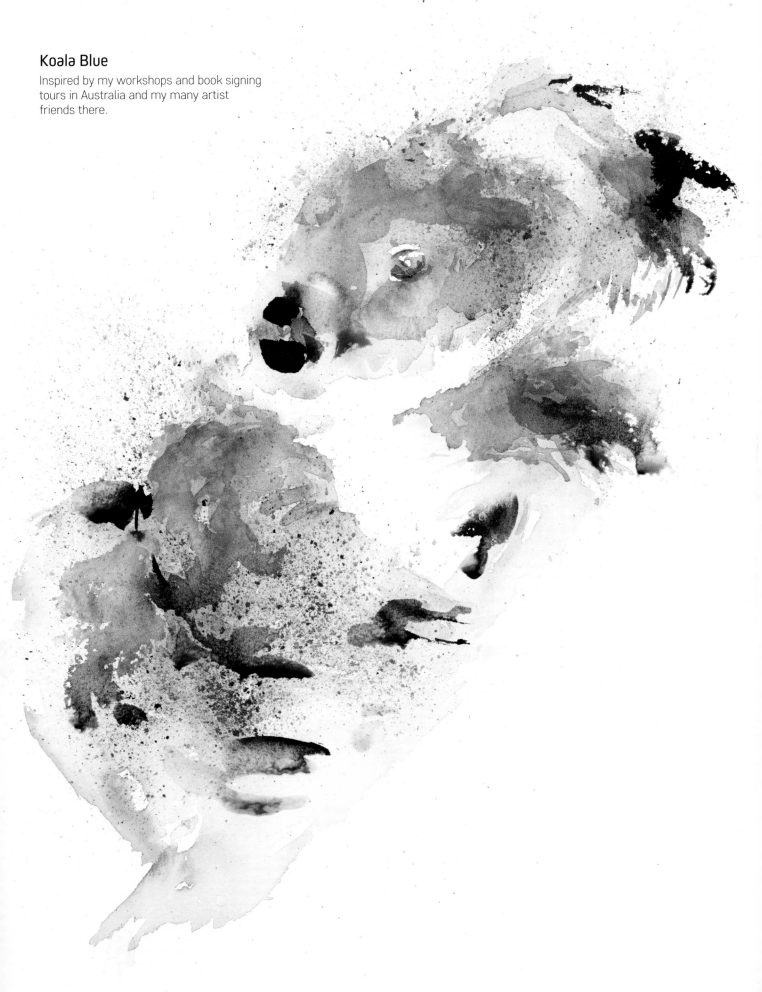

Moving away from a study

With all this information, I am ready to move away from a study and work on a full painting, complete with background. I repeat the process of painting my koala from the starting point of an eye, working away from it to complete a full study. To enhance the animal further I make the choice in this new piece to add a background. The natural progression from sketch to colour study then full painting makes the decisions in my new painting far easier. I know what goes where, which colours work and how to pull it all together because of the exercises I have carried out in my colour gym sessions. I would like my koala in a tree, so green is my obvious colour choice for the background.

Demonstration: Adding background and building up a painting

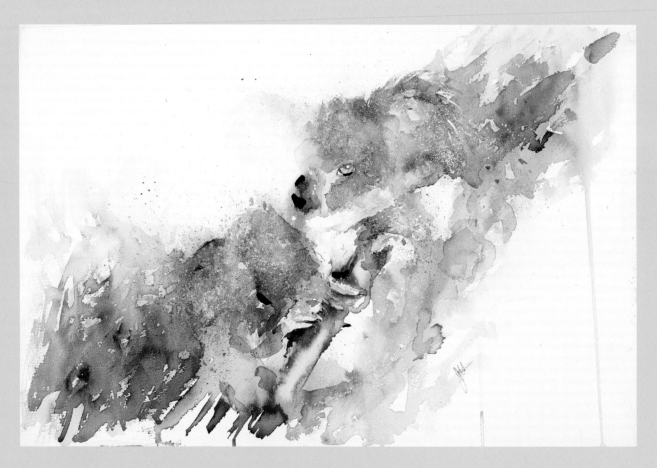

1 As in my study of a koala on page 123, I keep the whole painting soft before adding detail. I am happy with this stage before moving on with the painting.

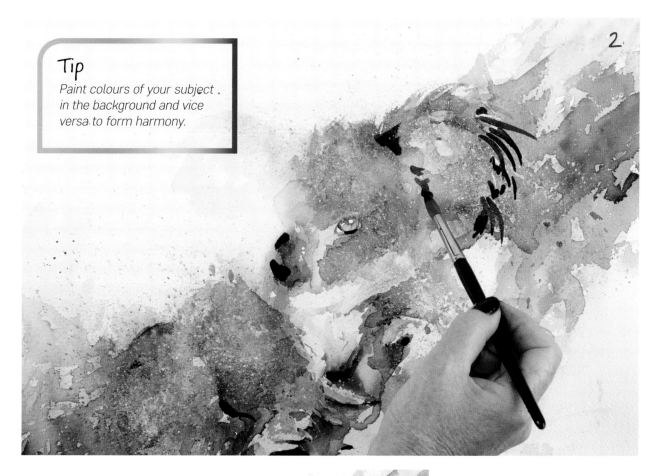

Tip

Paint colours of your subject in the background and vice versa to form harmony.

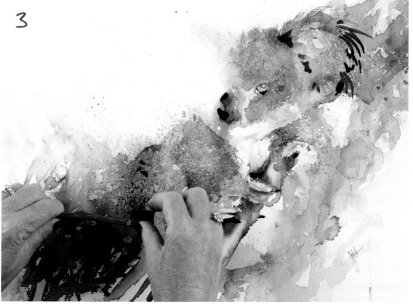

3

Tip

Always try to connect the subject and the background by skilful techniques of detail placement or by allowing colours to merge in places. This looks far better than a subject just floating woodenly within a painting with a well-defined outline. Bring life and connection into your work by thinking carefully about how to connect subjects with the colours around them.

2 Adding detail at this stage means I can incorporate the background and connect it to my subject. I do this by adding dark definition to the outer ear and over the surrounding background colour.

3 When I splatter this time, I allow the colour to fall on both the background and my subject. Again, this creates a sense of connection.

You should have now gained a wonderful insight into how I work from a tiny starting point to building up a whole painting. Use these techniques on as many subjects as possible to improve your skills as an artist, and never be afraid to try something new. Painting the same things all the time can become very boring and lead you to becoming repetitive. Push yourself on to new challenges all the time and be on the look out for wonderful subjects that you have never painted before. Maybe I should now consider painting a kangaroo or a wallaby!

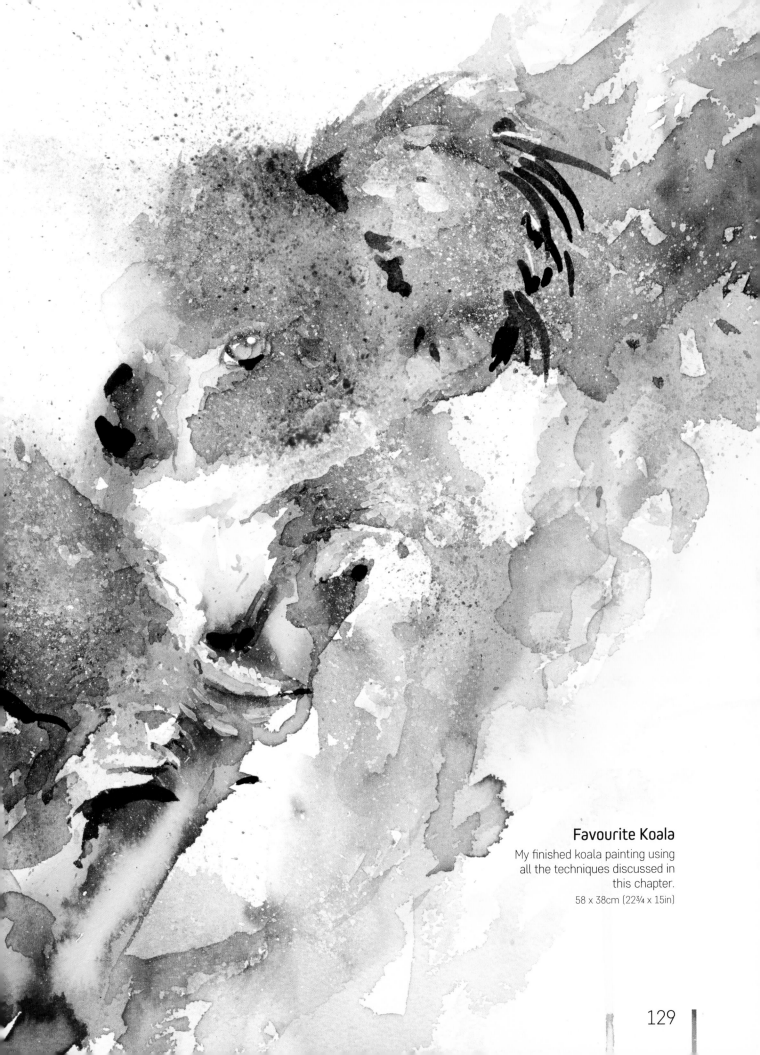

Favourite Koala
My finished koala painting using
all the techniques discussed in
this chapter.
58 x 38cm (22¾ x 15in)

Facing challenges

"No matter who we are, how old or how experienced, we can always learn something new."

Growing as an artist

People

When I lived in Dubai I became totally passionate about painting portraits. In all honesty they had never interested me before. In the United Arab Emirates, I was surrounded continually by wonderful faces, and I met fantastic artists who worked in portraiture. It was impossible not to be inspired by them. I was teaching watercolour courses at the Dubai International Art Centre, which gave me the opportunity to sign up for every course available to learn more about portraiture in every medium. At that time, I worked in oil, pastel and watercolour. I was hungry for information and leapt at any chance of learning to improve my skills.

I remember a leading portrait artist who gave a demonstration that the class was invited to follow. I observed the model as requested, but unlike the rest of the group I worked in my own style, minus a preliminary sketch. I loved the tips given on colour combinations for skin tones and how to achieve facial features. But without an initial sketch I was guided on colour and shape by my instincts alone. The demonstrating artist was very kind and advised me that my technique wouldn't work, so we were both more than surprised when it did. He sat next to me, painted in my style and his result was so full of life that he thanked me for giving him new ideas.

The point is, no matter who we are, how old or how experienced, we can always learn something new. We both shared our ideas and the combination was magical. Of course, this artist had a far more trained eye than I so his work without a preliminary sketch was superb. He knew exactly where each facial feature should be placed. This skill comes from observation, practice and time put into studying to improve.

Many artists on my workshops are terrified of painting portraits. To me they are simply another fascinating subject. We all grow as artists, and as personalities. I used to be so shy years ago but demonstrating to large groups of people has given me the opportunity to get over that fear. I have grown in my art, my life and as a person. So to grow as an artist, let's look at a few simple demonstrations.

"Things are only impossible if we allow ourselves to think they are."

In Dubai where I fell in love with painting portraits.

"Face challenges head on. Never be afraid to try something completely new."

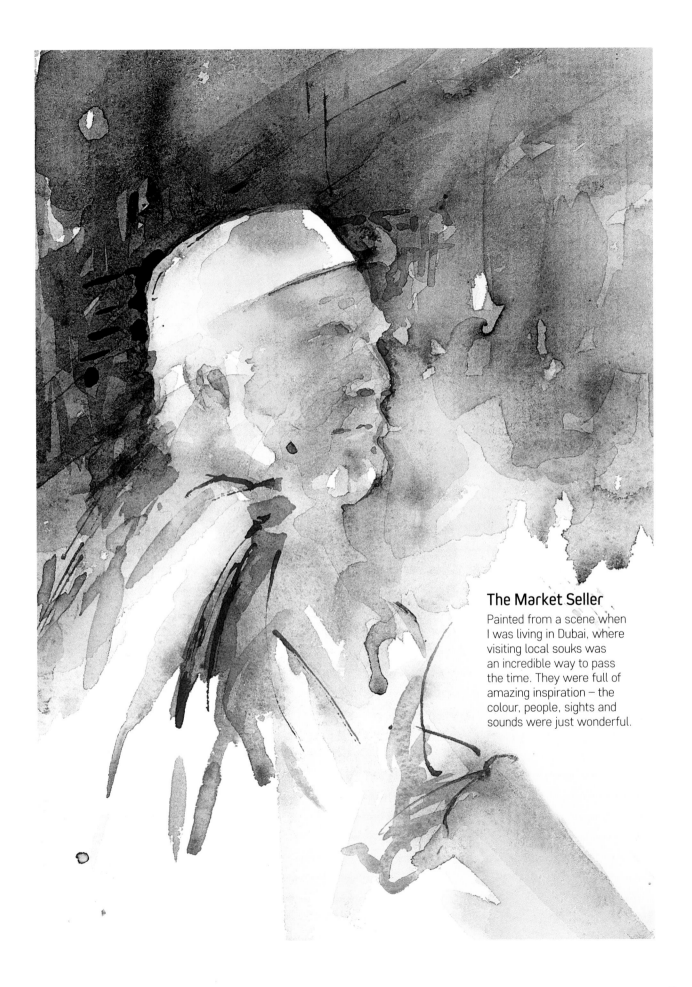

The Market Seller

Painted from a scene when I was living in Dubai, where visiting local souks was an incredible way to pass the time. They were full of amazing inspiration – the colour, people, sights and sounds were just wonderful.

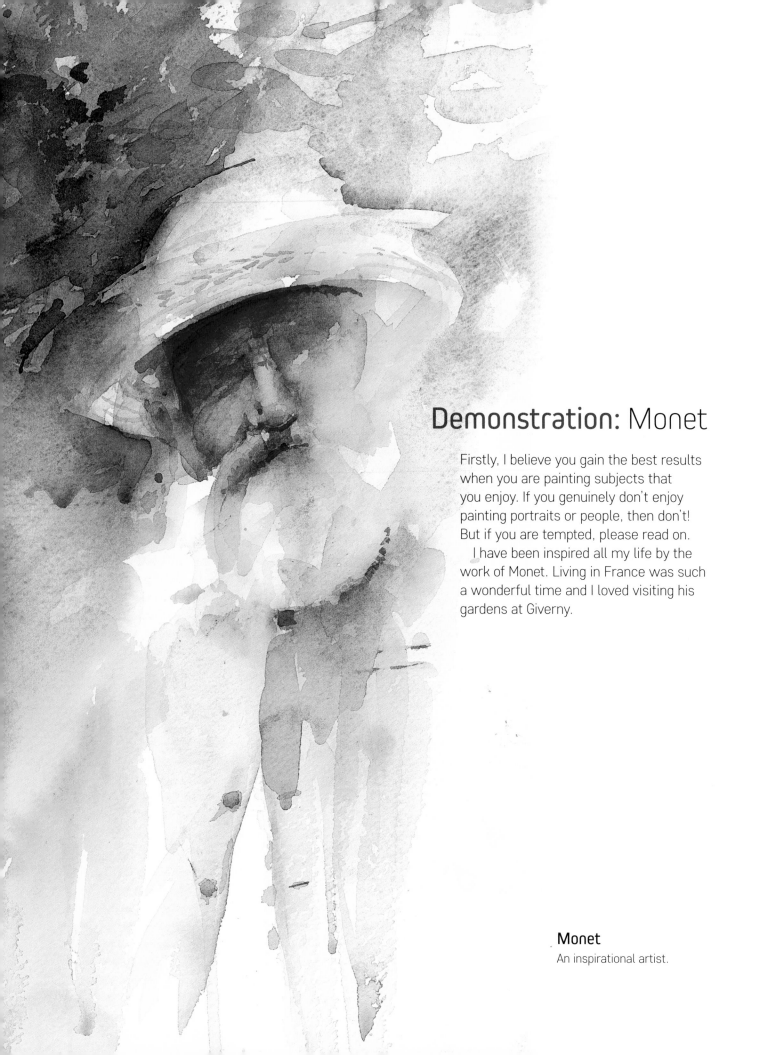

Demonstration: Monet

Firstly, I believe you gain the best results
when you are painting subjects that
you enjoy. If you genuinely don't enjoy
painting portraits or people, then don't!
But if you are tempted, please read on.
 I have been inspired all my life by the
work of Monet. Living in France was such
a wonderful time and I loved visiting his
gardens at Giverny.

Monet
An inspirational artist.

I prefer painting from life, but it isn't always possible. So for this demonstration I am going to use a photograph to show you how I would approach painting a face.

Tip

When working on darker skin tones substitute Perylene Maroon for the Alizarin Crimson.

1

2

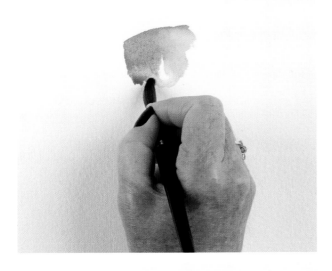

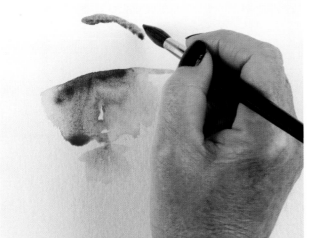

1 I suggest you forget you are painting a face. Try to imagine you are just painting shapes. I always find my starting point to work away from. As the facial features are so small in this photograph, I am happy to work with the whole face shape for my first brushmarks. My favourite flesh tones in watercolour are a mix of Alizarin Crimson and Yellow Ochre, heavily diluted. You can see I have left a lighter area for the nose.

2 Working with my size 10 brush, I leave areas of the paper white for the moustache and the nose. Observing the details of my subject, I next add the mouth line.

3 I begin adding the background. To do this I find the location of the top of the hat and work away from it into the space behind my subject.

133

4

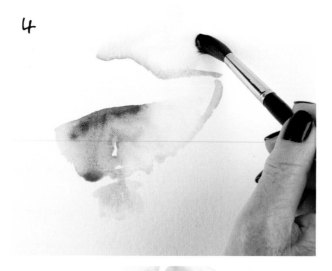

5

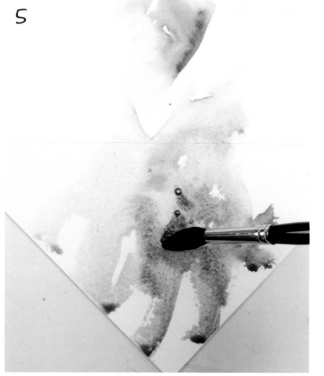

4 Once the outline around the hat is complete I softly bleed excess colour into the background area.

5 Knowing the pigment will be paler when dry, I add strong greens in the background at the top of my painting. In these stages, I find it easier to work with my paper upside down and at an angle, to allow pigment to flow to the outer corner of the paper.

6 I can now strengthen the outline behind the hat and introduce the shoulder on the opposite side, using the same shade of green to connect both sides of my subject.

Tip

While working I continually observe the subject, constantly looking for where my next brushstrokes will be. I am guided by what I am seeing, on this occasion the photograph of Monet.

6

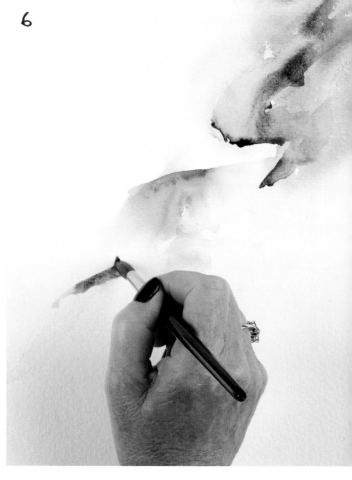

7

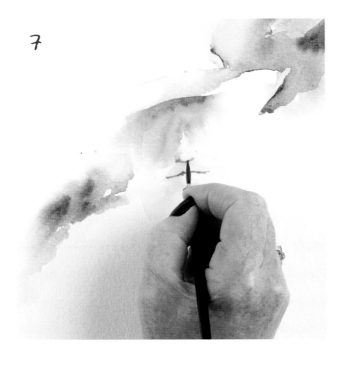

8

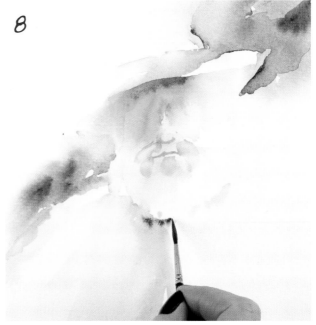

9

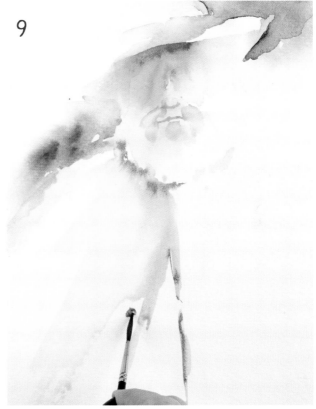

Tip

I change brushes frequently when I am working. This way, I find I can confirm the positioning of fine detail and correct outline edges or detail with my rigger brush without interrupting the creative process. I am often holding two brushes at a time, which is a technique my Shanghai mentor taught me.

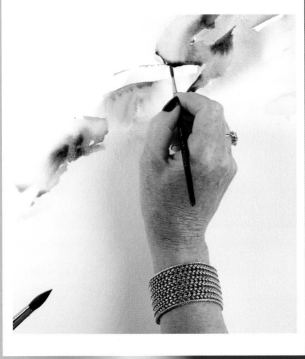

7 I strengthen sections, adding detail to the face where needed.

8 Now I work in a downwards direction to build up my painting by finding the lower point of the beard.

9 Finally I add details for the clothing.

Learning from previous paintings

One thing I have realised from writing books and teaching
workshops is that we are often our own best teachers, but we
sometimes don't realise it. I always recommend keeping paintings
and looking at them one year later to see how you have grown as
an artist. I regularly learn from my past work, studying what I liked
about it and what I would wish to improve.

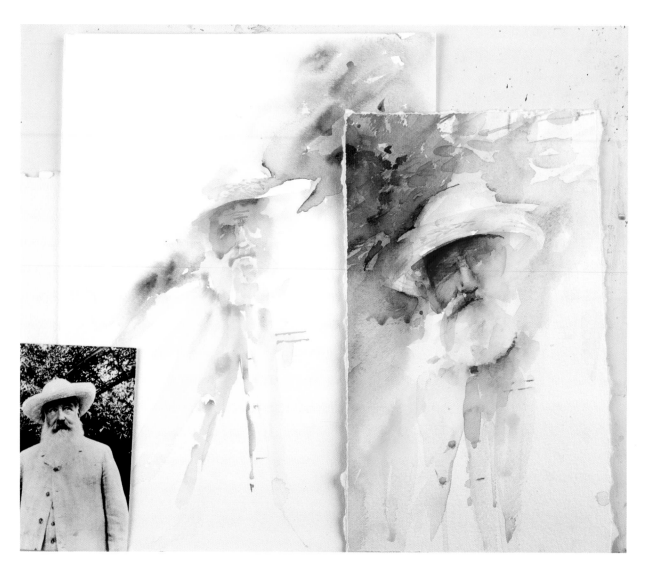

Comparing my two paintings of Monet, I enjoy the softer result of my new
painting but enjoy the detail in my earlier piece. This encourages me to paint
a new portrait in the future with a combination of the two results. I like the
light achieved by leaving the white of paper in the soft version, for example.
As I have grown as an artist, I have become more confident in my ability
to create new paintings from the same reference photograph. Here, I have
changed the position of the green background, and the result is far more
pleasing to me. But painting is a personal experience, and that is why you
must paint to make you feel happy above anything else. You need to find
what pleases you, which in turn encourages you to paint more frequently.

I don't always work from a starting point when painting portraits. I often work from a wash, finding the face shape within it. In this next demonstration I want to show another technique. Here I have fallen in love with a market scene and the profile of the main figure has caught my eye.

Demonstration: Profile

1

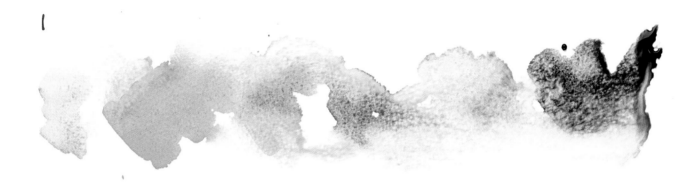

2

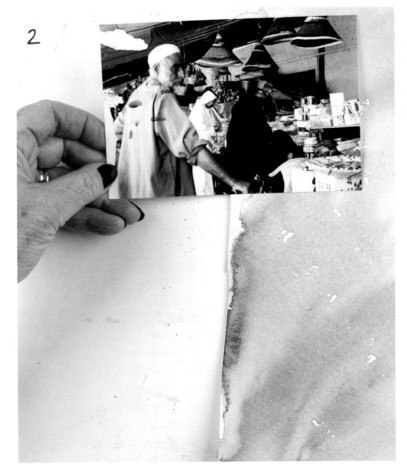

1 Firstly, I make a colour chart to see which colours appeal to me most for a full painting. If you look at the photograph I am working from, you will easily see there are some very dark areas. If I select very dark shades, though, like Indigo, they could kill the light effect in my finished painting, which in turn could make my results look dull. I'm also aware that having lived in Dubai, any painting I wish to create must capture atmosphere. I have chosen Perylene Green for my dark shade, Yellow Ochre and Alizarin Crimson for my skin tones, violet for any shadows, and turquoise for excitement, purely because I love that colour!

2 I create a background wash using the colours decided on in the colour chart. These suit my subject and the background.

3

4

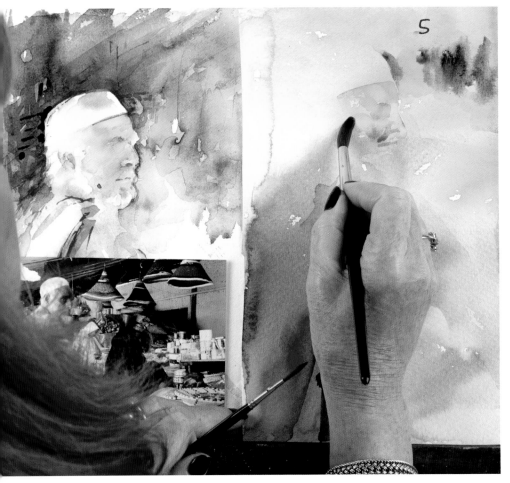

5

3 I work from a starting point, but this time on top of the initial background wash rather than white paper.

4 I find the outline of the hat and work away from it, as in the Monet demonstration on page 133.

5 Learning from my previous painting of the same subject, I can take parts of it that I like and change the parts I wasn't too happy with. I am aiming to keep my new painting softer, but I loved the golden background of my first piece so repeated it in my new painting.

6 When I can see my subjects coming to life, I take a break to study them and see what further brushstrokes can be added if necessary, and where.

7 I add small touches of white gouache to whiten the beard and moustache.

> **Tip**
> *I often work with two brushes in my hands at this stage of a painting where I am working on final details. I use my size 10 brush for soft blending of pigment and my rigger for adding fine detail.*

> **Tip**
> *You can create interesting effects by adding tiny amounts of white gouache for facial hair in portraits, especially if you lose the white areas of the paper or when working on a wash where the white areas will have been covered in earlier stages. But please use gouache minimally, as it can take over a painting if applied too heavily.*

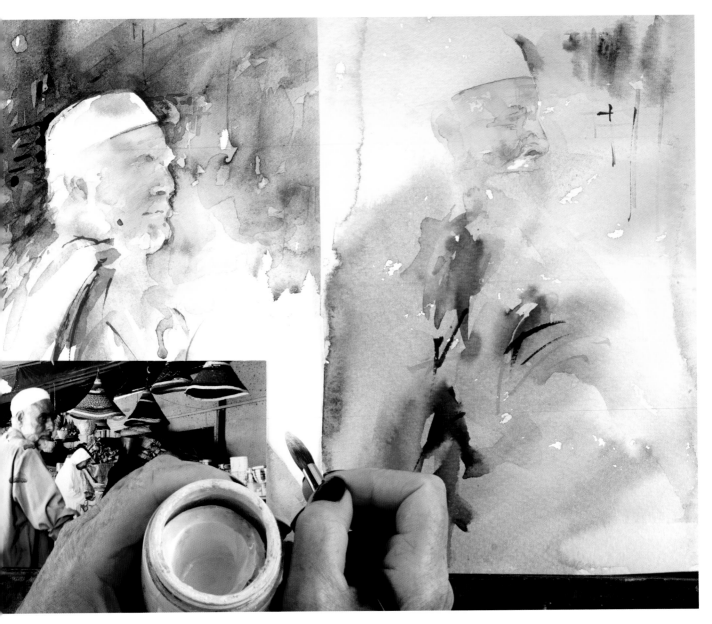

Taking the good points from previous paintings and carrying them into new ones helps you grow as an artist. In fact, I think we push ourselves the most when we are trying to improve what we have painted before. In this way, we can set our own challenges.

Painting comparison

Finally, I can compare the two paintings. The earlier version is much darker. The later, softer version leaves more to the imagination, but to me it seems more atmospheric. I can, of course, work much further on the second painting and could choose to add market stalls behind the figure or add more people in the background. This is where my painting now moves away from the photograph completely and becomes an original piece of art, because as the artist I am making choices.

Sometimes, when we are faced with painting from photographs, especially if they aren't our own and are of places or subjects we have not seen, the temptation is to copy the composition in front of us exactly as it is – an exact replica of the photograph. But to me, this is a form of direct copying. By allowing ourselves to be creative, we can produce something far more fascinating and exciting.

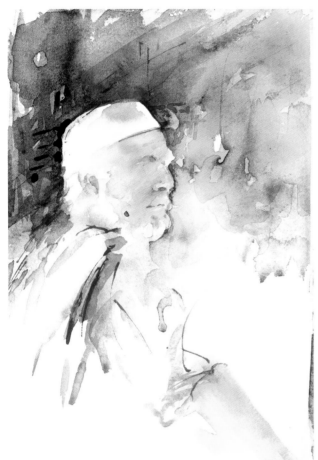

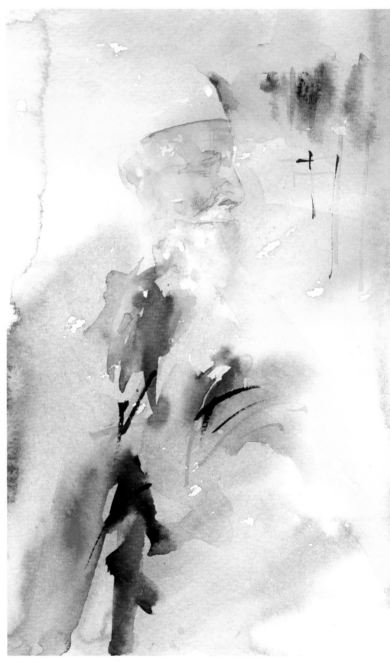

Comparing these two paintings side by side show me how I have grown as an artist since painting the first version, shown above. Aim to be an original artist, not a copier. Create rather than replicate, and enjoy every single brushstroke or decison you make.

Market seller in Dubai.

Finally, I fell in love with cowboys when visiting Texas to hold watercolour workshops there. I have never been a fan of Western movies, as my father watched them non-stop while I was growing up. I just couldn't see his fascination. Well I can now. When standing next to a tall cowboy in a cowboy hat I am blown away! Either I was lucky and all the cowboys I met were totally charming, or they are all like that. So to close this chapter, for my Texan friends and for all cowboys, here is my cowboy sketch from a workshop I taught in Lubbock, home of Buddy Holly, and the darker completed painting that leaves so much to the imagination. I cannot wait to return to Texas and the USA!

On the left is an atmospheric painting of a cowboy. With so much detail missing, this study leaves a great deal to the imagination, and yet it is both evocative and charming. It also highlights the magic of working in watercolour. The watermarks create drama and interest. To me, any further detail would not add to the freshness and mystery of the piece.

On the right is a darker, more detailed study of the same cowboy.
28 x 38cm (11 x 15in)

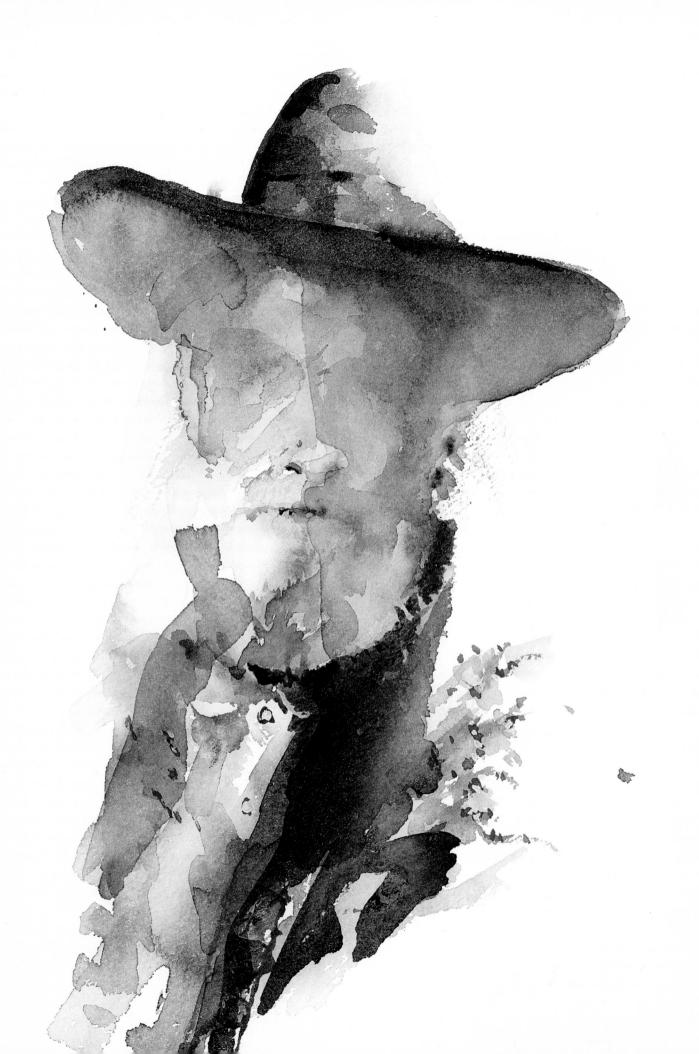

Beauty simplified

"I felt as though a veil were being lifted from my eyes."

Landscapes and cityscapes

It is amazing how the simplest of scenes can be so magical. Close your eyes and think of a warm summer's day with the clearest of blue skies above you, an empty green field in front of you and birdsong filling the air. It is sheer bliss for those who have had this experience. No wonder so many artists have fallen in love with painting landscapes over the years. We see so many wonderful sights in the world and it is impossible not to want to paint them, especially stunning landmarks or historical buildings. But it is often an area that leaves the new artist feeling defeated, challenged or bored because it has 'all been done before'.

The vibrant painting of Valencia opposite is in stark contrast to the rural study in monochrome below, but both capture the mood and atmosphere of the location perfectly.

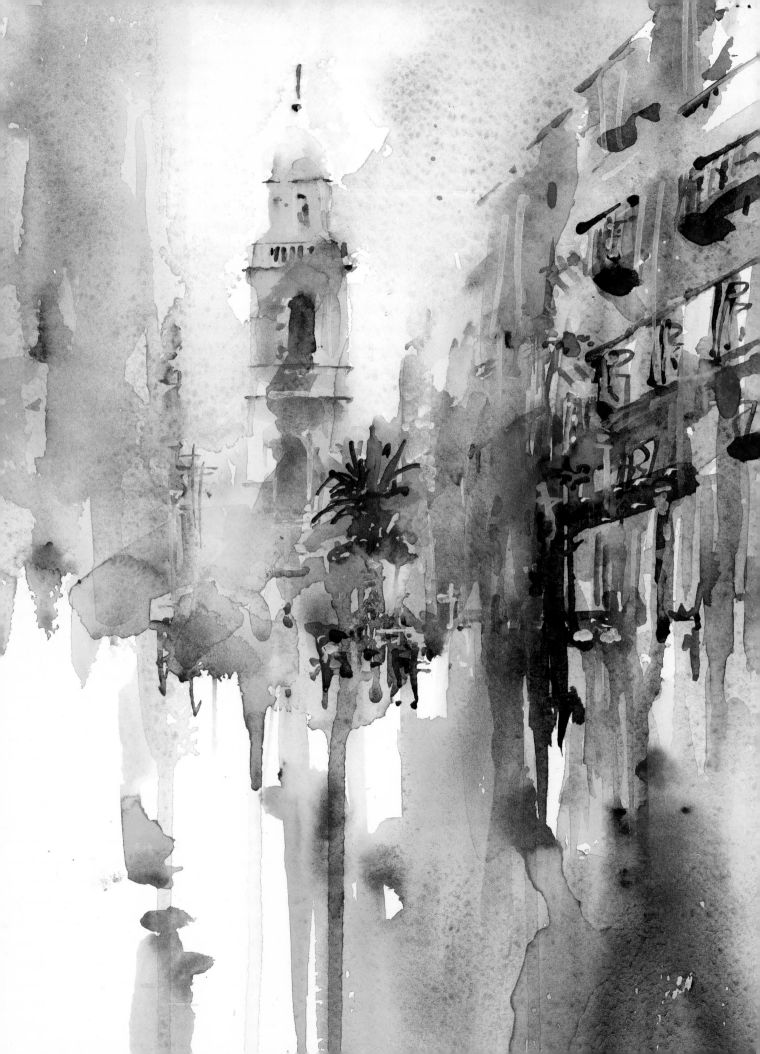

My love of painting landscapes began when I lived in England years ago. Apart from seeing paintings in my grandparents' home that I now own, I grew up seeing landscapes in watercolour painted repeatedly with the same regimented appearance. Usually they involved a blue-sky backdrop to trees, possibly a farm building in the middle, then a foreground with grasses or a track leading to it. I lived in the countryside so it isn't surprising!

But I was lucky enough to travel, live abroad and meet artists who had other ways of working in watercolour when painting landscapes and city scenes. I saw sand dunes and deserts in the United Arab Emirates and rice fields in Asia, and I fell in love, as every artist does, with Venice. I saw many sights worldwide where the colours were totally different from what I was used to.

My first ever painting to sell in a gallery was of a mosque in Dubai, and it was set against a pink sky. Perhaps this is where my passion for pink skies came from! But I felt as though a veil were being lifted from my eyes. I discovered I had choices. I realised that I didn't have to follow rules or paint boring scenes, I could be unique. I could be imaginative with colour. And so my journey into magical landscapes began, and I have been a watercolour addict ever since.

Tip

I select colours to set the mood for the places I am painting. For example, I could use red or orange washes to set the scene for Africa, textural gold washes for glowing corn fields, and atmospheric blue or violet shades to suggest cool snow scenes.

Demonstration: Landscape washes

Experiment with washes that could be interesting as a backdrop for landscapes – do not limit yourself to only creating blue skies. Try to be unique. Find different colour combinations and even textural effects. Stretch your imagination and 'reach for the skies'.

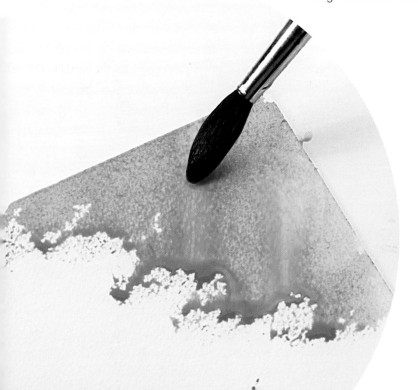

I usually start a wash by working from one corner directly to another, allowing colour to merge in the middle. I keep in mind that when dry I will be painting a scene on top of the dry wash, so the colour choice and depth needs to allow me to do so.

2 By applying different colours to opposite corners and holding my paper at an angle, I can encourage an interesting flow of pigment from one corner to the other.

3 Splattering with a toothbrush loaded with bold pigment onto a damp wash can create interesting patterns. These can add to a later composition. I can choose to work around these in my composition, or combine the pattern with my chosen subject.

4 This is a typical wash that a landscape could be painted on at a later stage. The salt will be removed before painting further.

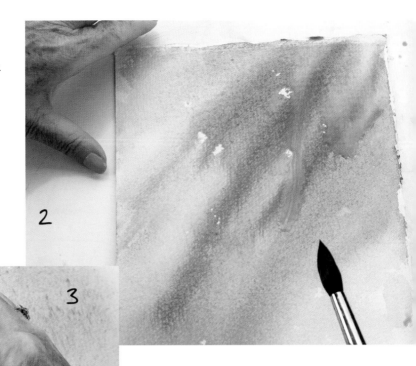

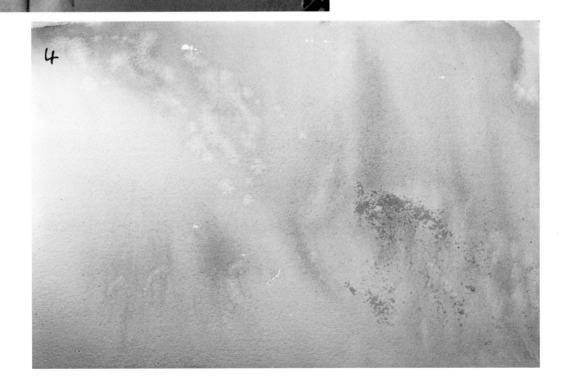

"Stretch your imagination and reach for the skies."

Demonstration: Taj Mahal

Painting buildings on washes

Once you have mastered creating fascinating watercolour washes suitable for painting landscapes, it is a great idea to practise painting architectural outlines. A combination of both can be quite magical. The colour you use for the background will indicate the country, season and weather you are painting. Try to make your colour selections fascinating and choose building outlines that are appealing in shape.

Because I have seen the Taj Mahal and adore India, in the next demonstration I am working with a scene that I found to be truly romantic and a dream come true, seen with my own eyes when my husband surprised me with a visit there on a special wedding anniversary. He knew that I had always wanted to see it and it was absolutely magical.

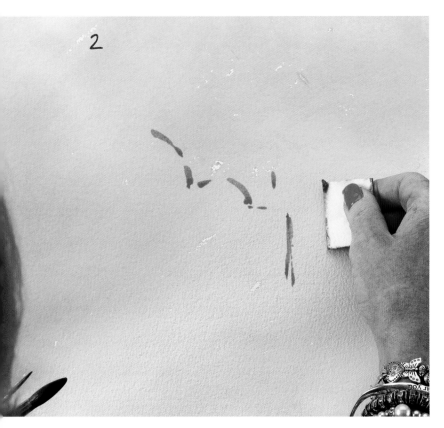

1 First I decide where my starting point will be and begin to paint the upper outline of the building.

2 Next, where I need straight lines in the architecture I fall back on using small pieces of card that have been dipped in colour on my palette. These are then placed where I want the lines to appear.

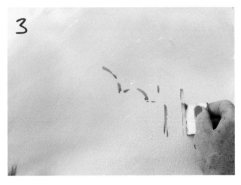

3 I can then repeat these lines using the same piece of card, which will give me lines of similar sizes.

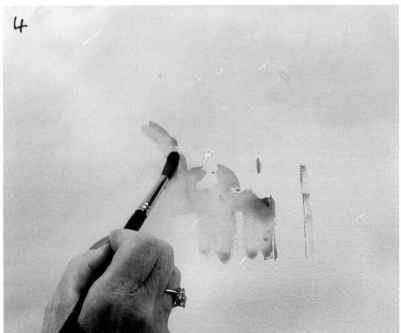

4 Next I blend the still-wet outlines inward, painting the building itself. I add fresh pigment if I need it. I am working in the same colours as my background in this study, which are Opera Rose, Alizarin Crimson, Cadmium Orange and Quinacridone Gold.

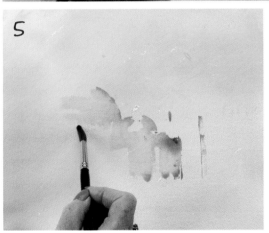

5 I gently bleed the colour on the paper from one side of the building to the other. The graduation of pigment strength when dry will vary across the paper and create interest.

6 Next, I add suggestions of arches or windows, keeping my work very soft so that I can add hard edges and detail later on.

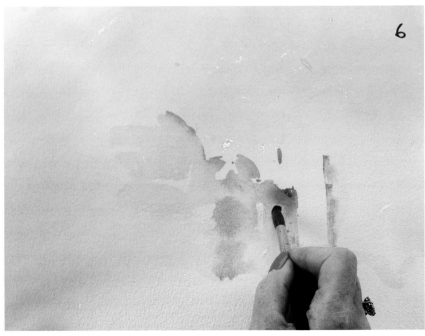

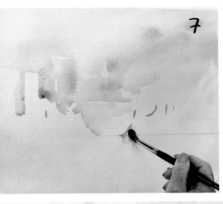

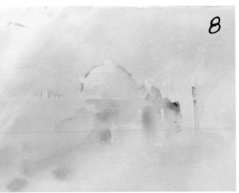

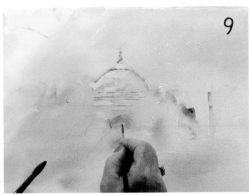

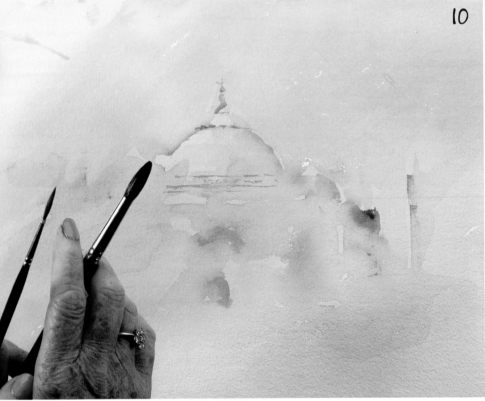

7 Turning my work upside down, I paint the outline of the opposite side of the top of the building and work away from it towards the sky.

8 If you like the softness of your painting at this stage, only add a few details to complete it.

9 Holding two brushes, I can switch from painting fine detail with my rigger brush, to using my size 10 brush for bleeding away or adding larger blocks of colour if needed for doorways or arches.

10 When I see areas I like that need strengthening, I work with further pigment to bring them to life.

11 What to add next is a personal decision. Hints of turrets or towers work well in this piece.

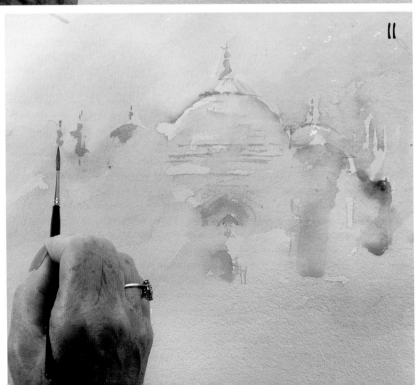

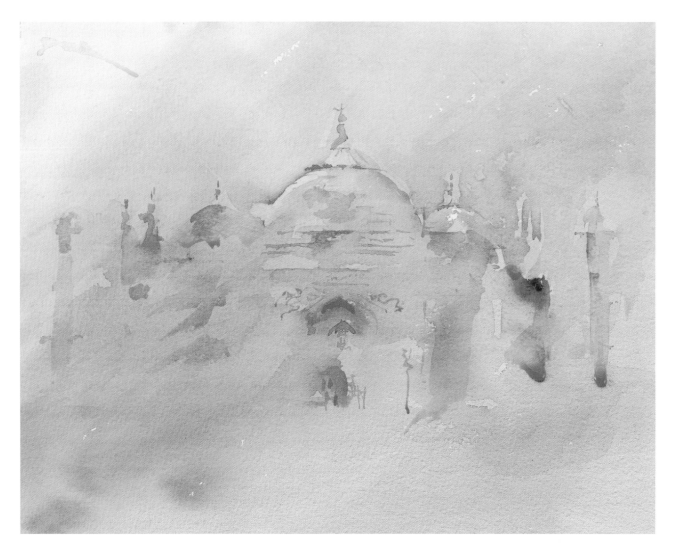

Only the artist knows when a painting is finished or not, but this is a fabulous way to paint many gorgeous buildings from all over the world. Choose your favourite and try painting as many as you can in as many ways as you can. I would paint Big Ben or the Houses Of Parliament against a blue violet background, as it often rains in England. The White House in the USA would be fantastic to paint with this technique, and how about the Pyramids of Egypt set against a glowing golden background?

There is no end of possibilities and, I must admit, I could paint another right now. I am so inspired by the thought of what could be achieved with a gorgeous background just waiting for intricate detail to be placed on top, telling the story of the chosen location.

Working from a starting point for cityscapes

I work with two main techniques when painting. I either create a wash suitable to be worked on further or I work directly from a starting point and build up my painting from there. It is easy to see how I work with this technique when painting animals or flowers, but it is perhaps a little more difficult to see how this painting method can be adapted when working on a cityscape or landscape.

The following demonstration is to share with you some simple tips for painting cityscapes.

Demonstration: Valencia, Spain

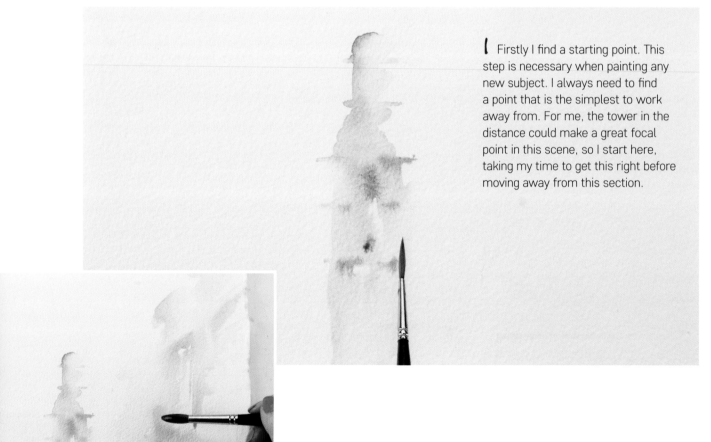

1 Firstly I find a starting point. This step is necessary when painting any new subject. I always need to find a point that is the simplest to work away from. For me, the tower in the distance could make a great focal point in this scene, so I start here, taking my time to get this right before moving away from this section.

2 I next add colour to the right of my focal point.

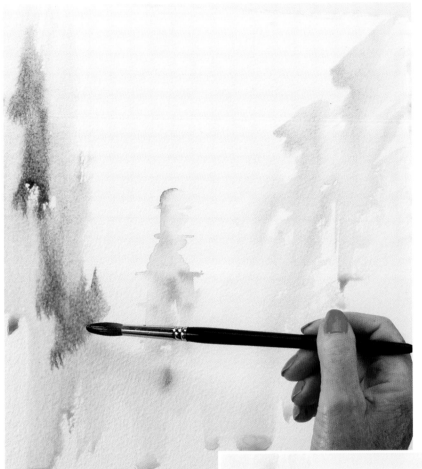

3 With downward brushstrokes, I then work on the left side of the focal point, painting the buildings here in a cooler blue. This can create a dramatic contrast to the opposite side of the street, which could be in full sunshine.

4 After adding a little green for distant palm trees, I use a small piece of paper with a straight edge to make lines on the buildings.

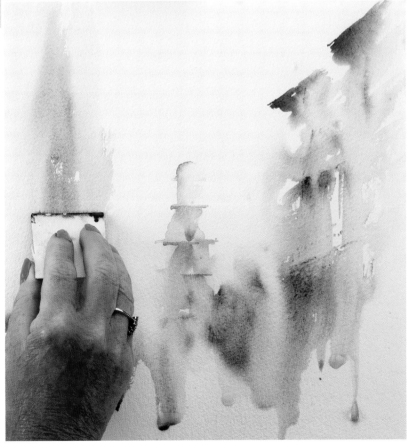

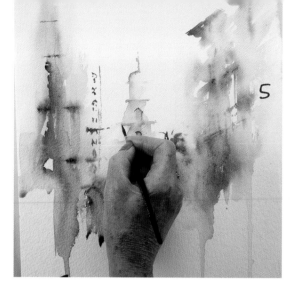

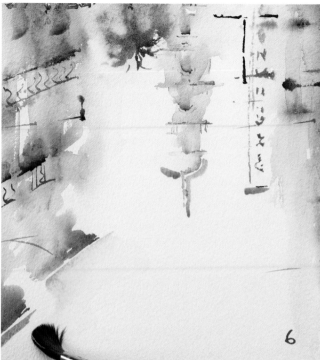

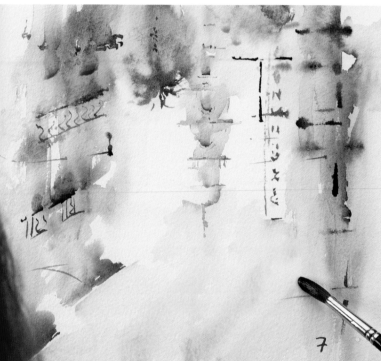

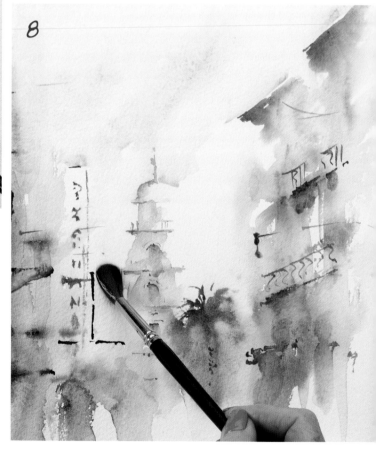

5 Happy with the early brushmarks and colour placement, I can now work further with a few hints of fine detail using my rigger.

6 For hints of the sky and to add colour to the white paper at the top of my painting, I turn the paper upside down and place a line of blue at the edge of the roof line. I can work away from the buildings, and this will prevent the blue wash from running onto my work below.

7 Keeping the painting upside down, I blend the painted blue outline above the buildings to act as the sky.

8 Turning the paper the right way round, I decide where the blue shade previously added for the sky should merge with the buildings.

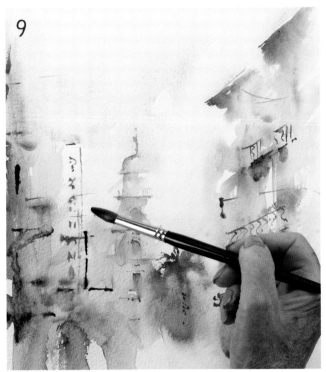

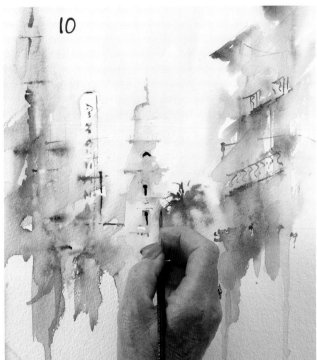

9 At this stage I add a few fine lines to add interest. I like to have a mix of vertical and horizontal detail if possible, and curved lines for balconies, lamps and street signs are all wonderful additions to painting cityscapes or architectural scenes.

10 I add a few final dark touches to give depth to the buildings where needed.

A simple landscape, which forms a basis as an idea on how to approach painting many other cityscapes and scenes.

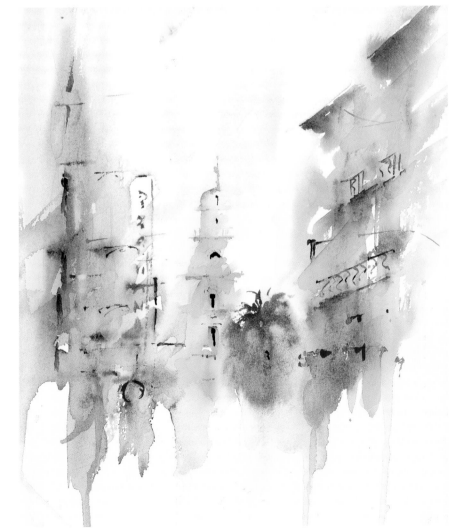

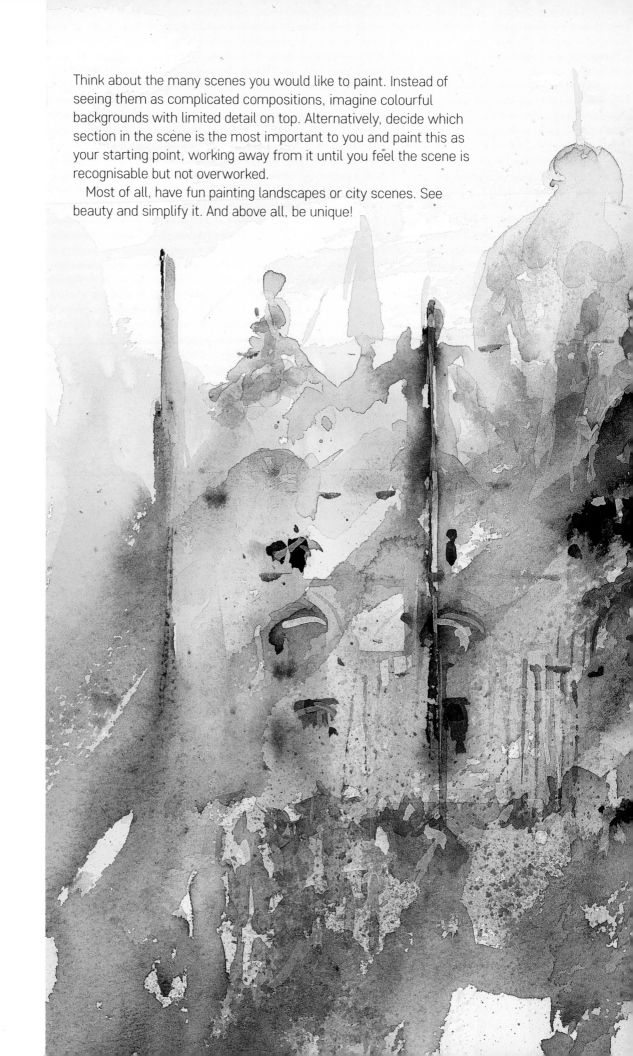

Think about the many scenes you would like to paint. Instead of seeing them as complicated compositions, imagine colourful backgrounds with limited detail on top. Alternatively, decide which section in the scene is the most important to you and paint this as your starting point, working away from it until you feel the scene is recognisable but not overworked.

Most of all, have fun painting landscapes or city scenes. See beauty and simplify it. And above all, be unique!

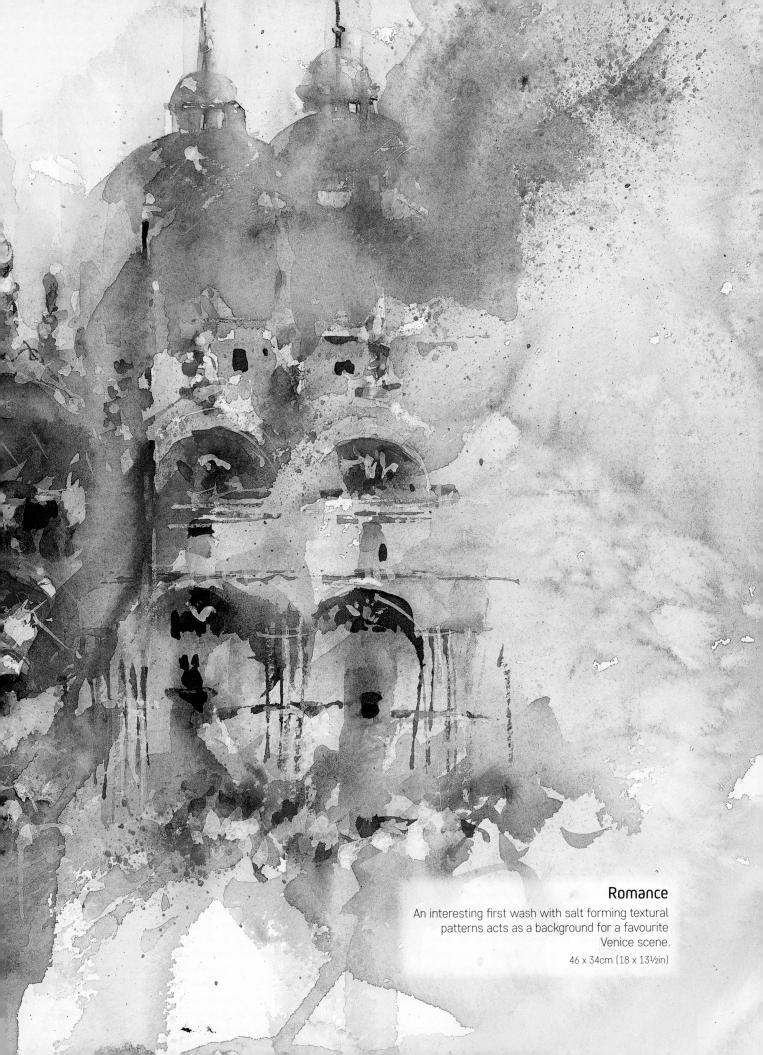

Romance
An interesting first wash with salt forming textural patterns acts as a background for a favourite Venice scene.

46 x 34cm (18 x 13½in)

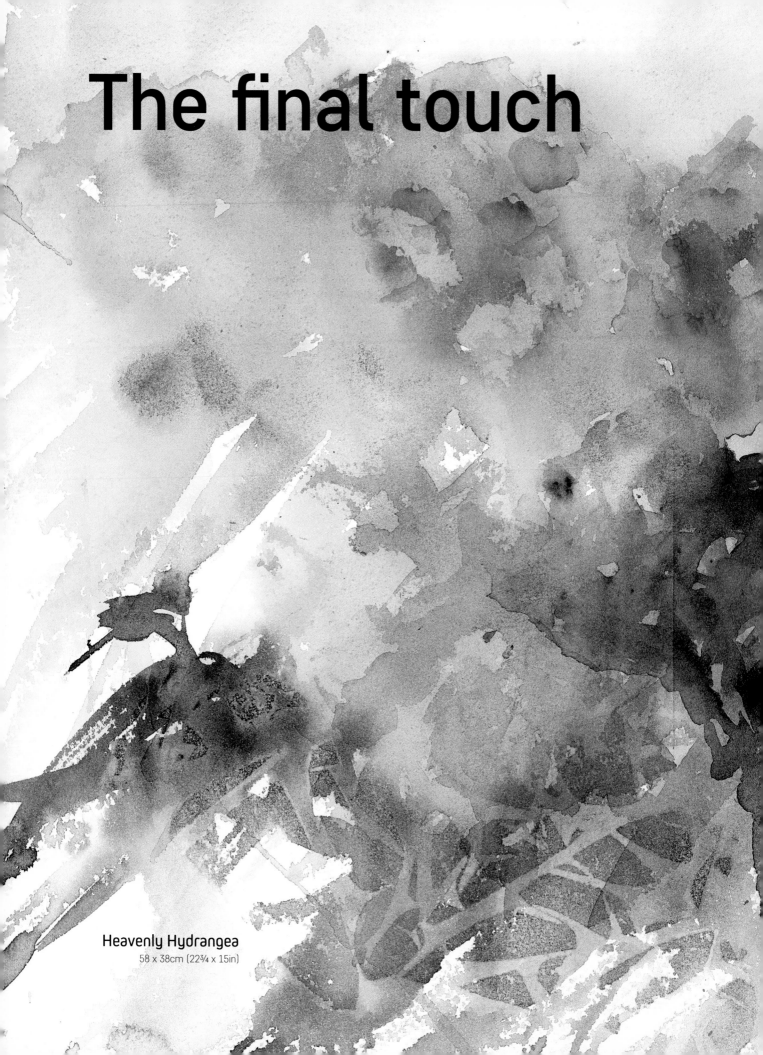

The final touch

Heavenly Hydrangea
58 x 38cm (22¾ x 15in)

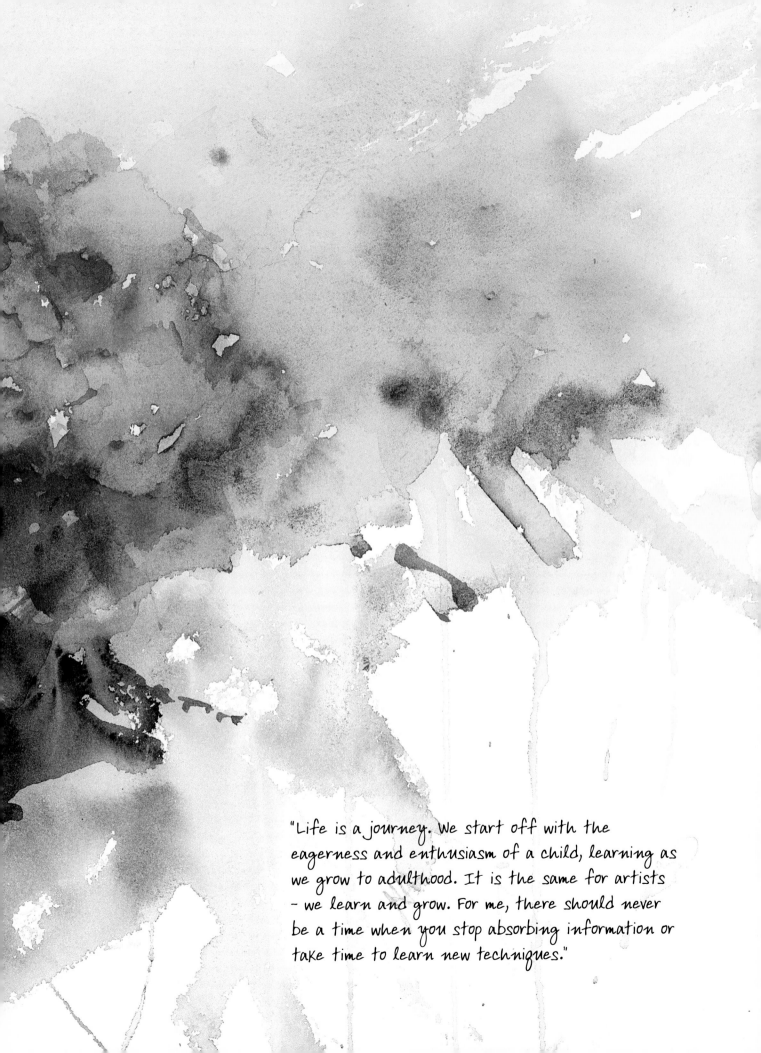

"Life is a journey. We start off with the eagerness and enthusiasm of a child, learning as we grow to adulthood. It is the same for artists – we learn and grow. For me, there should never be a time when you stop absorbing information or take time to learn new techniques."

Learning as artists

"In every painting, the creative steps involved teach us how to improve as artists."

A collection of tips

The chapters of my book should read like a watercolour journey. It is an exploration of colour and techniques that are aimed to inspire, but not by just copying the demonstrations. Its main goal is to show watercolour as a wonderful medium that is brilliant to work in. There are endless possibilities for painting all subjects in a variety of ways, from taking the first experimental steps of painting colour swatches to creating fascinating studies or finished watercolours.

I adore living in my world of watercolour, and if I could have just one wish come true it would be that everyone, who wanted to, could enjoy painting as much as I do, and feel the incredible amount of happiness it has brought me over the years. I have taken time to include these artist tips, which I hope you will find useful.

Putting ideas together.

1 Take time to learn about colour and how it interacts with water

Never underestimate the value of the time you spend just applying colour to scraps of paper. I am convinced it is this daily practice that has improved my skill as a watercolour artist.

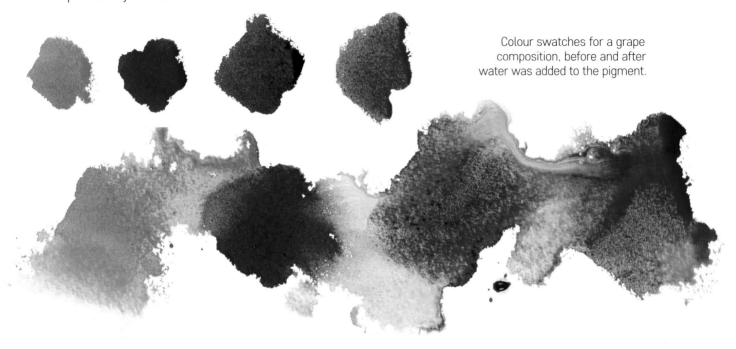

Colour swatches for a grape composition, before and after water was added to the pigment.

2 Don't race to complete a painting: learn with each brushstroke

If we race on any journey to a chosen destination, we often miss so much beauty along the way. So it is with a work in progress. In every painting the creative steps involved teach us valuable lessons on how to improve as artists. I take my time on each new piece of work and, apart from enjoying the process as my work evolves, I learn with every brushstroke. And I intend to keep learning. I create exciting washes, which still thrill me as they appear, and I linger over where to add further brushmarks to bring subjects to life. I do consider carefully where to place detail, as I love watching a painting develop in front of my eyes. Sometimes the process is quick, sometimes it is slow. But I allow my work to evolve at its own pace without the need to hasten it.

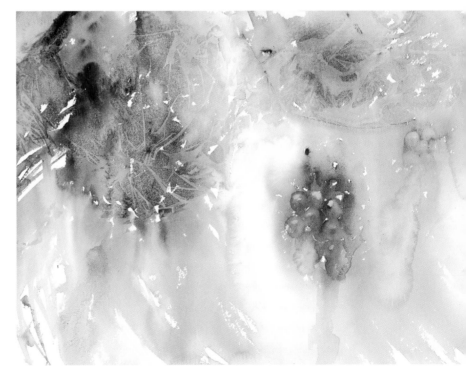

Stunning Harvest
A work in progress can be enjoyed as much as a finished painting.

3 Don't be afraid to follow your own instincts

Sometimes an artist's instinct takes over and they know intuitively where to add more colour or definition. But this takes time and often years of practice. Audiences watching my watercolour demonstrations often tell me how easy I make painting look. My answer is, 'possibly, but I have been painting for a very long time'. Yes, some things are easier to paint than others, like subjects I know well using familiar techniques. I have learned over the years to listen to my own instincts. I do believe there comes a time when you know better than anyone else what your paintings need or not. So learn to trust yourself as your own critic.

I must add here that I too have days where paintings don't always go as I had expected. I love 'happy accidents', but it's probably fair to mention I put less in the bin than I did years ago. Like everyone else, I am not perfect, neither do I strive to be.

4 Develop your style

I started learning watercolour almost believing that there was only one way to do things when painting in this medium. I now know this isn't true. I have developed my style, which is constantly evolving. Just like a painting, with each new brushstroke my art knowledge and experience grows and improves. Yours will too.

Adding detail, following my instinct, on an exciting first wash of grapes on the vine.

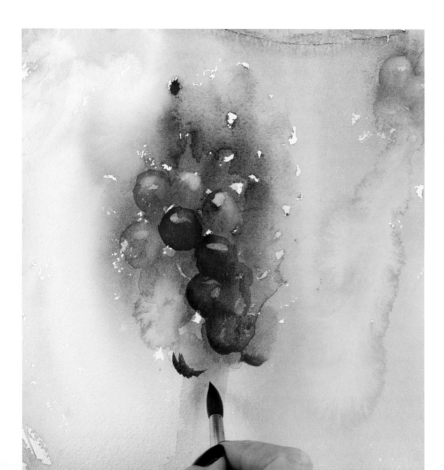

I am guided by where I feel colour needs to be added. I take a step at a time to develop a painting.

5 Learn from your mistakes

When I am happy with a result I repeat it. If I am not happy I learn what didn't please me and why. We often learn far more from our mistakes than from our successes, so never feel despondent when things go wrong. You are growing continually and please, never forget, being able to recognise something isn't working is an achievement in its own right.

6 Trust in your own ability

Creating textural washes that sing with exciting colour and working superb detail on top can lead to incredible and unique paintings. Once you have painted your first successful result you will experience the heady feeling that you can do it again, possibly achieving an even better result next time. It is a happy and positive feeling. Savour it and try not to doubt your own ability.

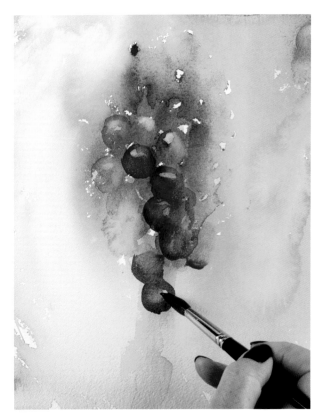

Adding each grape one by one, gradually builds up the composition.

Grape Harvest

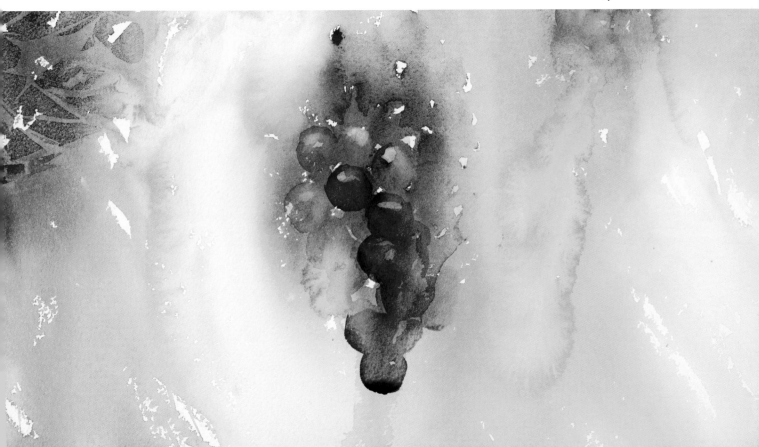

Becoming professional as an artist

For some, there comes a point when you know you want more from your art. It's therefore worth recognising what you really want out of your painting time. Are you painting as a hobby or do you dream of showing your work in galleries? This could be a whole new chapter, but for now I would suggest to everyone that no dream is impossible. If mine came true there is no reason why yours should not. So reach for your goals whatever they may be and, most importantly, never let anyone put you off achieving them.

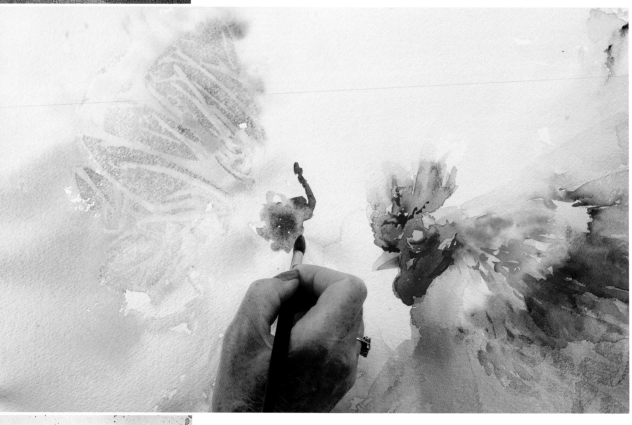

Here I am painting one of my favourite subjects, cockerels. I know what I love to paint. Take time to find out what you enjoy most and paint it. There is no fun in painting for the sake of it. Paint what inspires you and makes you feel happy while you are creating. The joy you feel during the creative process will shine in your results. And the better your skills become, the more your work will improve so that you find yourself gaining confidence as an artist.

Developing my own style has given me more enjoyment and pleasure than I ever imagined. Years ago I did not for one second believe that via my art I would be travelling all over the world teaching watercolour workshops and holding solo exhibitions in the way that I am now. I didn't see myself writing books or filming DVDs. I painted purely because I enjoyed painting. And I still do.

Please bear in mind that every single artist was a beginner at some stage in their lives. There is nothing at all that is out of your reach if you wish to achieve it. If you want to paint, you will!

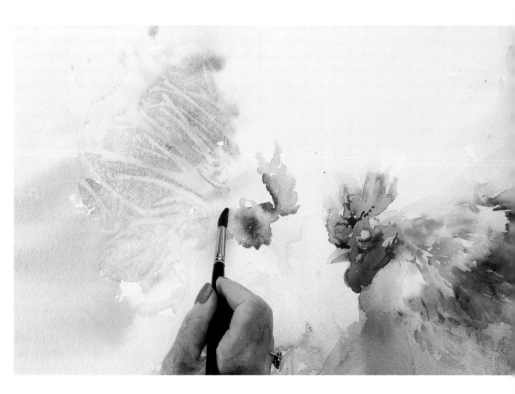

Over time my confidence grew and my instincts on where to place colour improved. Yours will too. Find time to practise and give yourself that time. Life often gets in the way of our plans, but making the time to paint quietly and without interruption is such a worthwhile thing to do. You deserve that time. And on occasions when you really have no time to paint, enjoy looking at what is around you and imagine what you will be painting when you next pick up a brush.

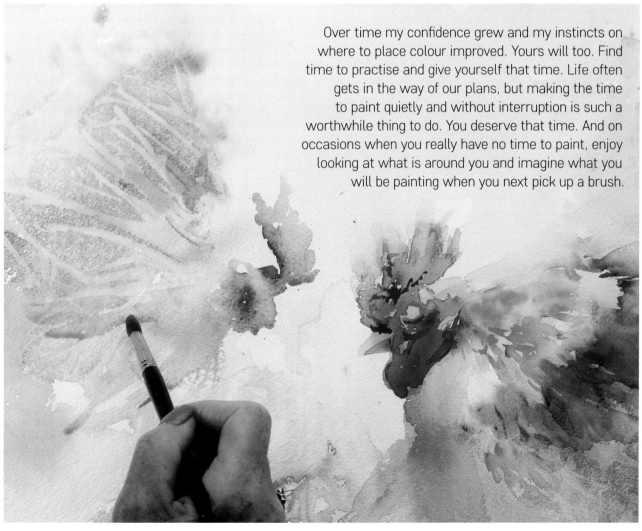

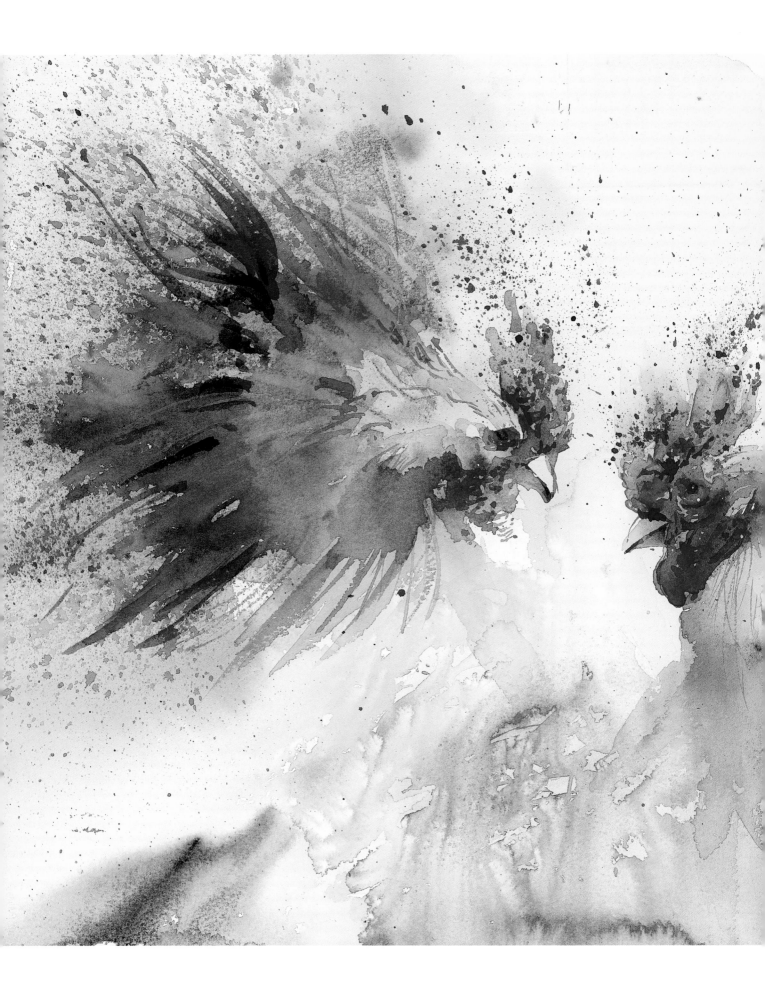

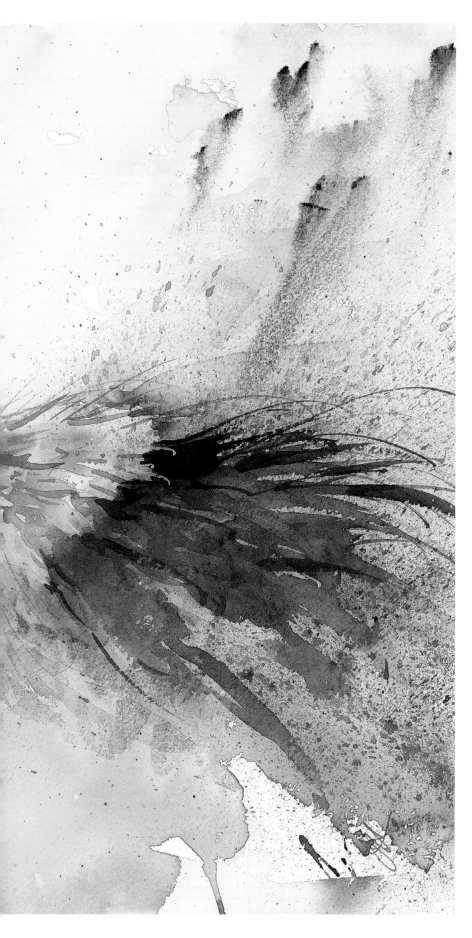

I meet many people on my travels. I meet people on my workshops who feel they are not worthy of being there purely because they lack confidence. I meet people who would love to paint but feel they have no artistic qualities. I meet people who paint but feel their work is terrible and yet they have more talent than they realise. Of course I meet a few artist 'divas' too but they are a whole new book!

Whatever your artistic level, please pick up your brushes as often as possible and paint. Paint yourself into a relaxed mood, or a happy mood or a quiet mood. But just paint! Because there is no better feeling than when watching colour flow across paper, and I seriously believe we are all artists, but some of us haven't realised it yet.

And if you hope to get your work into galleries, please follow my advice by aiming to be original. Gallery owners are not always looking to take on new artists who paint the same as everyone else. So finding your own style and your own favourite subjects will help you so much if you wish to have an art career. I can't stress these words enough: be unique.

Head to Head
56 x 38cm (22 x 15in)

Keeping it simple

Maybe as humans we overcomplicate things far too much. As artists we definitely can at times. I know my impressionistic style lends itself to working loose. However, I do add detail where it is needed to tell a story effectively. I simplify as much as possible, always searching for the most direct and enjoyable way to reach my goal while creating a painting.

Sadly I am at the end of writing my book and it is time to add the last step-by-step. A simple addition to recap on what I have shared in previous chapters. To improve your world of watercolour, these are my favourite tips.

"Simple pleasures in life are often the best."

Practise fantastic washes

Make them simple or fabulous, but keep the colours fresh and clean. They can be filled with light, leading with a subtle directional colour flow, or exciting with fascinating texture.

Love your subjects

Practise bringing subjects to life in watercolour. Paint what you want to and when you want to!

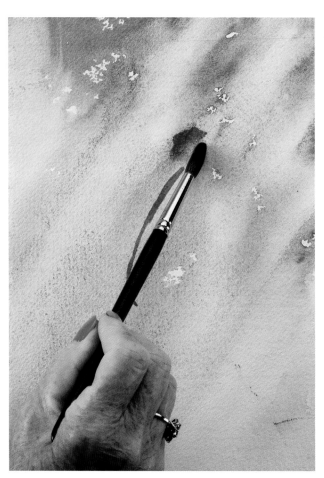

Keeping things simple: working from a starting point on a green directional first wash, a simple fish begins to appear in watercolour.

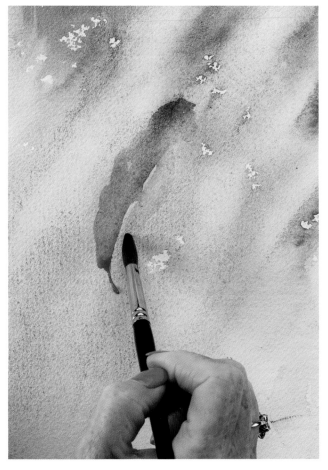

Simple goldfish: bringing a subject to life using simple colour and brushwork.

Choose colour carefully

Think about the colours you use. Select them to add beauty and interest to your work.

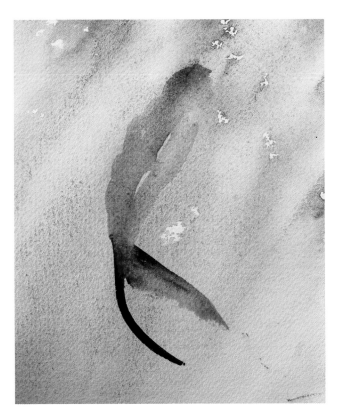

Translucent Orange gives a beautiful effect as it merges with the contrasting fish tail.

Improve your observational skills

Learn to really see, and enjoy doing so.

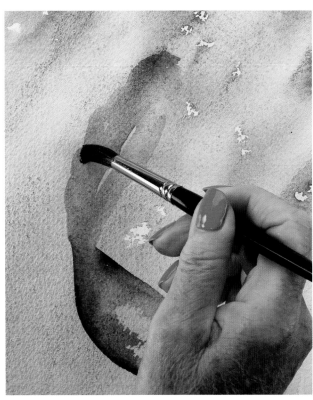

Adjust shapes if you are not happy with them, but don't fiddle too much or overwork. Keep things simple.

Enjoy your results

Most of all, to have the use of hands and the gift of sight are incredible gifts. Enjoy using both while you love painting in watercolour.

Simple goldfish. Art – like life – does not have to be complicated.

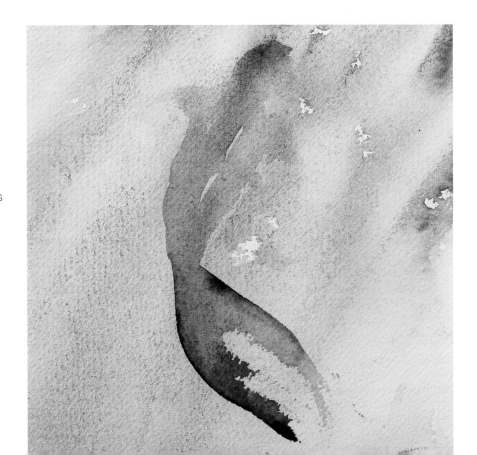

An artist's wish

Throughout my art career I have met many people who have told me they envy me because they would love to paint. I genuinely believe everyone can. The one thing I know I can positively share from writing books on watercolour is my passion for this medium and the joy I feel when painting.

I have written each new chapter in this book as if it were a gift to be opened and enjoyed. Every single tip I have been given over the years, or techniques I have developed, I seriously want to give away for others to enjoy.

I want to encourage others to love painting, to enjoy working in watercolour or see their dreams come true whatever they may be – whether it is just wanting to paint a cat that looks like a cat, winning art competitions, getting into galleries, teaching art or writing.

Through my love of watercolour I exhibit regularly, and travel to Europe, the USA and Australia to hold workshops. I constantly receive incredible invitations to demonstrate worldwide. But when I first started painting I had no idea how my life would change because of doing so. But change it has, and not a week goes by when something wonderful doesn't happen connected with my art.

I truly hope you have enjoyed entering my world of watercolour via this book. And I hope you enjoy your own art journey with as much pleasure in it as mine.

As I close this book, I happily return to being an artist once more. Seeing beauty in everything around me, loving the excitement in seasonal colour and possessing a zest for life that is undeniable. And all enriched with a love for a medium that fills my heart and world: Jean Haines' World of Watercolour.

Happy painting!

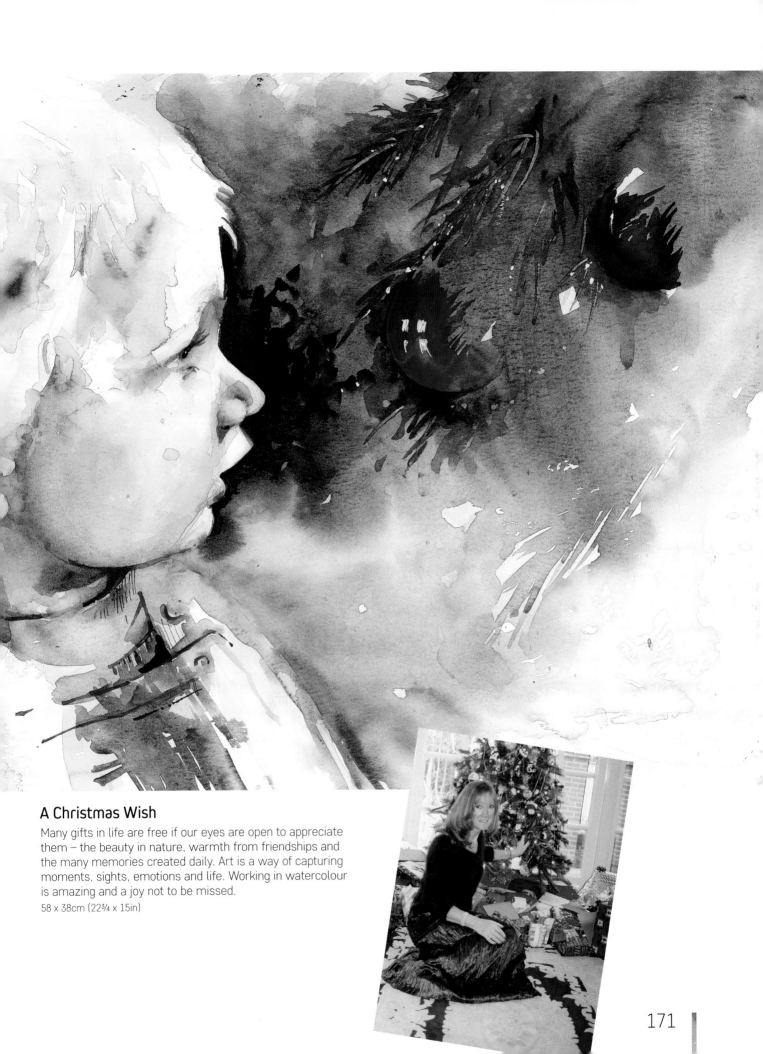

A Christmas Wish

Many gifts in life are free if our eyes are open to appreciate them – the beauty in nature, warmth from friendships and the many memories created daily. Art is a way of capturing moments, sights, emotions and life. Working in watercolour is amazing and a joy not to be missed.

58 x 38cm (22¾ x 15in)

Quotes

Throughout this book I have included quotes that I often use to help establish the ideas that I aim to put across when teaching. Here are some of them. I hope they offer you the inspiration and encouragement you need to continue on your artist's journey.

When we keep our imagination open we never know what we may achieve.

Even for the most experienced artist there can sometimes be a fear of really letting go.

I believe we learn from ourselves as much as from tutors, in that the harder we push ourselves to learn, the more experienced we will become as skilled artists.

We often learn far more from our mistakes than from our successes.

Studying how to handle brushes makes a huge difference, not only to our confidence as artists but also to our pleasure when creating.

Make your painting time enjoyable from the minute you pick up a brush.

If you look at your own palette and don't feel excited at the colour range there, something is very wrong.

Art is an endless journey and we should love every step that we take.

There is so much to explore that each new day painting is always an adventure.

The materials we choose to paint with can make our creative journey even more exciting.

It is a wonderful feeling to be so enthusiastic that you want to race to paint every morning.

Avoiding constant repetition adds interest to an artist's life.

The joy in discovering new ways to achieve incredible outcomes is never ending.

When a painting goes right you can feel on the highest of highs.

The more often someone works out in a gym, the healthier they become. Likewise, the more often you paint the better an artist you will become.

No matter who we are, how old or how experienced, we can always learn something new.

Life is a journey. We start off with the eagerness and enthusiasm of a child, learning as we grow to adulthood. It is the same for artists – we learn and grow. For me, there should never be a time when you stop absorbing information or take time to learn new techniques.

Aim to create rather than replicate.

In every painting, the creative steps involved teach us how to improve as artists.

Life is an adventure, with each new blank piece of white paper being an invitation to a new journey of creative excitement.

Index

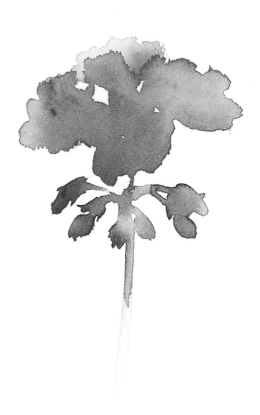

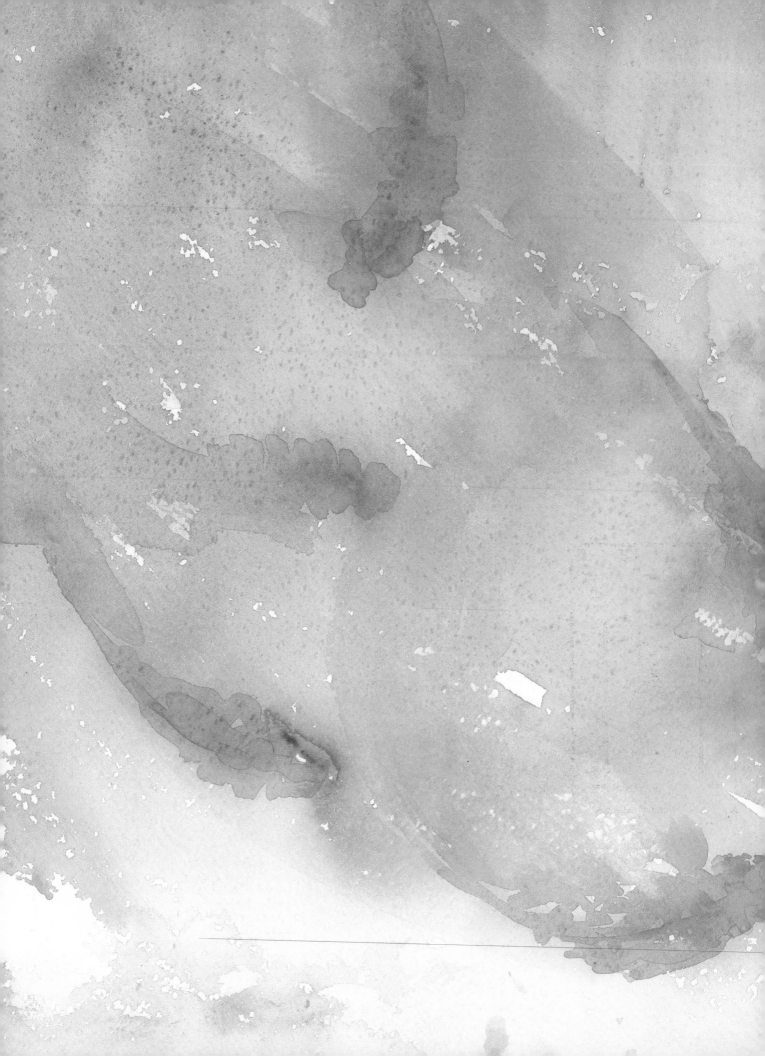